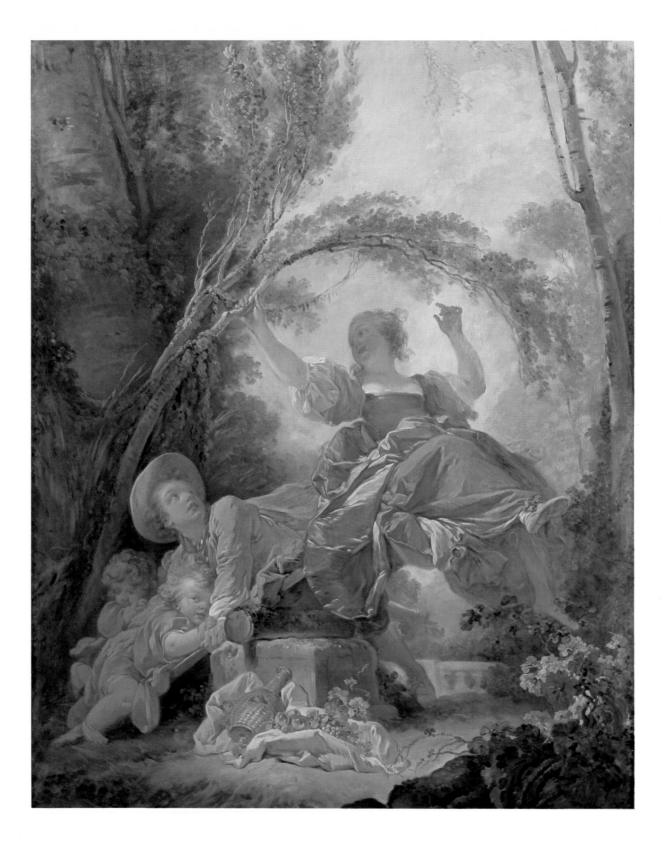

OLD MASTER PAINTINGS
FROM THE COLLECTION OF
BARON THYSSEN-BORNEMISZA

INTRODUCTION BY JOHN WALKER

CATALOGUE BY ALLEN ROSENBAUM

THIS EXHIBITION IS SUPPORTED BY A
GRANT FROM UNITED TECHNOLOGIES CORPORATION

ORGANIZED AND CIRCULATED BY THE
INTERNATIONAL EXHIBITIONS FOUNDATION
WASHINGTON, D.C.
1979–1981

TRUSTEES OF THE
INTERNATIONAL EXHIBITIONS FOUNDATION

This exhibition is supported by a Federal indemnity from the Federal Council on the Arts and the Humanities, by a grant from the National Endowment for the Arts (a Federal agency), by a grant from United Technologies Corporation, and by grants from the Government of the Canton of Ticino and the Tourist Office of Ticino. The catalogue is underwritten in part by The Andrew W. Mellon Foundation.

Library of Congress Catalogue Card No. 79-88886
ISBN: 0-88397-009-0

Special Consultant: Washington Corporative Arts, Inc.

Printed in Switzerland by Conzett+Huber AG, Zurich

Cover Illustrations: (front) Hans Memling, *Portrait of a Young Man* (Cat. No. 25)
 (back) Hans Memling, *Still Life* (Cat. No. 25, *verso*)
Frontispiece: Jean Honoré Fragonard, *The Seesaw* (Cat. No. 47)

PARTICIPATING MUSEUMS

NATIONAL GALLERY OF ART
WASHINGTON, D.C.

THE DETROIT INSTITUTE OF ARTS
DETROIT, MICHIGAN

THE MINNEAPOLIS INSTITUTE OF ARTS
MINNEAPOLIS, MINNESOTA

THE CLEVELAND MUSEUM OF ART
CLEVELAND, OHIO

LOS ANGELES COUNTY MUSEUM OF ART
LOS ANGELES, CALIFORNIA

THE DENVER ART MUSEUM
DENVER, COLORADO

KIMBELL ART MUSEUM
FORT WORTH, TEXAS

WILLIAM ROCKHILL NELSON GALLERY OF ART
ATKINS MUSEUM OF FINE ARTS
KANSAS CITY, MISSOURI

THE METROPOLITAN MUSEUM OF ART
NEW YORK, NEW YORK

TABLE OF CONTENTS

Acknowledgments 7

Author's Acknowledgments 9

Introduction 11

Illustrations 21

Catalogue 81

Index 153

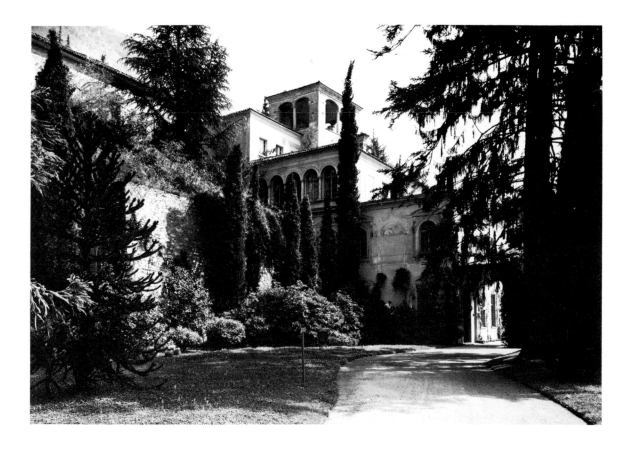

ACKNOWLEDGMENTS

It is with profound pleasure that I write these few remarks as a preface to the catalogue of the exhibition "Old Master Paintings from the Collection of Baron Thyssen-Bornemisza."

Spanning some six centuries of Western European art, the masterpieces exhibited here speak a universal language that transcends cultural, political and national barriers. It is a privilege for the International Exhibitions Foundation, as it enters its fifteenth season, to bring these extraordinary pictures to nine leading U.S. museums so that they may, for the first time, speak to American audiences.

In the course of several delightful visits to the Villa Favorita I have been repeatedly impressed by the warm hospitality of Baron and Baroness Thyssen, as well as by his interest in scholarship and connoisseurship, and his deep and sincere commitment to sharing his collection with the public. Nonetheless, for the Baron to allow these 57 treasures to leave their home beside Lake Lugano for an extended tour in the United States is an act of singular generosity and international goodwill for which we are deeply grateful.

We are indebted to our friend and colleague, John Walker, for making the selection, in collaboration with Baron Thyssen, and for writing his lively and informative catalogue Introduction. Our warm thanks go also to Professor Allen Rosenbaum of Princeton University for researching and writing the individual catalogue entries. His lucid, scholarly text bears witness to the diligence with which he pursued this endeavor, and as a result of his efforts the catalogue contains much new information not available heretofore.

We wish to thank His Excellency Raymond Probst, the Ambassador of Switzerland, for graciously agreeing to serve as honorary patron of the exhibition during its tour. Dr. Francis Pianca, formerly Cultural Counselor at the Swiss Embassy, was especially helpful throughout the organization of the exhibition and we are most grateful both to him and to his successor, M. Pierre-Yves Simonin.

It is always a great pleasure to recognize those organizations which have provided financial assistance. The National Endowment for the Arts in Washington, D.C., a Federal agency, has given a magnificent grant in support of the exhibition and catalogue. The project is also supported in part by a Federal indemnity from the Federal Council on the Arts and the Humanities. We are also extremely grateful to the Government of the Canton of Ticino and the Tourist Office of Ticino, whose generous financial support has helped to bring these paintings to the United States. And we are once again indebted to The Andrew W. Mellon Foundation for underwriting a portion of the cost of catalogue production.

The exhibition's corporate sponsor, United Technologies Corporation, is deserving of our special thanks. In addition to providing a very generous grant they have given whole-hearted and enthusiastic support to every phase of the project, and it has been a great pleasure to collaborate with them. We are also grateful to Mabel H. Brandon for her efforts on our behalf.

Throughout the organization of the exhibition we have been fortunate to have the cooperation of many friends and colleagues whose help has proved invaluable. We are especially indebted to Mr. Alexander S. Berkes, Curator of the Thyssen Collection, and Mrs. Gertrude Borghero, Librarian of the Collection, who have patiently and efficiently responded to our many requests for information and assistance. Mr. Marco Grassi, Conservator, deserves our thanks for having given freely of his time and expertise at every stage of the project. Credit is also due the directors and staffs of the museums participating in the tour, and in particular our colleagues at the National Gallery of Art, all of whom cooperated with us in every way to make the exhibition a success.

The exhibition catalogue, beautifully printed by Conzett+Huber, was produced with the very capable assistance of Mr. Bruno Giovannini of that firm. Taffy Swandby of the Foundation staff edited the text and saw the publication through the press, while Virginia Staniak devoted countless hours to typing the catalogue manuscript with her customary efficiency and unflagging good spirits. To them, and to Christina Flocken, Crystal Sammons and Heidi von Kann of the Foundation staff, I extend my warmest appreciation. They have faithfully attended to the many complex practical details of the exhibition and tour, and they have my sincere thanks for a job well done.

Annemarie H. Pope
President,
INTERNATIONAL EXHIBITIONS FOUNDATION

AUTHOR'S ACKNOWLEDGMENTS

Many friends and colleagues were extremely helpful in the preparation of the catalogue, giving generously of their expertise, information, assistance, advice and encouragement. I am most grateful to Christine Armstrong, Guy Bauman, Elizabeth H. Beatson, Betsy Becker, Adelaide L. Bennett, Mariana Berry, P. H. von Blanckenhagen, John Brearly, Jonathan Brown, Robert Brown, Sharon Cather, Barbara Chabrowe, Frederick Den Broeder, Gary Farmer, Rona Goffen, Barry Hannegan, Jeffrey Harrison, Henry S. Horn, Ellen Jacobowitz, Leslie Jones, Mary Keating, Linda Klinger, Robert A. Koch, Marilyn Aronberg Lavin, Meg Licht, Hayden B. J. Maginnis, John R. Martin, Marianne Roland Michel, Keith Moxey, Edgar Munhall, Mary L. Myers, Sir John Pope-Hennessy, James H. Stubblebine, William S. Talbot, Sir Francis J. B. Watson and Mary Wisnovsky. Donald Posner deserves special thanks for his many valuable suggestions in regard to the eighteenth-century French paintings.

I wish to thank the following staff members of the Art Museum, Princeton University, whose goodwill and professional support allowed me to write the catalogue while still trying to keep up with my duties at the museum: Frances F. Jones, Virginia Wageman, Robert Lafond, Eve Utne, Lynda Gillman, Bernard Rabin, Youngja Kim, Jo Anne Carchman, Louis Papp, James Staats, Jennifer Guberman, and especially Fred Licht for his patience and for his many stimulating discussions and suggestions.

Research was greatly facilitated by the cooperation of Mary Schmidt and the staff of Marquand Library, Princeton University: Ray Ford, Grace Claycombe and Liza Rolland.

Mrs. John A. Pope and her staff at the International Exhibitions Foundation were consistently encouraging and remarkably patient, especially my editor, Taffy Swandby. I am sure that all editors suffer, but few could have done so more gracefully or professionally than she.

In Castagnola Mr. Alexander S. Berkes and Mrs. Gertrude Borghero were very helpful with many practical details and in making information on the paintings available to me from their files.

I am greatly indebted to Marco Grassi for sharing his intimate knowledge of the paintings and for the invaluable assistance he has provided me at every stage.

Finally, I wish to thank Baron and Baroness H. H. Thyssen-Bornemisza for their extraordinary hospitality during my stay at the Villa Favorita while studying the paintings. It has been both a great privilege and pleasure to have worked with such wonderful works of art.

Allen Rosenbaum

THE THYSSEN-BORNEMISZA COLLECTION

Except for the Royal Collection inherited by the Queen of England, the Thyssen-Bornemisza Collection is now the greatest private collection in the world. This catalogue reproduces fifty-seven masterpieces which, while only about one-sixth of the painting collection, represent some of its most magnificent pieces. Paintings, however, are only one part of the treasures assembled in the Thyssen villa on the shores of Lake Lugano. The few pieces of Romanesque and Gothic sculpture rank with the finest in any museum. Many of the Oriental rugs, which have been separately catalogued, are, in the opinion of experts, among the rarest in existence. There are also tapestries, Renaissance jewels, porcelains, medieval ivories, French gold boxes, and examples of vermeille and silver, including one of the pair of Meissonier tureens acquired recently at Christie's by Baron Thyssen and The Cleveland Museum of Art for the highest price silver has ever brought at auction. The collection continues to grow. About half the pictures in this exhibition have been added since the death of the present Baron's father in 1947.

To bring together all these works of art a great fortune has been needed. The foundations of the Thyssen fortune were laid by August Thyssen, who was born in 1842. He was the Andrew Carnegie of Germany. The son of a successful manufacturer of wire, he was tough, determined and ambitious. In 1871 he started his first iron and steel works near Mulheim. Like Andrew Carnegie, he found an almost overwhelming demand for his products. In two years between 1871 and 1873 the price of iron increased from 60 marks per ton to 360 marks. Profits soared. August Thyssen built new blast furnaces and foundries. He had his own harbor on the Rhine where he could load his ships with his coal and ore. He expanded into France. It was there that he met Rodin, the only artist in whom he seems to have taken an interest. He was not a collector; and although he owned a large country house, he occupied two sparsely furnished rooms.

August Thyssen's second son, Heinrich, was the founder of the collection at Lugano. He had little to do with the Thyssen industrial empire. When still a young man he fell in love with the daughter of a Hungarian aristocrat who had married an American. The present Baron Thyssen-Bornemisza is very proud of the fact that because of his American blood he has the right to be buried in the family plot in Delaware. He tells how his maternal grandfather and grandmother made an appalling mistake. Baron Bornemisza, the descendant of an ancient but impoverished Hungarian family, had been Chamberlain to the King of Hungary. He thought, when he met a beautiful young girl from Brandywine, Delaware, that she must have plenty of stocks and bonds; Miss Price, the young lady in question, felt sure that a European aristocrat holding high office must have ample lands and numerous serfs. They were both wrong! They found themselves with neither American money nor Hungarian acres. But fortunately their lovely daughter met Heinrich Thyssen and married him in 1906. The young couple decided to live in Hungary. Shortly afterwards Thyssen was adopted by his father-in-law and became Baron Thyssen-Bornemisza, having taken on Hungarian citizenship. He bought the family place at Rohoncz and settled down to the life of a Hungarian magnate. This ended with the revolution of Bela Kun, when he and his family had to flee the country. They went to Holland, where the second Baron Thyssen-Bornemisza was born in 1921.

The first Baron Thyssen-Bornemisza, although his father put him on several of his boards of directors, was a financier rather than an industrialist. Business activity, he may have thought, took too much time and kept him from his real vocation, collecting works of art. He moved to Switzerland in 1933 and bought from Prince Leopold of Prussia a villa, *La Favorita*, at Castagnola, a small village on the outskirts of Lugano, close to the Swiss-Italian border. He then built a museum, consisting of a long gallery with rooms leading from it, large enough to show about three hundred paintings and numerous pieces of sculpture. After World War II visitors were permitted on certain days to see this part of the collection.

The villa, where the family lives, is separated from the gallery by a garden terrace. Its large rooms on the *piano nobile* are decorated with considerable formality. The furniture is magnificent; the tapestries impressive; the rugs in many instances unique; and the vitrines reveal jewels and *objets de virtue* that are riveting. But the atmosphere in this part of the house is somewhat cold; the carefully arranged décor is suggestive of a museum – a museum, however, where everything is of the highest quality. The present Baron prefers to live in a charming and informal apartment his wife has arranged on another floor. He is now the head of the family and its only member deeply interested in art. He has brought to *La Favorita* some of its greatest masterpieces.

It was his father, however, who had acquired two-thirds of the collection now on view in Lugano. His first love was the German school; but hating Hitler, and being violently anti-Nazi, he did not go to Germany. Nevertheless, through agents headed by Dr. Rudolf Heinemann, he assembled a collection of early German pictures unrivaled in any private collection and in very few museums. In this section of the Thyssen-Bornemisza Collection there are over seventy paintings. Eight of these are in the present exhibition, including Hans Baldung Grien's *Portrait of a Lady* with those almond eyes popularized by Lucas Cranach; and by Cranach himself *The Madonna with the Bunch of Grapes*. Of these marvelous studies of feminine psychology the most subtle and perhaps the most unusual is by Altdorfer, a likeness of a woman approaching middle age whose shyness is expressed by her half smile and the way she holds her beringed hands, perhaps to keep her fingers from trembling. Also one cannot help but admire the startling *Wedding Portrait* by a South German master (Sebald Bopp?), with the wistful and dubious bride nervously holding a pink, the symbol of her matrimony, and the *Assumption* by Koerbecke, a companion piece to the *Ascension* in the National Gallery of Art.

A love of German primitives led quite naturally to an interest in early Flemish painting. As with the German School, the assemblage of pictures from Burgundy and Flanders at Lugano is unique among private collections. The earliest example is the *Annunciation* by Jan van Eyck, one of the rarest paintings to be found anywhere. On two panels the artist has depicted the Angel Gabriel and Our Lady, both represented as simulated sculpture standing on pedestals. To increase the illusion, Gabriel's wings project beyond the picture's painted frame and the Virgin's shadow is reflected in the black marble of the background. They must once have been the left and right wings of a diptych rather than the wings of a triptych, as one might suppose, for there are reasons to think the panel was never intended to be divided.

Almost as great a rarity is *Our Lady of the Barren Tree* by Petrus Christus. In this pre-

cious and jewel-like painting there is a further instance of illusionism. From the twigs hang fifteen Gothic letters "A." These initials, symbolizing fifteen Hail Marys, appear to be of cut gold. To enhance their metallic appearance, each reflects the light differently.

This tiny, exquisite painting has had a history illustrative of the difficulties involved in the formation of a private collection today. It was promised as a legacy to the present Baron Thyssen-Bornemisza by his aunt, who lived in Germany. As the picture was listed as a national treasure and therefore prohibited from export, had he received the bequest he could never have legally brought the painting to Switzerland. But he and his aunt quarreled and shortly thereafter she had a visit from an important member of the West German government. He praised the Petrus Christus highly. Impulsively she said that if he liked the picture so much, since he himself was a collector, she would give it to him. Overjoyed by this unexpected gift he took the painting away; but some years later needing money, he decided to sell it; and as the best market, he was told, was in Switzerland, he had it flown to Zurich. Because of the owner's rank no one questioned the shipment. When Baron Thyssen-Bornemisza learned that the picture was for sale in Switzerland, he bought it and brought it to *La Favorita* with perfect legality, something he could never have done, ironically enough, if he had inherited it, for then it would have had to remain in Germany!

On the other hand, the purchase in 1938 of the equally wonderful *Portrait of a Young Man* by Memling must have presented no difficulties whatever, for it came from Scotland, where until recently there were no export restrictions. However, after the Second World War, there was new legislation; and

now in all probability, if offered for sale, it would have been preempted by a British gallery, and under the present law would never have left the United Kingdom. This is also true of the one certain portrait of Henry VIII by Holbein, a panel, alas, too precious to travel from Lugano. To such an extent have nearly all nations placed controls on works of art going abroad that today to assemble another collection like the Thyssen-Bornemisza Collection would be virtually impossible.

The other six Flemish and Burgundian pictures included in the exhibition are among the finest examples in the Thyssen-Bornemisza Collection of more than sixty paintings of these schools. The earliest is a portrait of Wenceslas of Luxembourg, Duke of Brabant, by an unknown Burgundian artist who was active at the beginning of the fifteenth century. Clad in blue, his favorite color, the Duke is portrayed looking upward in prayer. The next century is represented by four paintings: Juan de Flandes' *Pietà,* strongly influenced by Hugo van der Goes; Gossaert's *Adam and Eve* based on Dürer's famous engraving; Heemskerck's *Lady with a Spindle,* considered his most monumental portrait; and Lucas van Leyden's *Cardplayers,* one of the first paintings to show gambling, a subject to be popularized in the next century by Caravaggio.

Among the later Flemish pictures of particular interest to those who have visited the National Gallery in Washington is Rubens' *Toilette of Venus,* a painting closely related to one by Titian treating the same subject, which was acquired by Andrew Mellon from the Hermitage Gallery. Although Rubens may have been inspired by another version, a lost canvas by Titian, a comparison of the Thyssen and Mellon pictures brings out important and interesting stylistic differences.

One sees clearly the change toward more direct handling of paint and a less generalized and more detailed observation of the model. These are basic alterations in style that took place between the sixteenth and seventeenth centuries.

All the paintings I have mentioned so far have come to the Thyssens from European collections; but four of the finest and most valuable pictures in Lugano – a Duccio, a Ghirlandaio, a Carpaccio, and a Hals – have come from the United States. It is a shock for an American to realize that whereas our self-made millionaires were once omnipotent in the art market and were recognized by art dealers as the greatest purchasers of masterpieces, times have changed. The Depression of the thirties and later, taxes, have forced a few of these lordly collectors to disgorge some of their treasures to wealthy Europeans.

Sad as this is for us, I felt a certain ironical satisfaction when I was told that many of the great paintings in the Thyssen collection have made the reverse journey across the ocean, not to stay permanently but temporarily for restoration. After the Second World War Baron Thyssen-Bornemisza sent a large part of his collection to New York to be restored either by Mario Modestini or William Suhr, two men he considers leaders in their profession. This is a tribute from a great connoisseur to two distinguished "conservators," as they are called in academic circles, who happen to reside in our country. A third restorer of equal ability, Marco Grassi, who also lives much of the time in New York, must likewise be mentioned. In recent years he has done a great deal of his work in Lugano itself, and the beautiful condition of the newly acquired paintings is due to him.

Of these masterpieces, once proudly carried across the sea to the New World, and now in Lugano, the Frans Hals *Family Group* represents the greatest loss to America. It belonged at one time to the Otto Kahns; but on her husband's death, Mrs. Kahn, having to pay inheritance taxes in the midst of the Depression, sold it for what now seems a trivial sum. What, one wonders, were our museums doing, that they permitted one of the finest works of art in the United States to leave? Unfortunately, because of its exceptional size it could not travel safely and had to be omitted from the present exhibition. But in the Dutch section of the show there are superb compensations: a Rembrandt portrait of a man, a late work of the greatest beauty recently acquired by the second Baron; the famous and unique self-portrait of Jan Steen; the rare winter scene by Jacob Ruisdael, as well as landscapes by Salomon Ruysdael, Franz Post, and Joos de Momper. The still-life paintings of Kalf, Heda, and de Heem are among the finest I know. Especially fascinating also is the *Interior of the Council Chamber of Burgomasters in the Town Hall in Amsterdam* by Pieter de Hooch, the only picture in existence which shows the interior of this important example of seventeenth-century Dutch architecture as it originally appeared.

The first Baron Thyssen-Bornemisza for a time showed little interest in Italian art. His enjoyment of cisalpine painting came later; but he and his son finally acquired over eighty panels and canvases; and the Italian Schools are now the richest part of the whole collection. Again the United States provided the collection with its three finest Italian paintings, two of which are in this exhibition: the Carpaccio *Young Knight in a Landscape,* which also came from the Otto Kahn Collection and was acquired during the Depression by the first Baron, and the Duccio *Christ and the Woman of Samaria,* which the second Baron bought recently from the Rockefeller

family. The Carpaccio canvas portrays in his battle armor Francesco Maria della Rovere, heir to the Duchy of Urbino and Captain General of the Venetian forces, who looks as though he might just have risen from King Arthur's Round Table on a beautiful spring day. It is one of the first life-size, full-length portraits in European painting, to quote Dr. Rudolf Heinemann, and it is certainly one of Carpaccio's greatest masterpieces, which he proudly signed VICTOR CARPATHIUS and dated 1510. The Duccio panel was painted exactly two hundred years earlier. It is for me in some ways the most fascinating of the ten panels which became separated from the Maestà, once the high altar of the Cathedral of Siena. This breathtaking work, the most glorious altarpiece ever painted, is not only the supreme creation of the Sienese School, but also the culmination of Byzantine art. To see these two works, the Carpaccio and the Duccio, again in America is a joy, but a joy somewhat clouded by the sorrow of knowing that we have lost them. The third great Italian painting from the United States, Ghirlandaio's exquisite portrait of Giovanna Tornabuoni, once in the Morgan Collection, has remained in Lugano.

There are, however, twelve other superb Italian paintings in the show, including one by the Sienese master of the fifteenth century, Giovanni di Paolo. He treats, in his very personal style, that most touching scene in the history of the papacy: St. Catherine on her knees, surrounded by prelates, pleading with Pope Gregory XI to return from Avignon to Rome. How fragile and feminine she seems confronted with the massive authority of the Church!

Portraits of painters by painters, which are always fascinating, are only infrequently to be found in Italian art. The identification of Cossa's portrait as being of Francesco Fran-

cia, the Bolognese artist, seems well documented. But regardless of the identity of the sitter, it is a beautifully preserved work of the Ferrarese School.

A master seldom met with is Antonello da Messina. He was one of the painters who introduced into Italy oil as a medium, a procedure he probably learned through his contact with Northern artists. This technical innovation, which gradually replaced tempera, gives his portraits a glow of light that seems to come from within the figure. His way of painting had a profound influence all over Italy, but especially in Venice. Giovanni Bellini, one of the greatest of all Venetian artists, learned from him and followed his example closely. *Nunc Dimittis,* the picture by Bellini chosen for this exhibition, is a biblical scene rarely to be found in Italian art. Apart from the beauty of the work itself, the subject matter makes the painting especially precious.

From these quattrocento artists we next turn to the High Renaissance. The *Portrait of a Young Woman* by Palma Vecchio, called "La Bella," and rightly so, comes from the collection of Archduke Leopold William, the seventeenth-century governor of the Netherlands, whose picture gallery was painted by Teniers. Palma Vecchio stamped on the taste of his time this type of Venetian beauty, never more wonderfully portrayed than here, just as Rossetti's paintings, with which "La Bella" has much in common, determined what constituted Victorian sex-appeal.

After these beauties Titian's ugly Doge, *Francesco Venier,* with his red nose, makes a strong contrast. Executed when the artist was in his late seventies, it shows his ever increasing power of characterization. It was undoubtedly painted from life and was probably the model for the official portrait in the Ducal palace, which was destroyed by fire.

The Spanish pictures in the Thyssen-Bornemisza Collection are less numerous than the other schools, but the six examples in the exhibition are of exceptional interest. The two Annunciations by El Greco are ravishingly beautiful. One was done early in his career, the other much later. They illustrate the change in his style from the monumental solidity of his Italian period to the flamelike designs which marked his work in Spain. These flames, so conspicuous a part of El Greco's ardent piety, are extinguished a generation later in the religiosity of Murillo. Nevertheless, the latter's canvas of the *Madonna and Saints Appearing to Saint Rose* is a fine example of the sentimental, pious type of work which made his great reputation. The Zurbarán *Saint Agnes* by contrast is a fashion plate. Put aside the saint's attributes, the palm of martyrdom, and the lamb derived from her name, and she might be a beautiful model posing in *Vogue*. But this lovely Spanish girl, dressed in the height of fashion, has an unpretentious honesty missing in Murillo. Probity was likewise an outstanding characteristic of Goya. The second Baron Thyssen-Bornemisza has shown himself more interested in those paintings by the great Spanish master that reveal his psychological insight and his social understanding than in his official and sometimes pompous portraits. The likeness of Asensio Julia in his littered studio, which Goya has inscribed "to his friend Asensi," shows the painter in his dressing gown looking over his shoulder, entranced, as only an artist can be, by his latest work; while in the much later study of a blind beggar, *El Tío Paquete,* the model expresses in his gay and laughing countenance the ability of a human being to surmount a terrible affliction. Little wonder that "Uncle Paquete," as he was affectionately called, was often asked to play his guitar and sing to the Spanish nobility, for such a triumph over adversity must have been enheartening to their spoilt and decadent society.

The first Baron Thyssen-Bornemisza felt that art ended with the eighteenth century. But even for work of the rococo period his enthusiasm seems to have diminished. Most of the eighteenth-century pictures in the exhibition were bought by his son. Of the Venetian School he acquired from Prince Liechtenstein two masterpieces by Canaletto. Both hang in the dining room of *La Favorita* and are not regularly seen by the public. These are among the largest and finest views of Venice that indefatigable scene painter ever executed. Particularly interesting is the *View of the Piazza San Marco* showing the original brick pavement of the Piazza which was replaced in 1723 by the stone mosaic flooring we see today.

Canaletto's rivals, the Guardi family, are responsible for two canvases which are the quintessence of rococo art. Mozart might have used them as stage sets for his *Escape from the Seraglio*. These "Quadri Turchi," as they were called, were highly prized by eighteenth-century connoisseurs, who found Turkish themes in painting and on the stage most enjoyable. The theatre too, perhaps in this case a comedy by Goldoni, is suggested by the enchanting minx and her companions in Longhi's *Il Solletico*. Such pictures introduce a note of gaiety in the exhibition, which I am sure the present Baron Thyssen-Bornemisza, himself a light-hearted and charming person, would have wished.

Joyousness, made more poignant by a hint of melancholy, appears in the two exquisite paintings by Watteau. Their note of wistful sadness is not, however, characteristic of rococo art. Much more in keeping with its spirit is the sophisticated and unclouded pleasure suggested by Boucher's *La Toilette*. What delight to watch a lovely coquette tying on a garter and choosing a hat for her coming conquests! Fragonard's *The Seesaw* is the gayest of all. It was painted in the artist's

youth when he was happily working in Boucher's studio. How distant seems the Revolution through which he was to pass, a forlorn witness left over from what was once a desirable and carefree life, in a world he watched disappear forever.

Baron Thyssen-Bornemisza I feel, like many of us, would have been happy living in the *ancien régime,* happier I believe than in our present age of anxiety. From the problems of modern life, however, he can escape to his collection. For him it is a constant solace and joy. Much of his free time, scarce as it is, he spends walking through his galleries, arranging and rearranging his works of art. In their presence he experiences a sense of satisfaction – a serenity and delight – that even his most successful business enterprises cannot give him.

I once asked him how he happened to become a collector. He said it was because his father had built a gallery for his works of art, and when he died, they were divided between his two daughters and his two sons. As head of the family the present Baron felt they should be brought together again to be a memorial to his father. He began by buying as much as he could from his brother and sisters. Then he decided to fill the gaps in the collection. One acquisition led to another until the collecting virus had entered his bloodstream. He told me that each New Year's Eve he made a resolution not to collect anymore, and that by the first of January the resolution was always broken.

Unlike his father he does not think art ended in the eighteenth century. He has bought distinguished nineteenth-century paintings by Turner, Delacroix, Cézanne, Pissarro, Sisley, Degas, Gustave Moreau, Renoir, Van Gogh, Caspar David Friedrich, and others. But more remarkable and unexpected is his collection of twentieth-century masters, part of which has been catalogued by Hanna Kiel. It is particularly rich in the German Expressionists. There are also some Fauve and School of Paris pictures, as well as the Russian Abstractionists so unpopular today in the Soviet Union. But the group of American canvases is the most surprising. In scope and catholicity it is probably unique in Europe. One of his favorite painters is Ben Shahn, who reflects so clearly, in the Baron's opinion, the social forces and problems of our time. The loneliness implicit in Hopper's works likewise appeals to him. But not only the realists but also the important figures among the New York Abstract Expressionists are to be found in his apartment. These modern canvases, realistic and abstract, are the paintings he lives with.

Baron Thyssen-Bornemisza is both an active person, constantly traveling to supervise his widespread industrial holdings, and a contemplative person, spending a good deal of time at his desk puzzling over his own philosophy of modern life. His contemporary paintings, he feels, help him. The painter, he believes, holds a mirror up to the world. In it is reflected the actuality around us seen through the temperament of the artist. Baron Thyssen-Bornemisza has learned to appreciate modern art, not by reading books, but by looking at the works themselves. He has painstakingly compared one with another until his taste has become remarkably refined.

The present Baron is not a narrow connoisseur absorbed in his own collection. He is interested in preserving art elsewhere. It is a pleasure indeed to come across a collector who has worked and given money to save masterpieces he does not own! During the floods in Florence he spent a considerable amount to salvage many of the world's greatest treasures. With these funds a studio was created where damaged frescoes could be

dried out and restored. When this work was finished, Baron Thyssen-Bornemisza learned that the wall paintings of Fra Angelico in San Marco were in perilous condition, and he has donated money for their complete restoration. He has also contributed a scholarship to *I Tatti,* the Berenson villa at Settignano which was left to Harvard University for graduate studies in the history of art. He is interested in such studies because he believes in the value of scholarship and connoisseurship. His insistence that his own works of art be soundly attributed represents an attitude not always taken by the many private collectors I have known.

The treasures of *La Favorita* are truly a private collection. Baron Thyssen-Bornemisza can do with them whatever he chooses. He hopes his children will keep them together, as he has done with his father's collection; but unpredictable circumstances in an uncertain world must determine their future. Meanwhile *La Favorita* remains a pilgrimage site for lovers of art. There, under the able curatorship of Mr. A. S. Berkes, the visitor can see in an indescribably beautiful setting of park and gardens, lake and mountains, some of the world's most entrancing and most moving works of art.

It is a privilege to exhibit in the leading museums of America a part of what two passionate collectors, father and son, have brought together. We are very grateful to Baron Heinrich Thyssen-Bornemisza for his generosity in lending the United States fifty-seven of the greatest paintings ever to cross the ocean.

John Walker

ILLUSTRATIONS

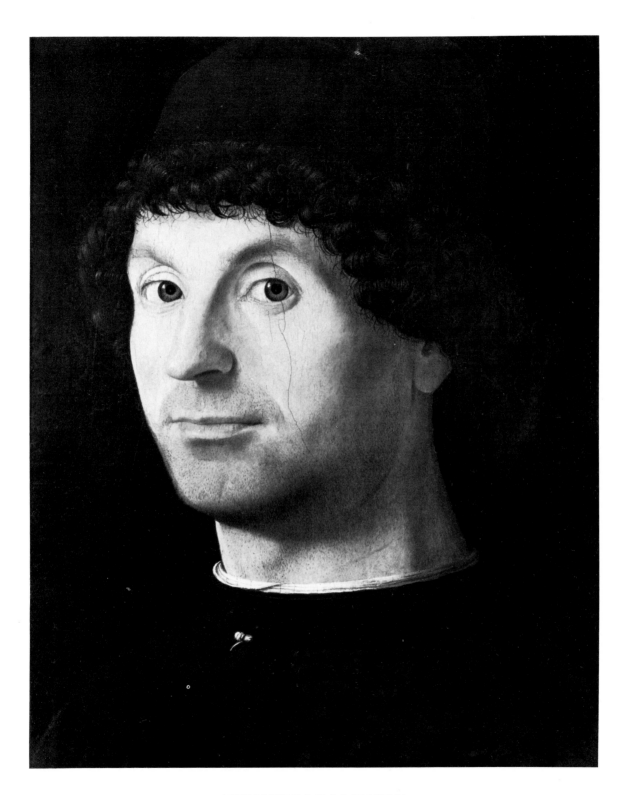

ANTONELLO DA MESSINA
1. Portrait of a Man

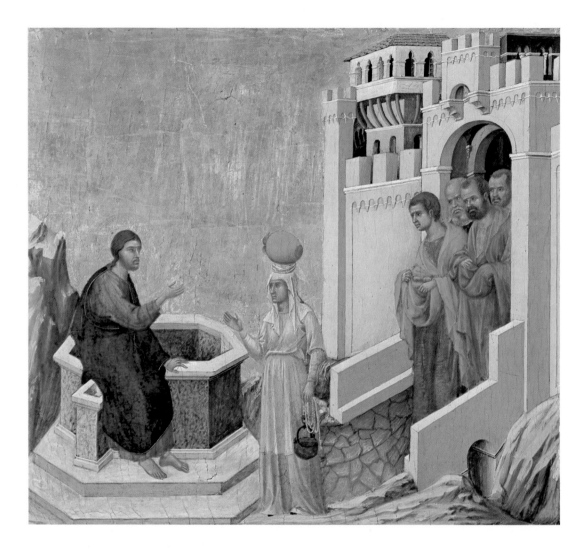

DUCCIO DI BUONINSEGNA
9. Christ and the Woman of Samaria

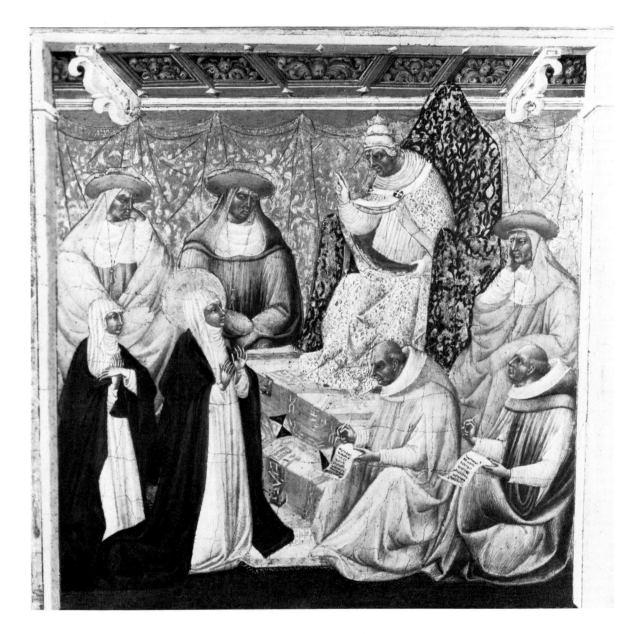

GIOVANNI DI PAOLO
10. Saint Catherine Before Pope Gregory XI at Avignon

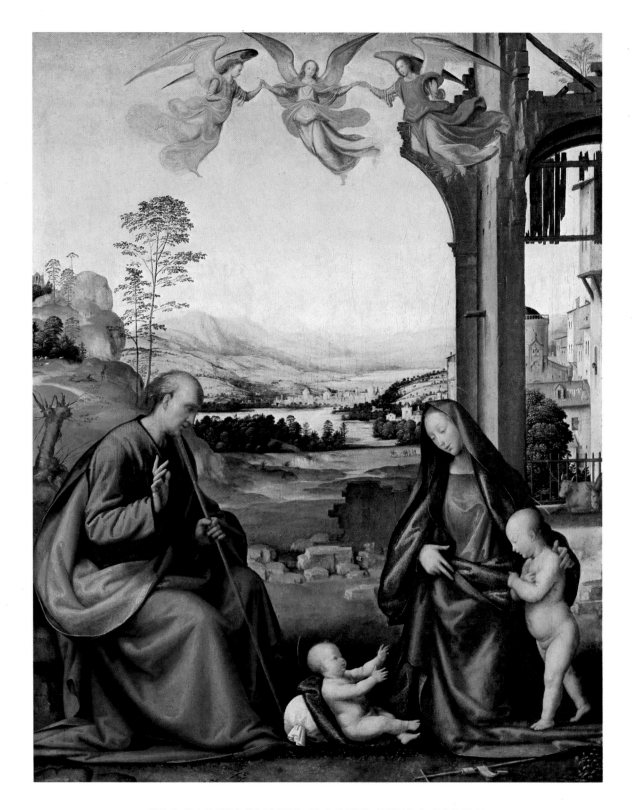

FRA BARTOLOMMEO (BACCIO DELLA PORTA)
2. Holy Family with Infant Saint John in a Landscape

GIOVANNI BELLINI (?) AND WORKSHOP
3. Nunc Dimittis

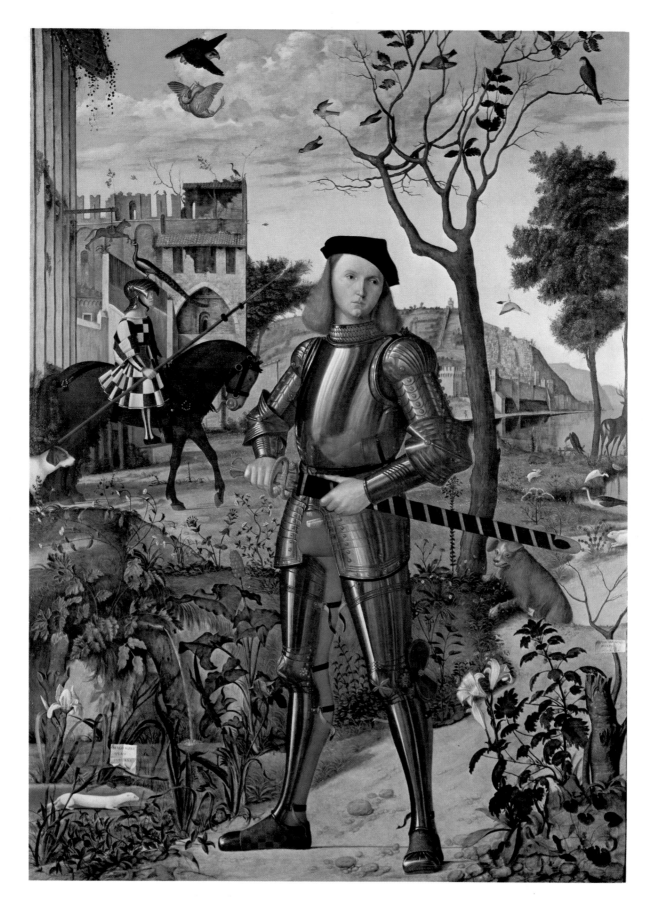

VITTORE CARPACCIO
6. Young Knight in a Landscape

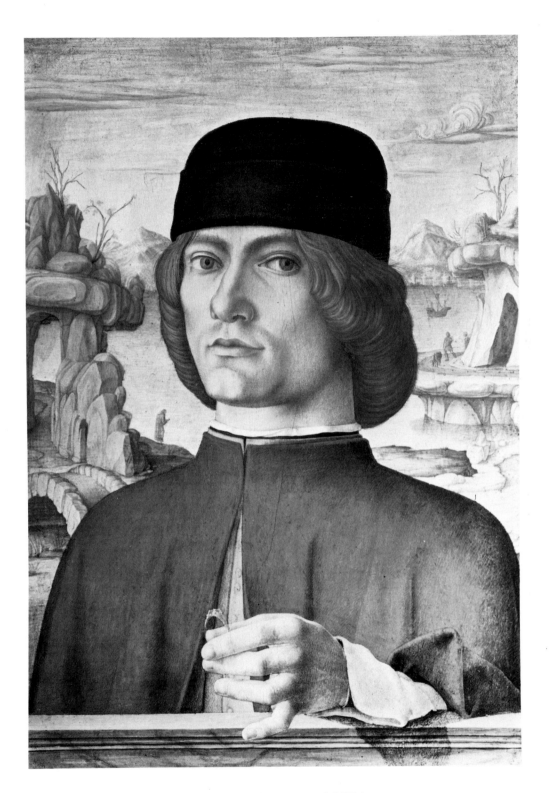

FRANCESCO DEL COSSA
8. Portrait of a Man Holding a Ring

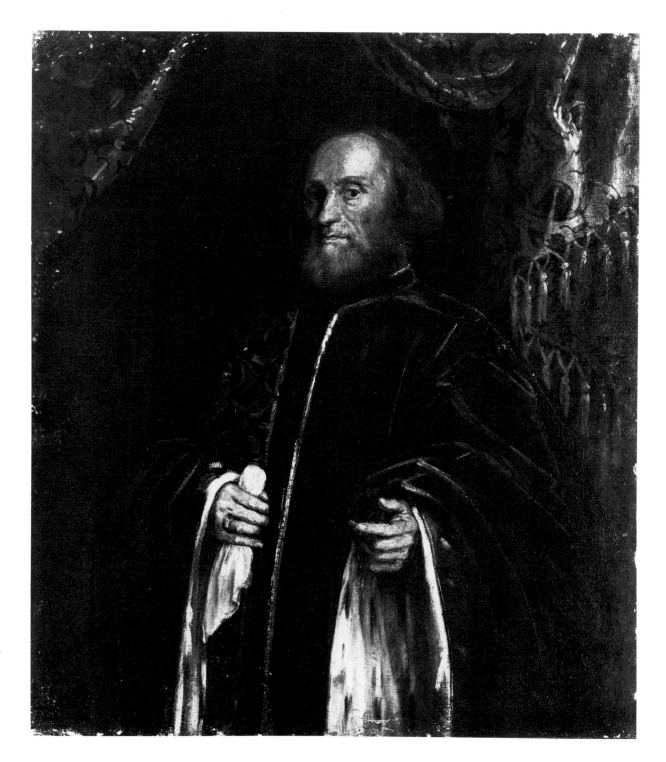

TINTORETTO (JACOPO ROBUSTI)
16. Portrait of a Venetian Senator

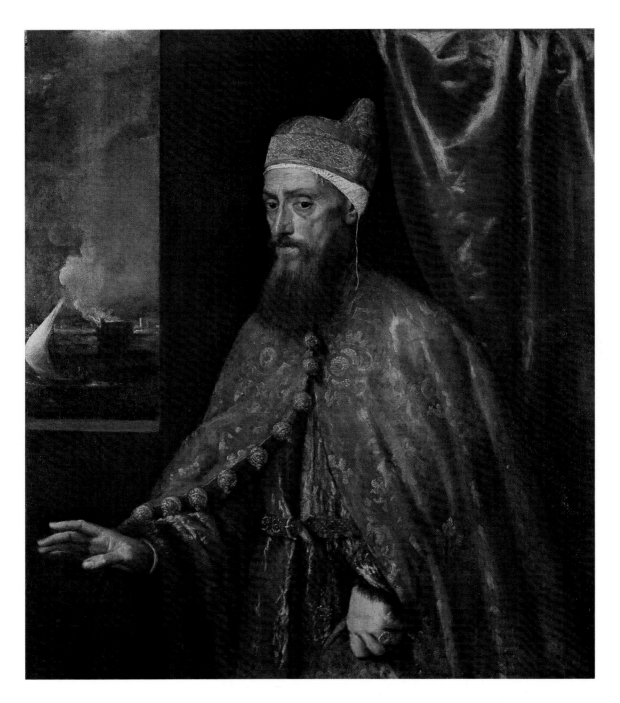

TITIAN (TIZIANO VECELLIO)
17. Portrait of Doge Francesco Venier

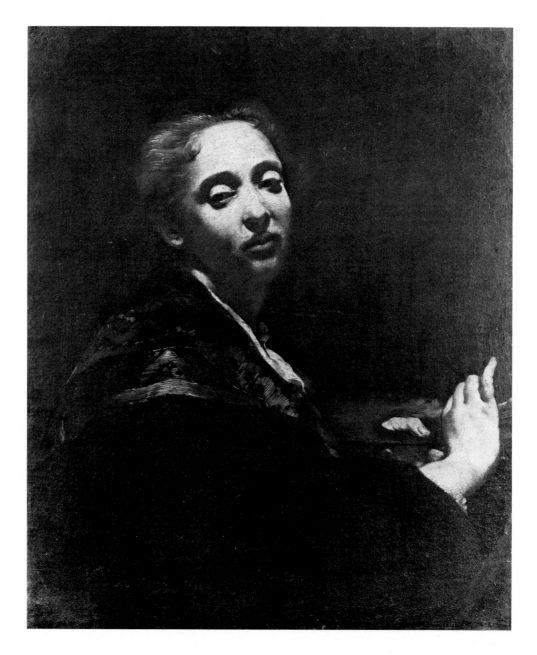

GIOVANNI BATTISTA PIAZZETTA
15. Portrait of Giulia Lama

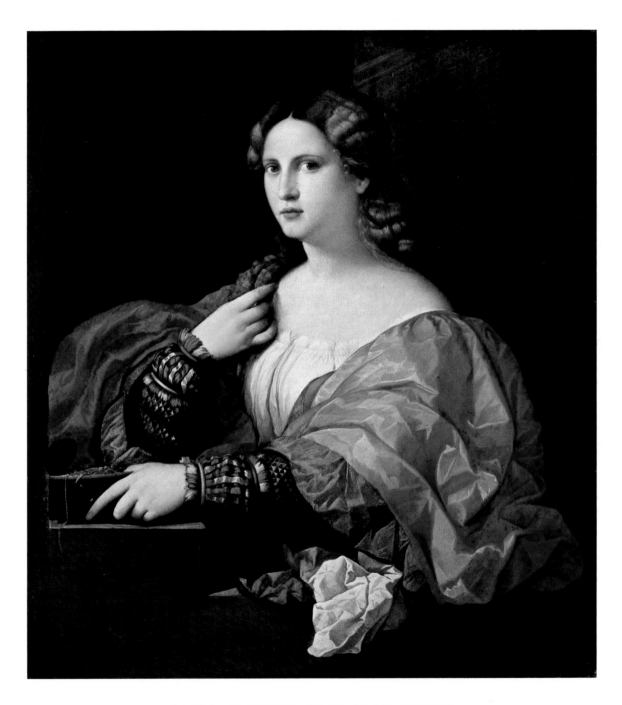

PALMA VECCHIO (JACOPO NEGRETTI)
14. Portrait of a Woman, "La Bella"

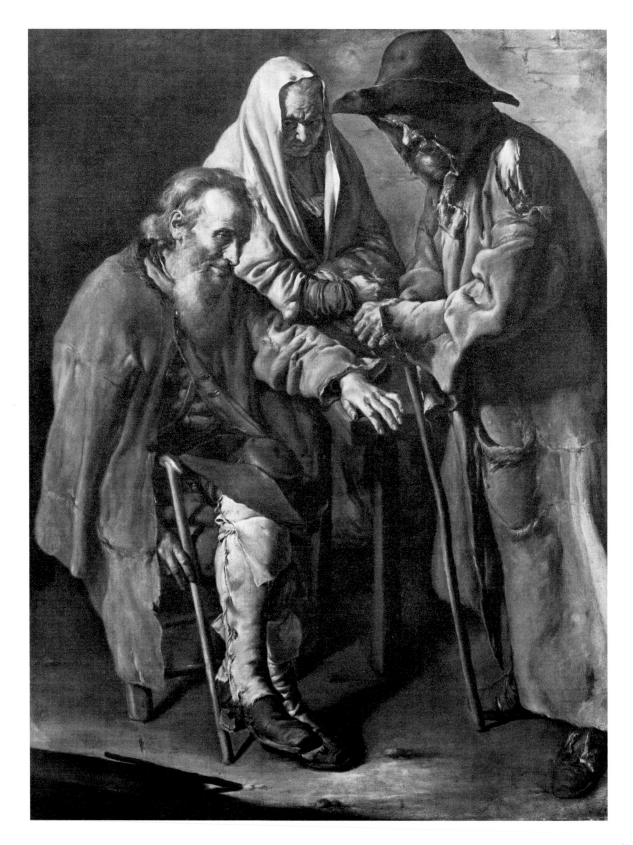

GIACOMO CERUTI
7. Group of Beggars

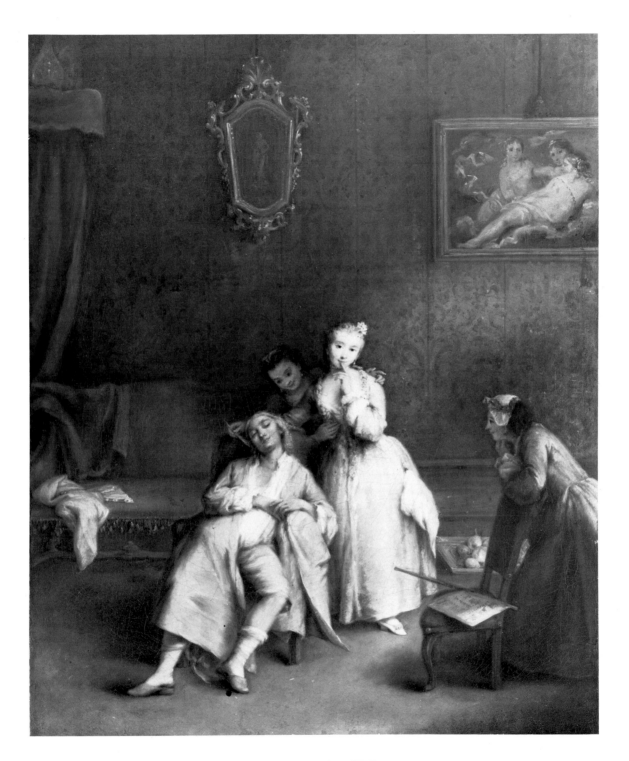

PIETRO LONGHI
13. Il Solletico

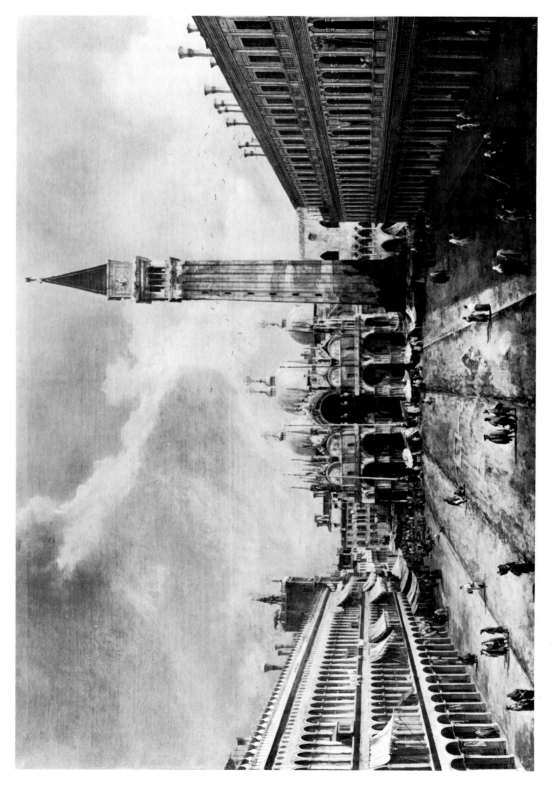

CANALETTO (GIOVANNI ANTONIO CANALE)
4. Piazza San Marco in Venice

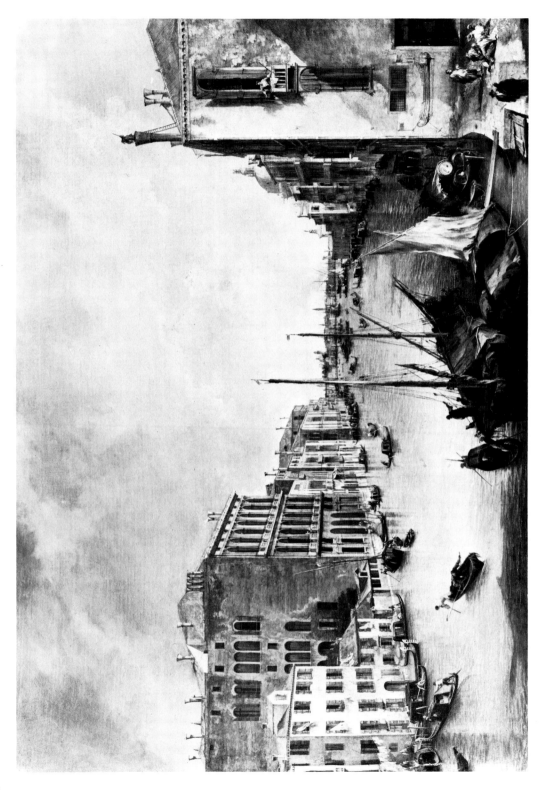

CANALETTO (GIOVANNI ANTONIO CANALE)
5. View of the Canal Grande from San Vio

GIOVANNI ANTONIO GUARDI
11. Scene in a Garden of a Seraglio

GIOVANNI ANTONIO GUARDI
12. Scene in a Harem

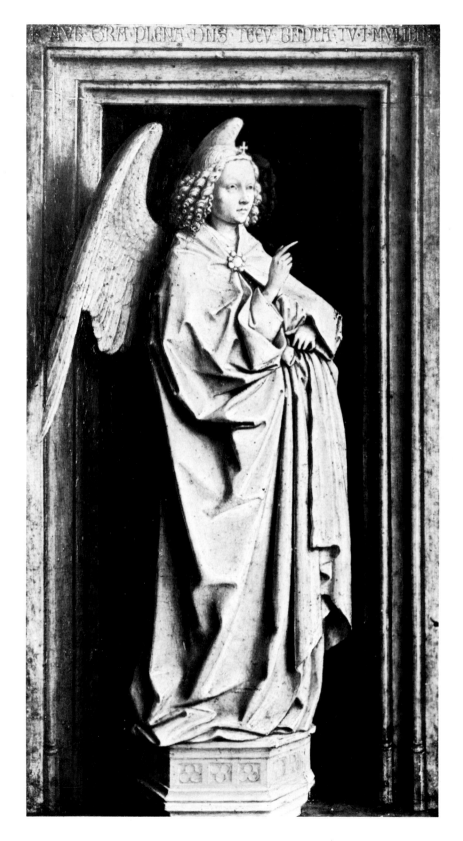

JAN VAN EYCK
20a. Diptych: Angel of the Annunciation

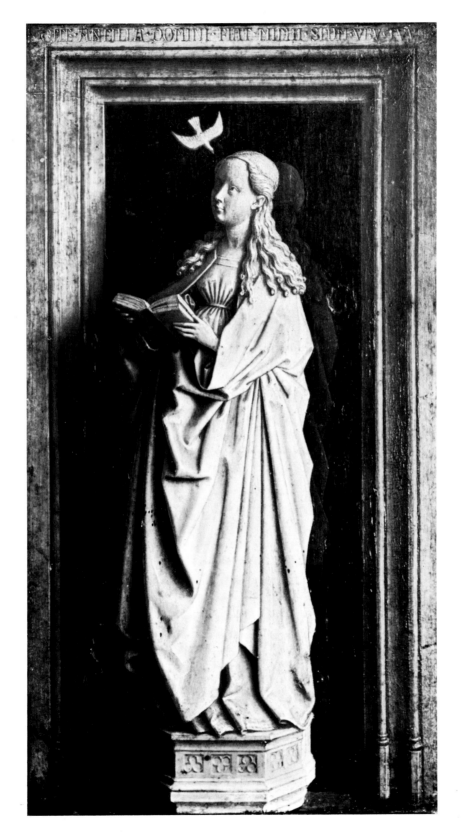

JAN VAN EYCK
20b. Diptych: The Annunciate

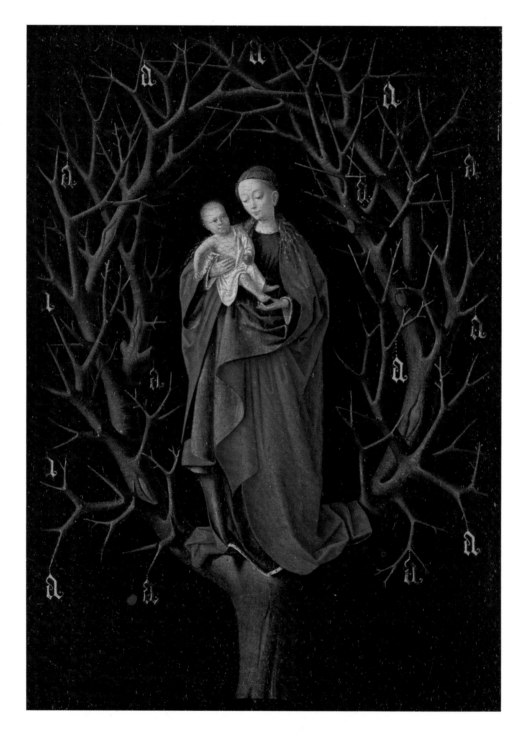

PETRUS CHRISTUS
19. Our Lady of the Barren Tree

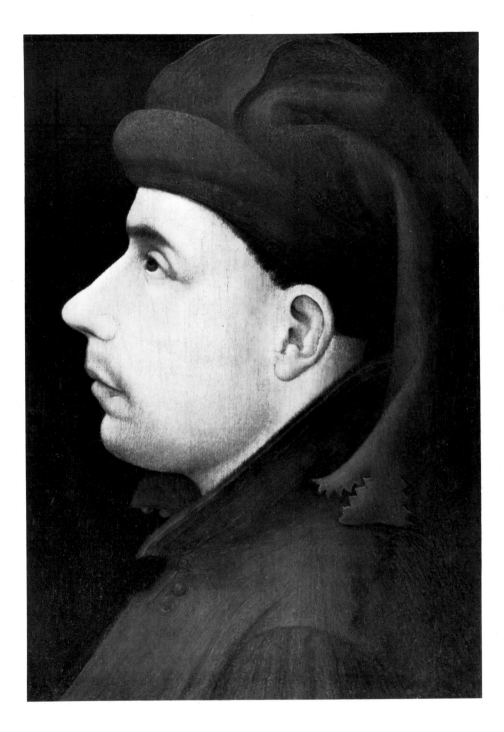

BURGUNDIAN MASTER
18. Posthumous Portrait of Wenceslas of Luxembourg, Duke of Brabant

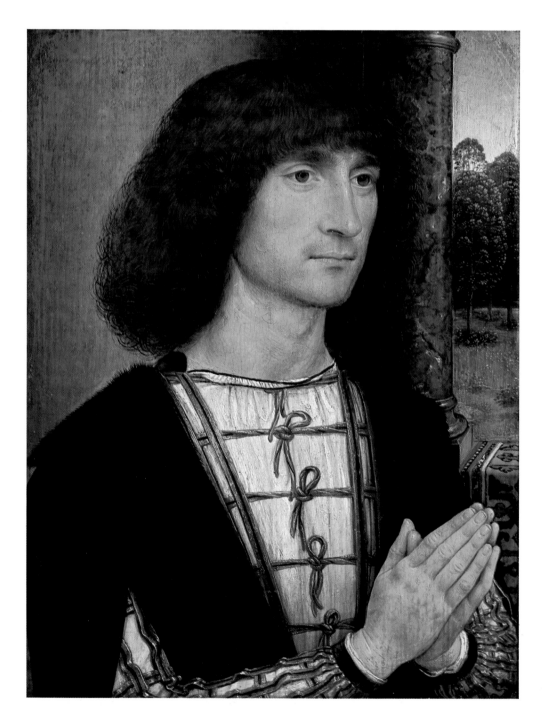

HANS MEMLING
25. Portrait of a Young Man

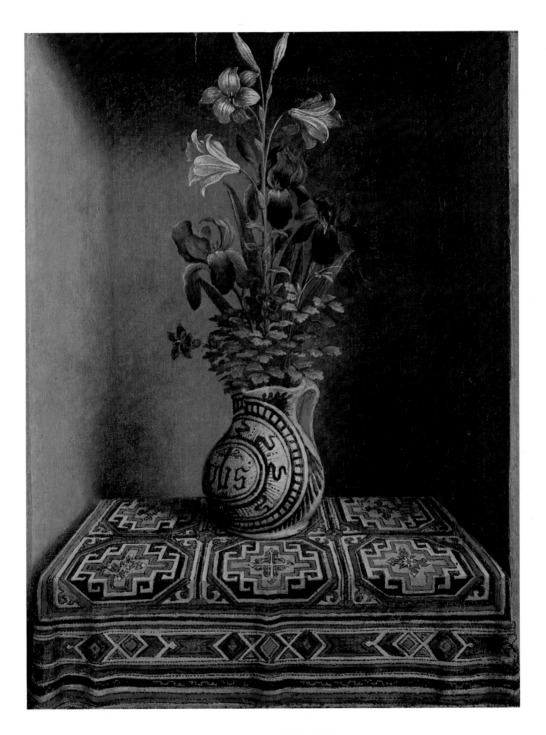

HANS MEMLING
25a. Still Life

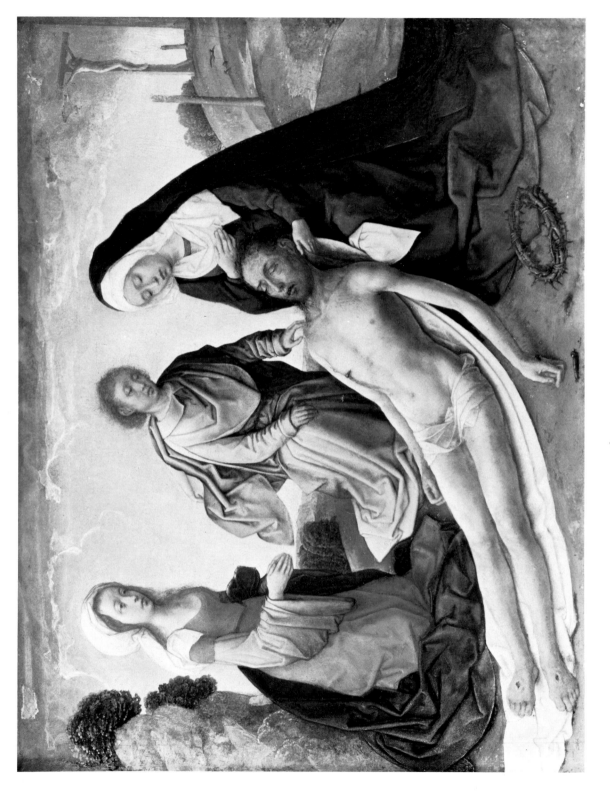

JUÁN DE FLANDES
23. Pietà with John the Evangelist and Mary Magdalene

44

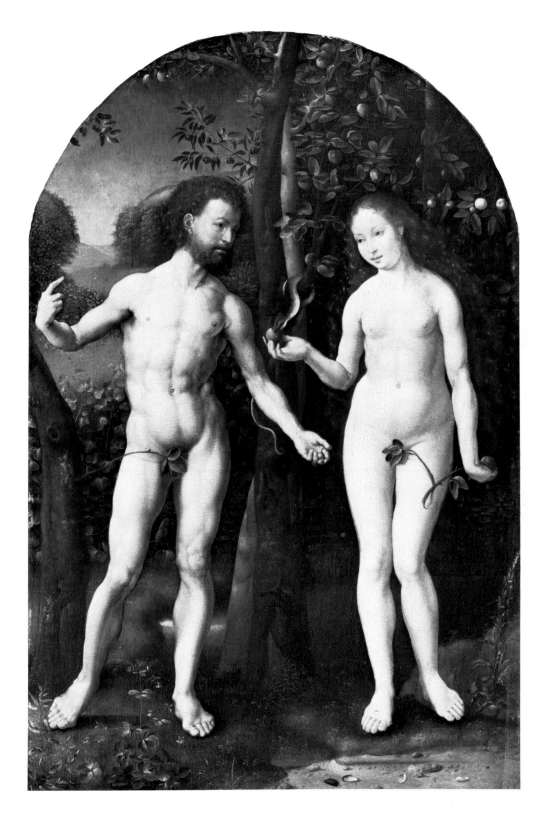

JAN GOSSAERT, called MABUSE
21. Adam and Eve

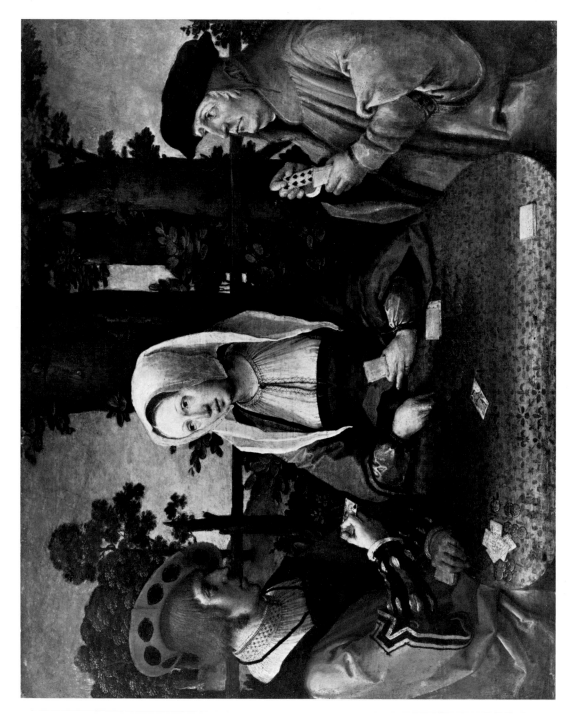

LUCAS VAN LEYDEN
24. Cardplayers

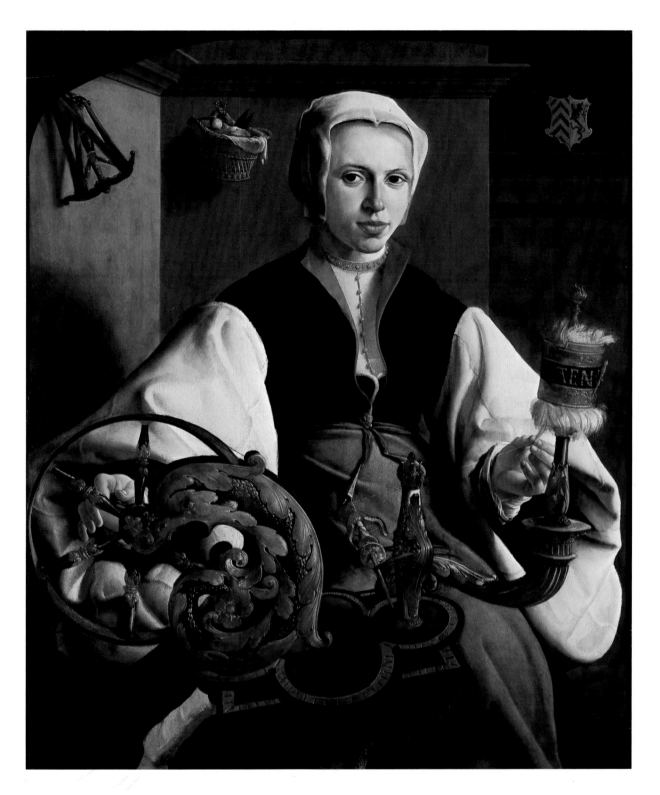

MAERTEN VAN HEEMSKERCK
22. Portrait of a Lady with Spindle and Distaff

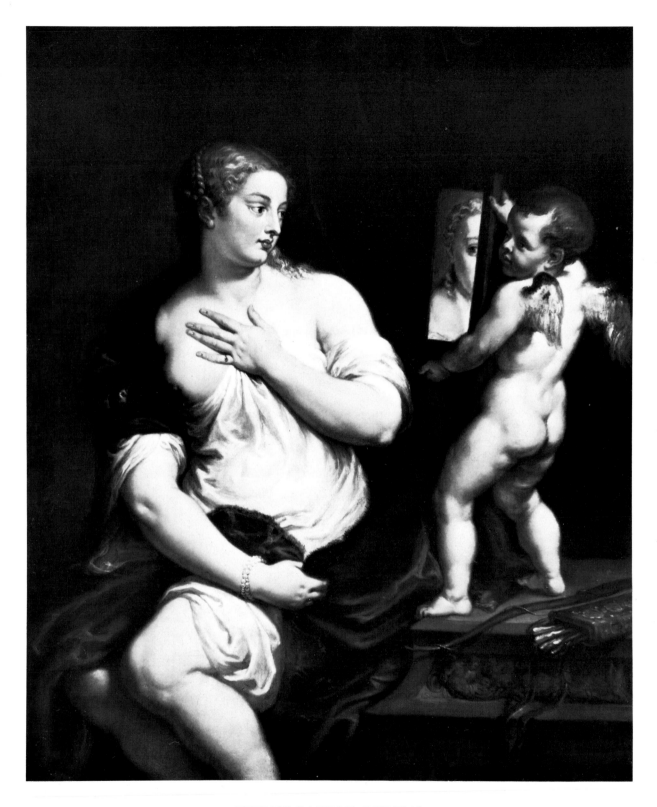

PETRUS PAULUS RUBENS
26. The Toilette of Venus

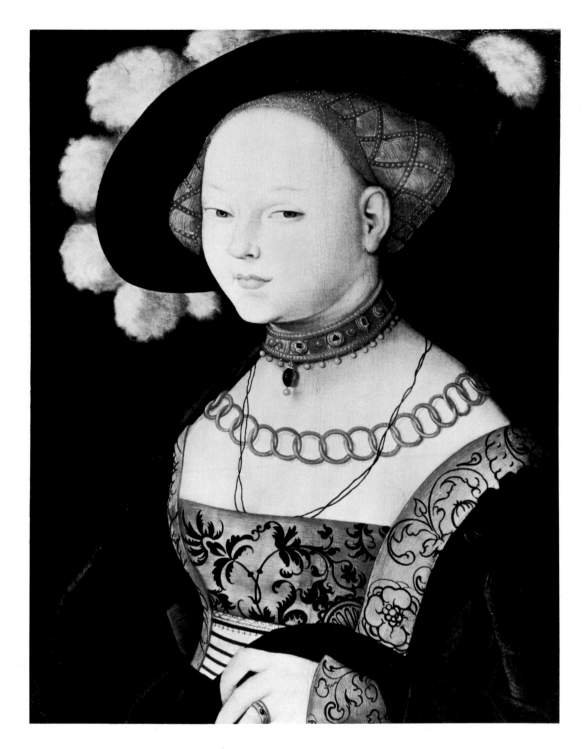

HANS BALDUNG, called GRIEN
29. Portrait of a Lady

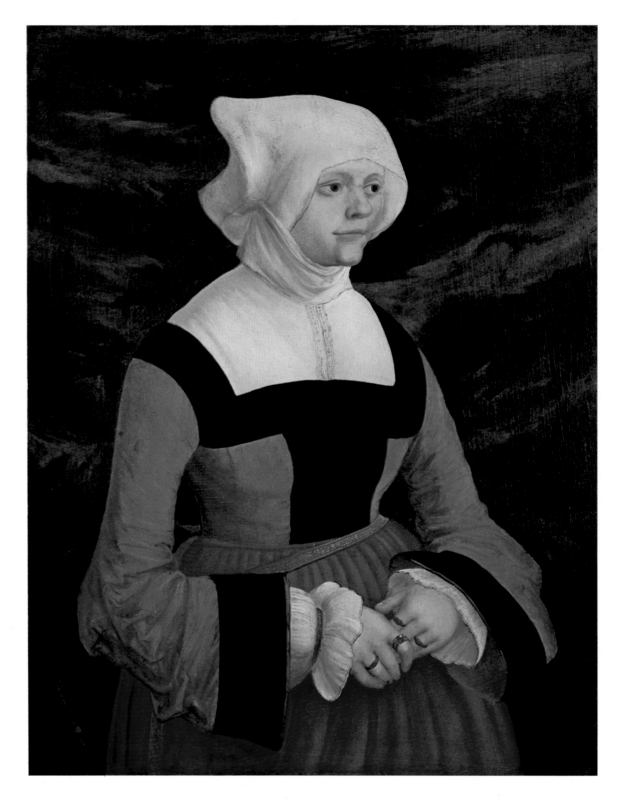

ALBRECHT ALTDORFER
27. Portrait of a Woman

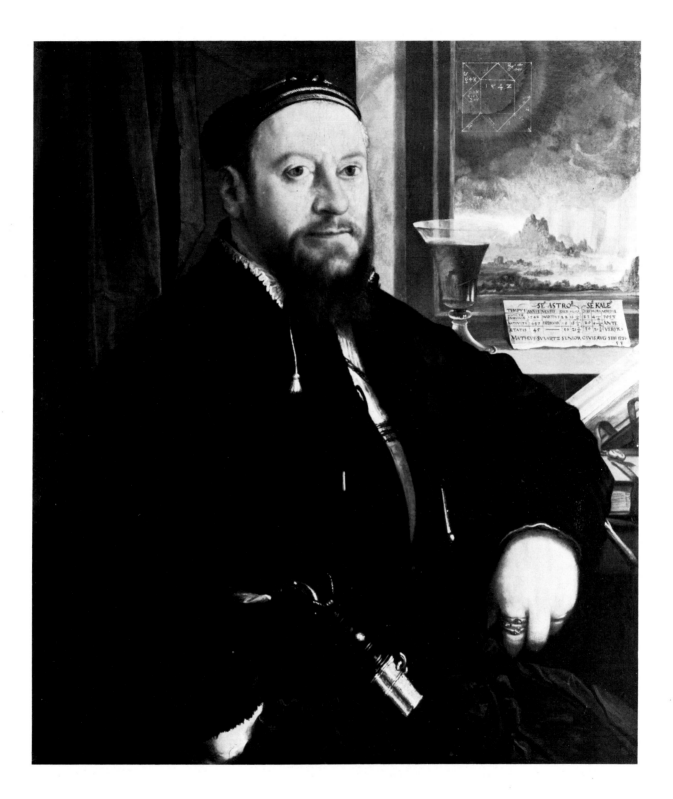

CHRISTOPH AMBERGER
28. Portrait of Mattheus Schwarz

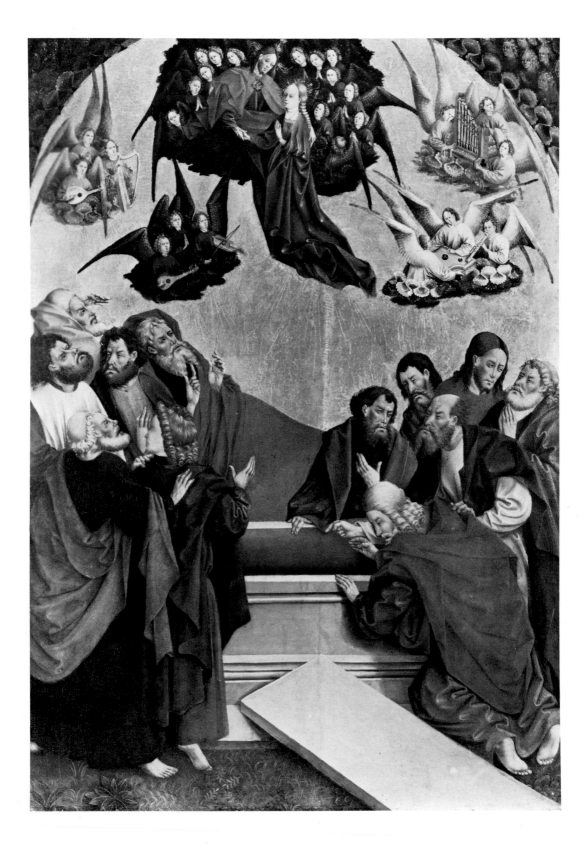

JOHANN KOERBECKE
31. The Assumption of the Virgin

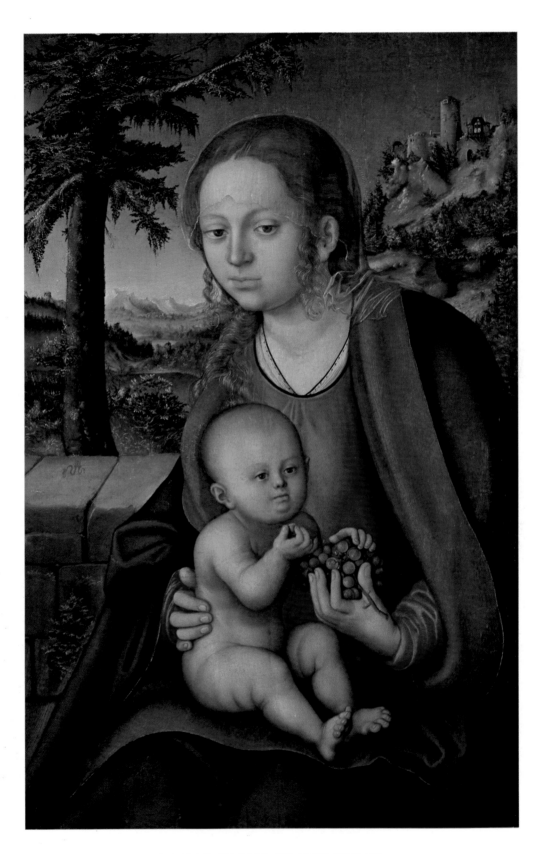

LUCAS CRANACH THE ELDER
30. The Madonna with the Bunch of Grapes

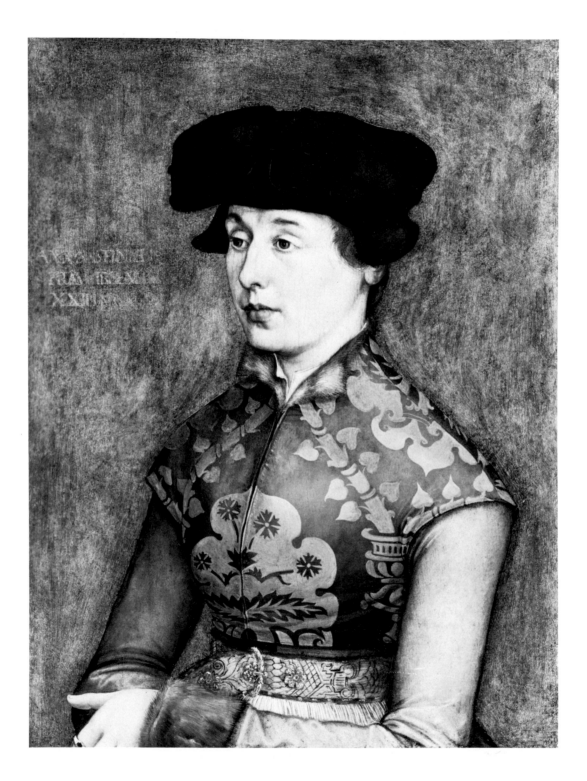

NÜRNBERG MASTER
32. Portrait of a Young Woman

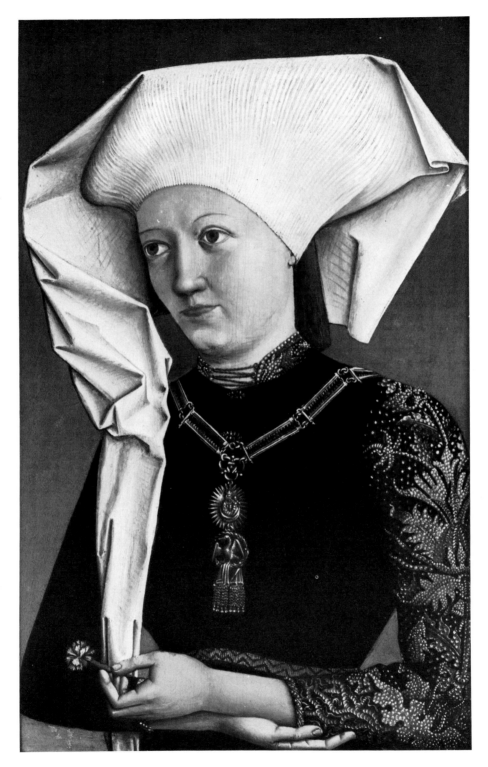

SOUTH GERMAN MASTER
33. Wedding Portrait of a Woman Wearing the Order of the Swan

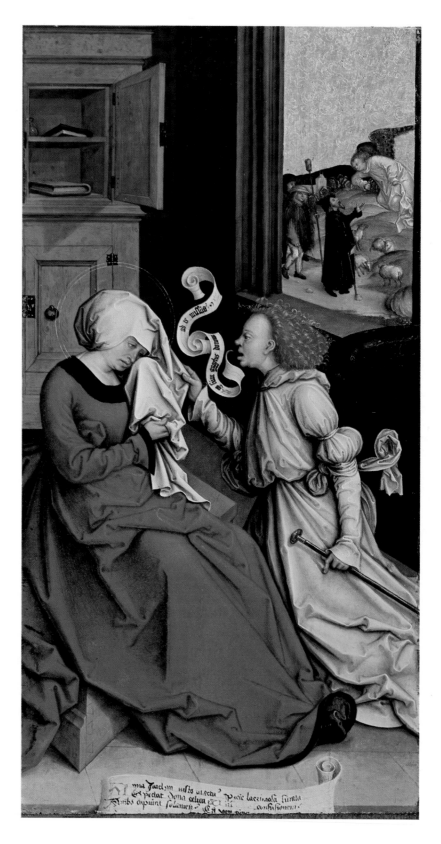

BERNHARD STRIGEL
34. The Annunciation to Saint Anne and Saint Joachim

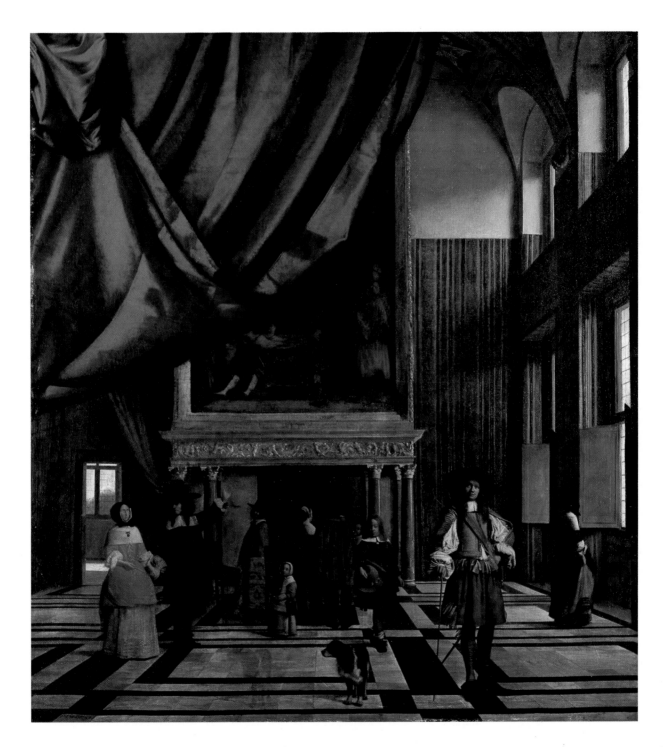

PIETER DE HOOCH
38. Interior of the Council Chamber of Burgomasters in the Town Hall
in Amsterdam, with Visitors

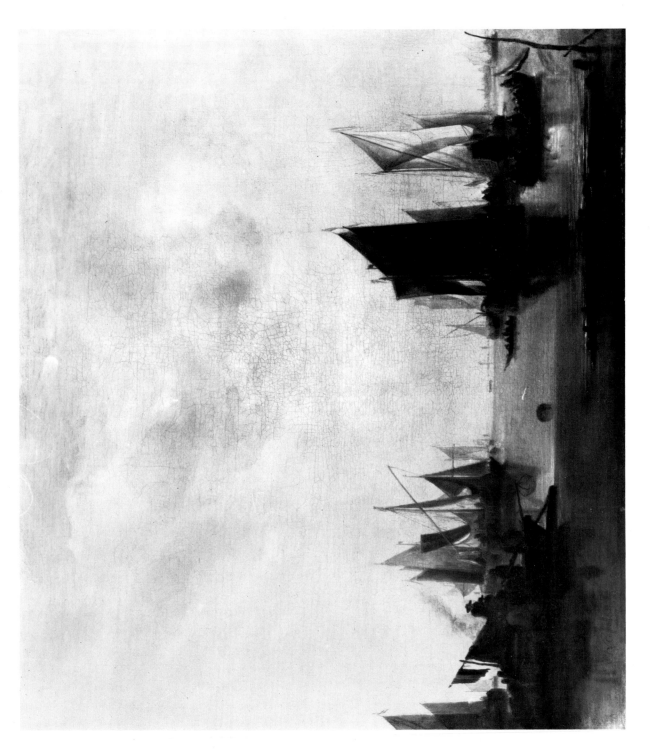

JAN VAN DE CAPPELLE
35. Calm Sea with Many Ships

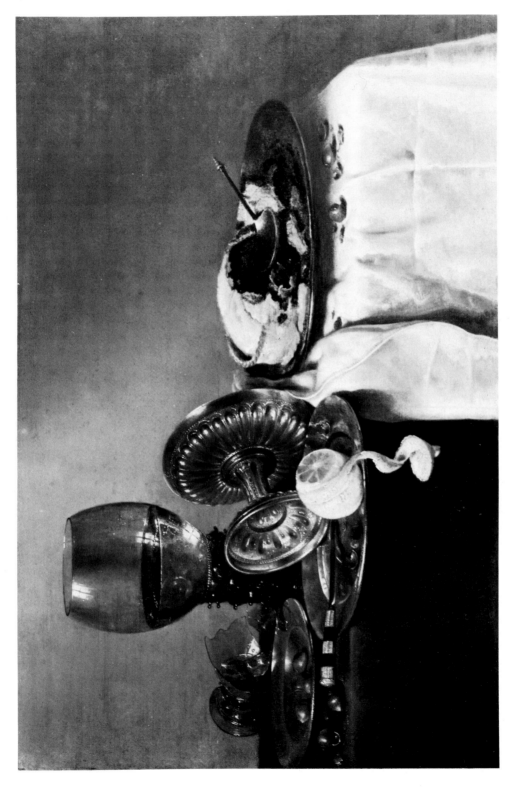

WILLEM CLAESZ HEDA
36. Still Life

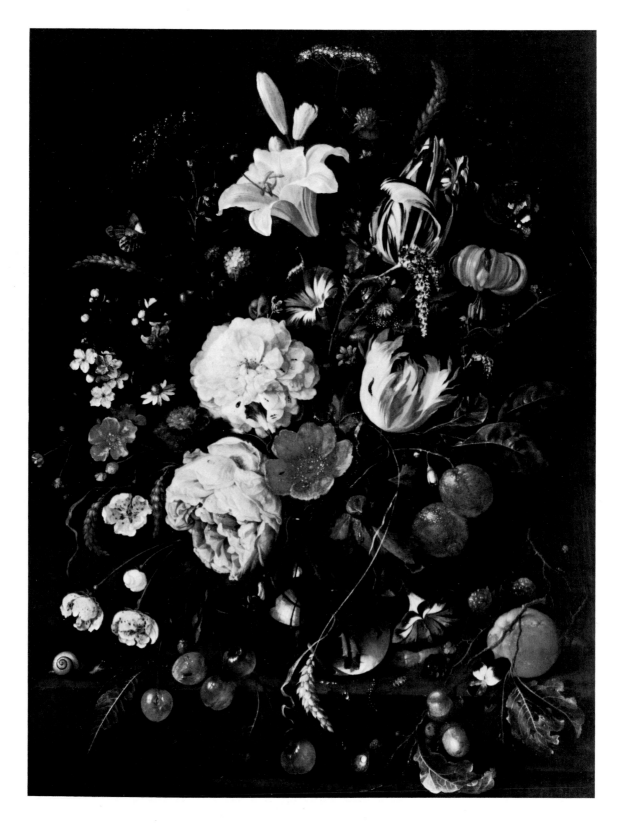

JAN DAVIDSZ. DE HEEM
37. Still Life with Flowers

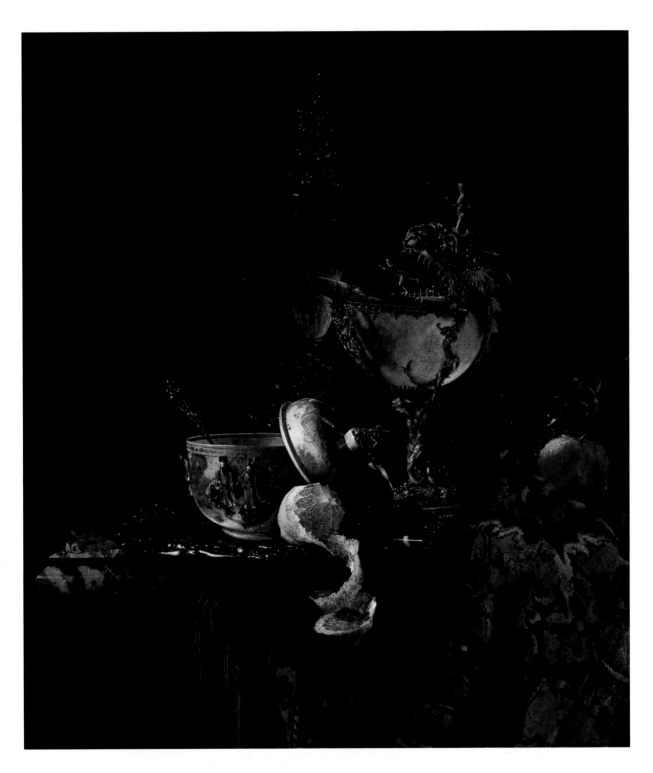

WILLEM KALF
39. Still Life with Nautilus Cup

JOOS DE MOMPER
40. View of a Port, with Motifs from Rome

FRANS JANSZ. POST
41. Village with "Casa-Grande" in Brazil

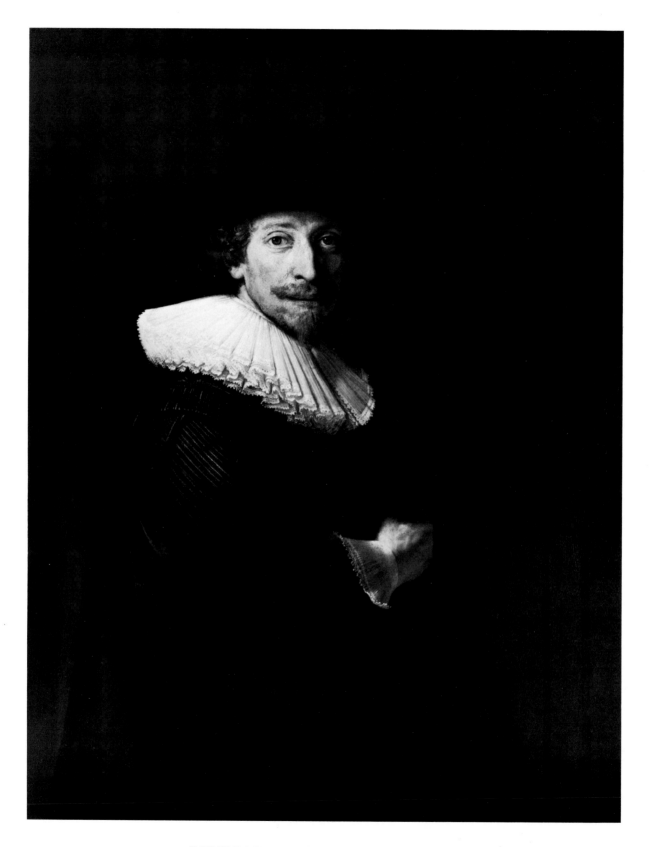

REMBRANDT HARMENSZ. VAN RIJN
42. Portrait of a Man Before an Archway

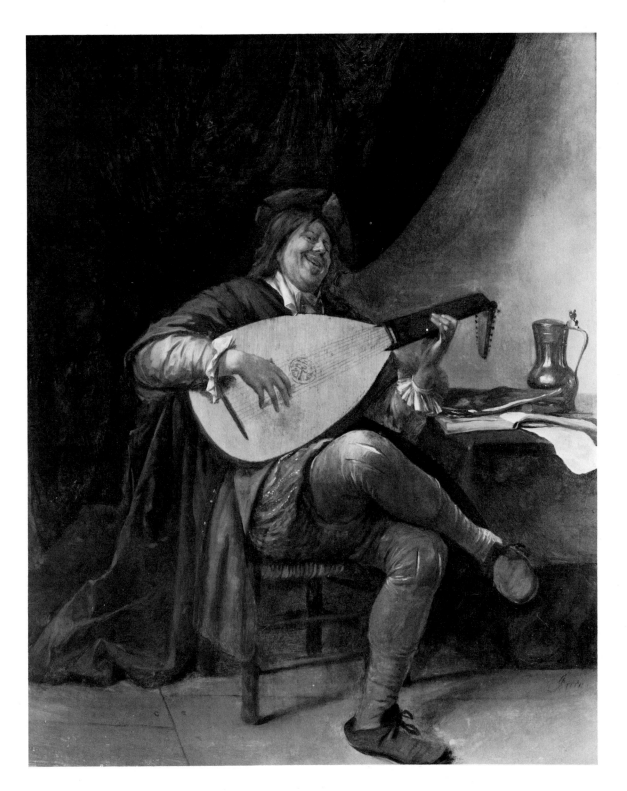

JAN STEEN
45. Self Portrait

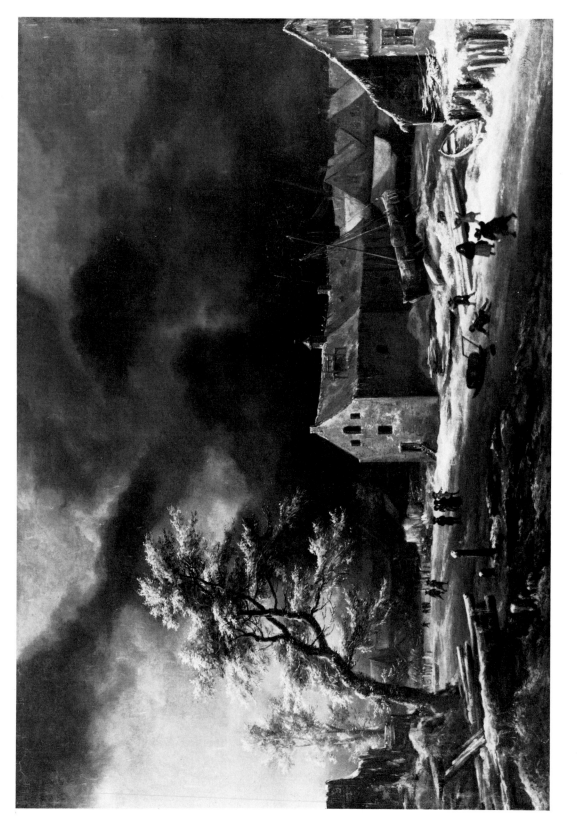

JACOB ISAACK VAN RUISDAEL
43. Winter Landscape

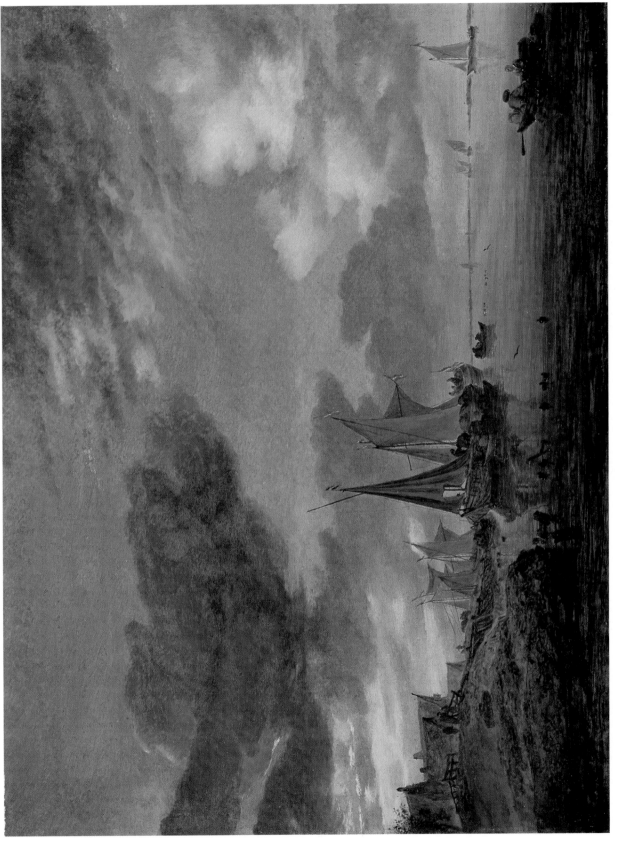

SALOMON VAN RUYSDAEL
44. Return of the Fishermen

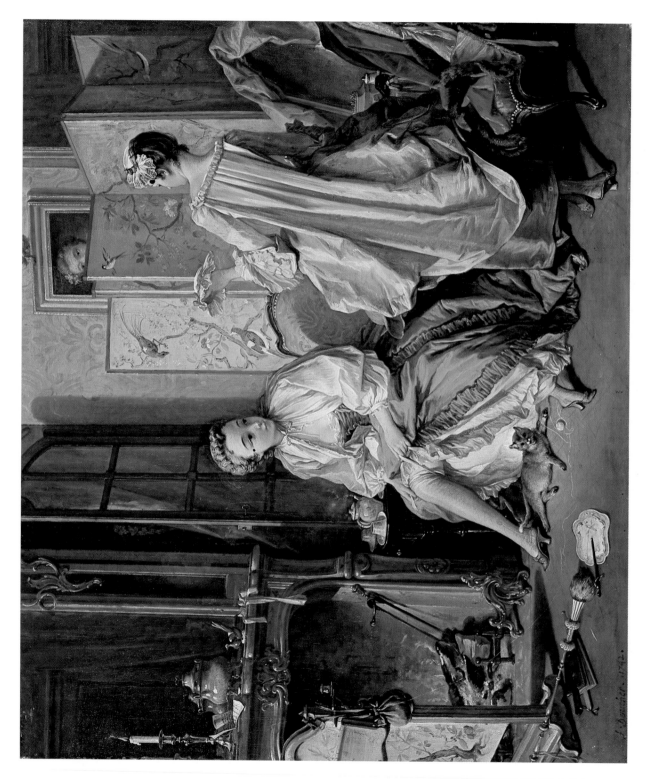

FRANÇOIS BOUCHER
46. La Toilette

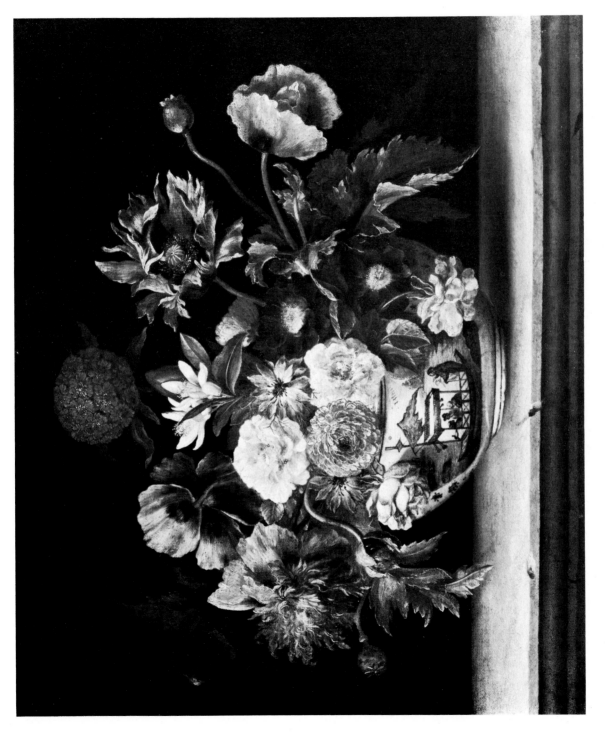

JACQUES LINARD
49. Chinese Bowl with Flowers

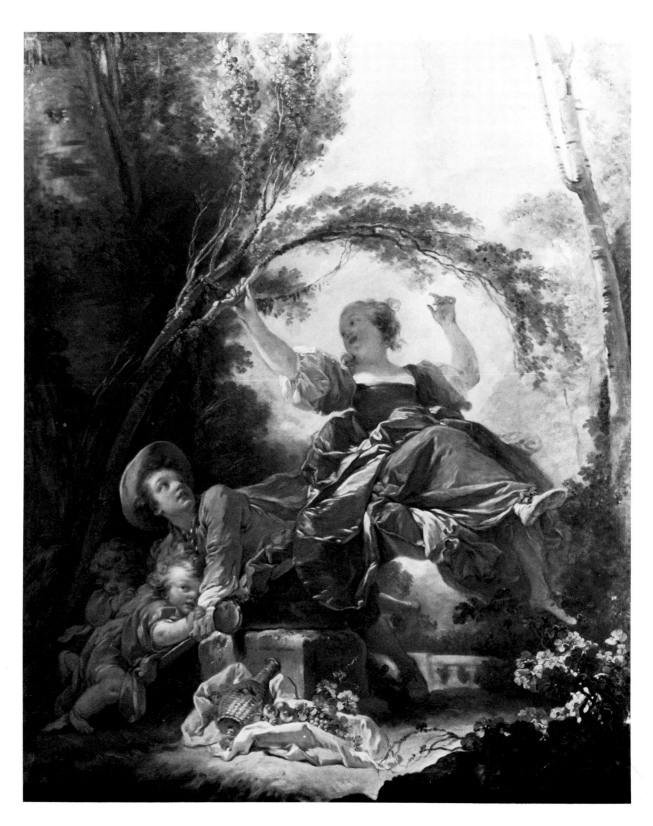

JEAN-HONORÉ FRAGONARD
47. The Seesaw

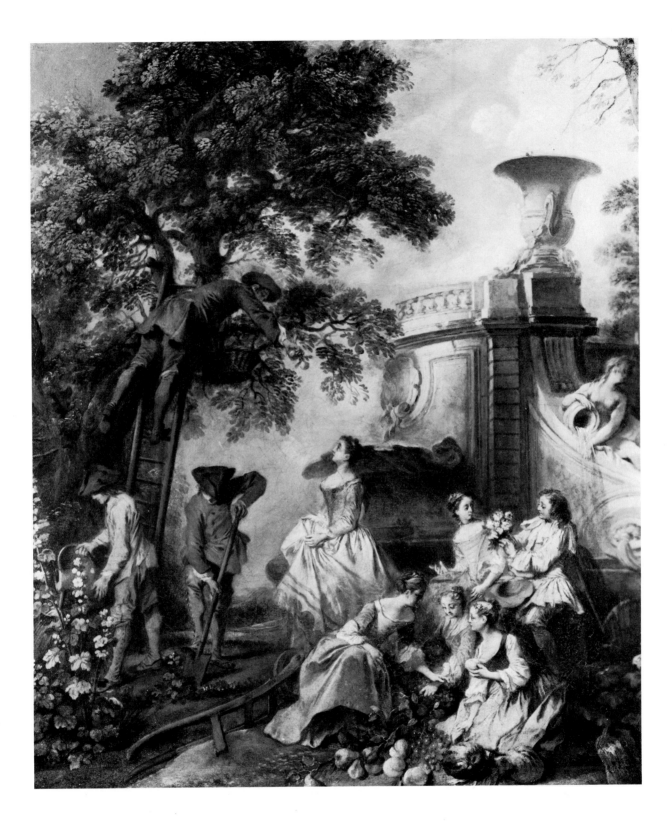

NICOLAS LANCRET
48. La Terre

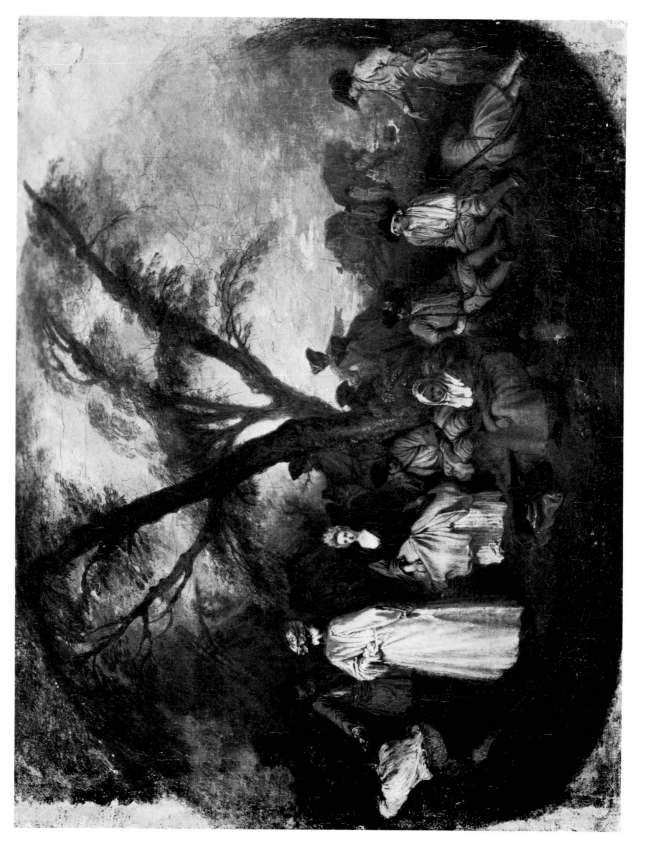

ANTOINE WATTEAU
50. La Halte

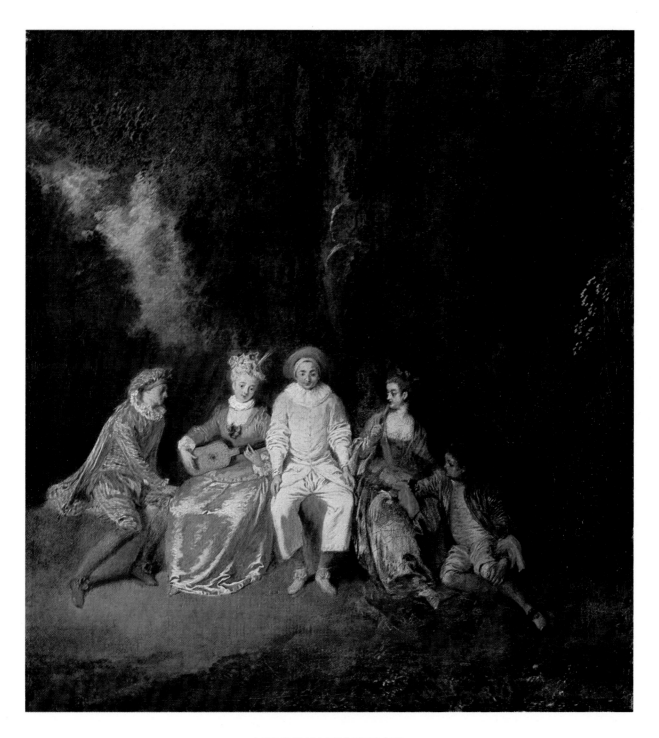

ANTOINE WATTEAU
51. Pierrot Content

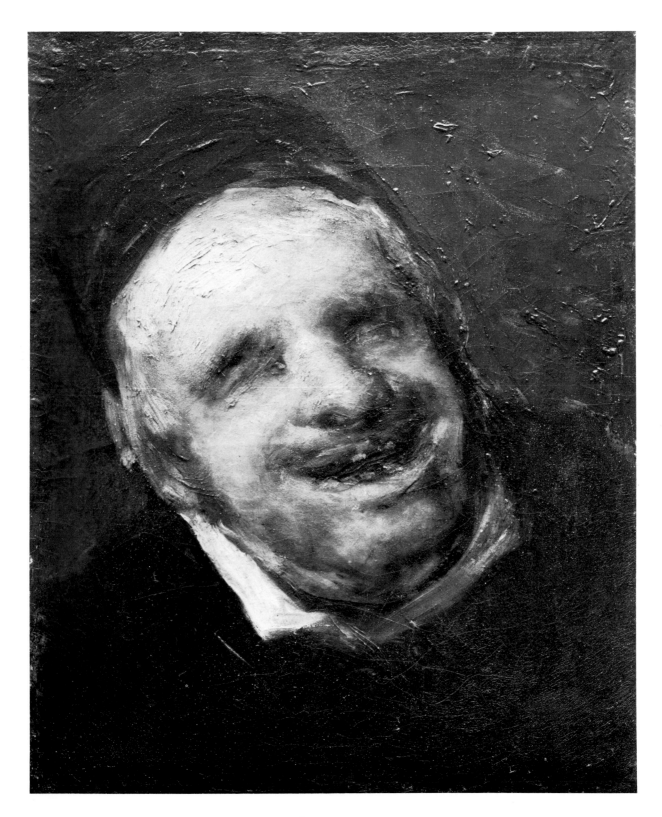

FRANCISCO JOSÉ DE GOYA Y LUCIENTES
52. El Tío Paquete

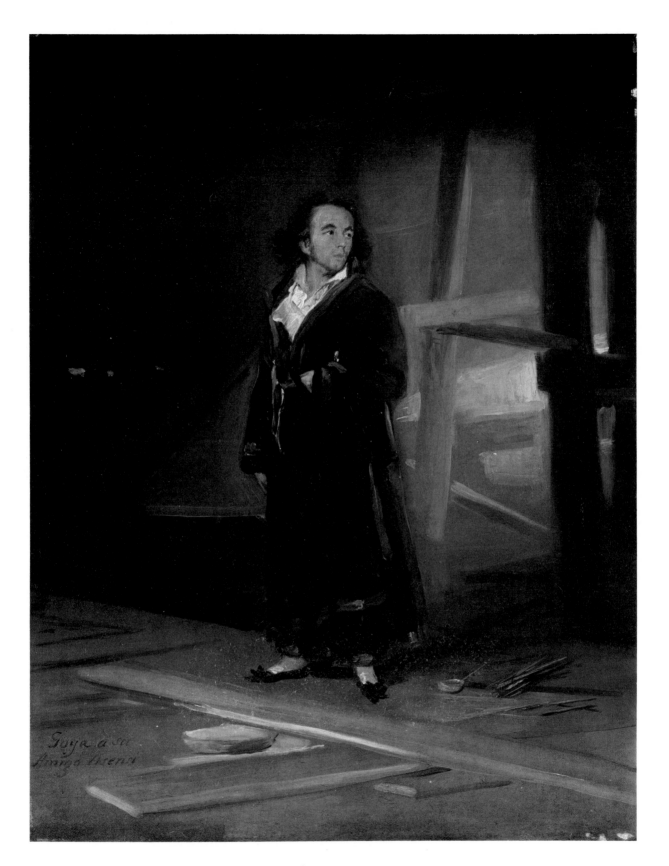

FRANCISCO JOSÉ DE GOYA Y LUCIENTES
53. Asensio Juliá in His Studio

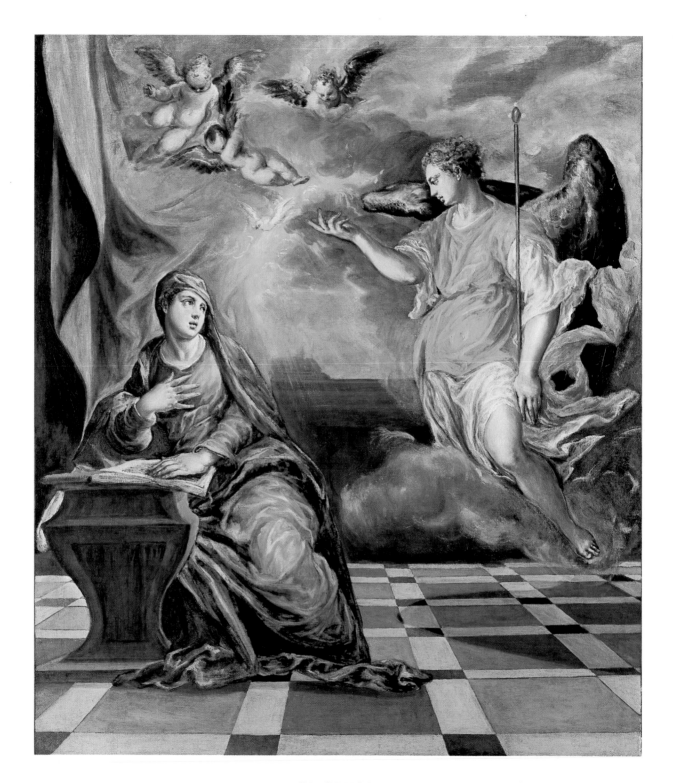

EL GRECO
54. The Annunciation

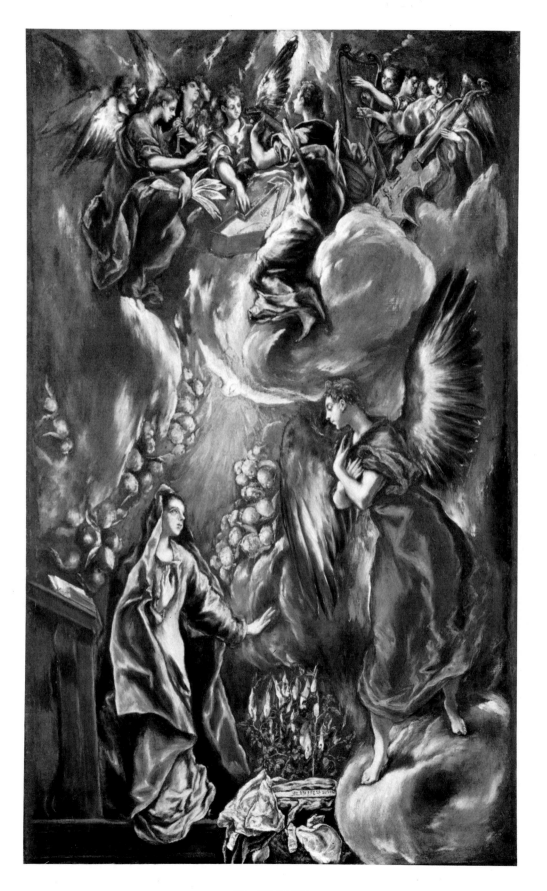

EL GRECO
55. The Annunciation

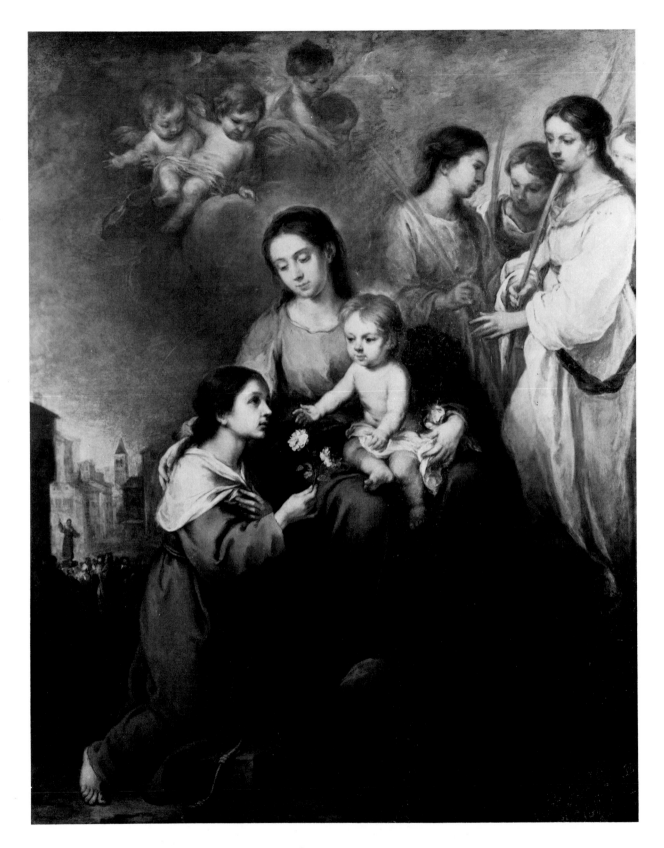

BARTOLOMÉ ESTEBAN MURILLO
56. The Madonna and Saints Appearing to Saint Rose

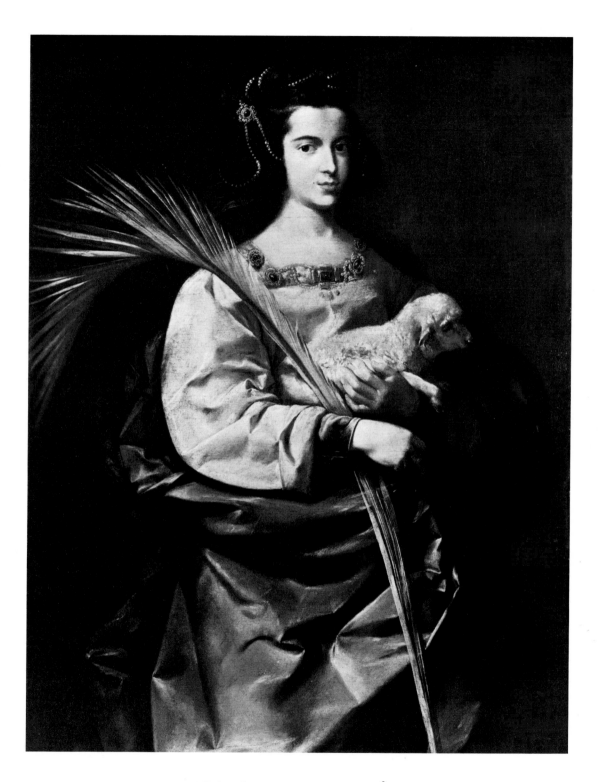

FRANCISCO DE ZURBARÁN
57. Saint Agnes

NOTE ON THE CATALOGUE

Most of the paintings in the present exhibition appear in the *Catalogue of the Thyssen-Bornemisza Collection* (Lugano-Castagnola, 1969) edited by Rudolf Heinemann and with text by: Johan Conrad Ebbinge-Wubben (Dutch and Flemish Masters), Christian Salm (German Masters), Charles Sterling (French Masters), and Rudolf Heinemann (Italian and Spanish Masters), which provides extensive bibliographic and exhibition information for each painting. Rather than repeat this material in its entirety in the present catalogue, we will here include only that literature and exhibition history not appearing in the earlier volume. For additional information the reader is invited to consult the appropriate entry in the *Catalogue of the Thyssen-Bornemisza Collection,* here referred to as "1969 Catalogue."

ITALIAN

ANTONELLO DA MESSINA
Messina c. 1430–1479 (active 1456)

1. PORTRAIT OF A MAN

Panel, transferred to plywood, 27.5×21 cm.
Inscribed on the stone ledge:
ANTONELLUS MESSANUS PINX

Provenance: Sir George Houston-Boswell, Caulder-haugh, Berwickshire, Scotland; Lady Houston-Boswell, Foliejon Cottage, Winkfield, Windsor; Mrs. Phoebe Timpson, Old Rectory, Lower Basildon, Goring-on-Thames, Berkshire; acquired 1964.

Literature: 1969 Catalogue, no. 4; R. Pallucchini, "Due nuovi Antonello," *Arte Veneta*, 21, 1967, p. 263, pl. 330.

Antonello da Messina was greatly influenced by the art of the Netherlands, and was celebrated in his day for his mastery of the brilliantly refined technique of oil painting developed by the early Netherlandish masters. Oil was used at the time in Italy, but the northern masters turned the viscous and translucent properties of the medium to a greater advantage and achieved a depth of illusion and luminosity quite magical in effect, as if an alchemical transformation had taken place and paint had been changed into light. The face in the Thyssen portrait is softly radiant. The illusion of resonance and depth depends on the application of carefully structured layers of translucent colored oil glazes which modify underlying opaque colors and allow the artist to model from dark to light in depth. This is why the shadows in the face appear so luminous and continuous with the illuminated areas; they are actually suspensions of darker pigment over the flesh tones. The beard stubble appears to emerge from the shadow and grow from the skin, and light actually seems to play within the iris of the eye. Physical light passing through these strata of glazes reflects from the opaque ground colors and creates the illusion of vibrant reality.

How this technique as well as his Netherlandish style was transmitted to Antonello remains something of a mystery. His master in Naples, Colantonio, was supposedly instructed in the Netherlandish manner by the painter king René d'Anjou, and there were paintings by Jan van Eyck and Roger van der Weyden in Naples which the young artist could have studied. He might have had direct contact with one of the northern artists either in Italy or possibly on a journey to the Netherlands, but there is no evidence for such an encounter or trip. The art of Petrus Christus is central to Antonello's development and a meeting between the two artists remains a serious possibility. A *Lamentation* in the Louvre, given variously to Petrus Christus (G. Bazin, "Petrus Christus et les rapports entre l'Italie et la Flandre au milieu du XVe siècle," *La Revue des Arts,* December, 1952, IV, pp. 194–208); to the Master of the Dessau Crucifixion, possibly Colantonio, according to P. H. Schabacker (*Petrus Christus*, Utrecht, 1974, p. 70–74) and thought by Panofsky (*Early Netherlandish Painting,* Cambridge, 1964, p. 490, n. 8 [to p. 311]) to be by a southerner in Christus' immediate circle, might interestingly be considered a work by Antonello. Antonello's understanding of Christus' art is such that it would seem to depend on more than a knowledge of pictures by the Netherlandish master in Italy. The lucid definition of form, the spatial disposition of the figure, and even the directness of the gaze in the Thyssen portrait depend from Christus's example. But despite the minutely observed naturalistic detail, the portrait is conceived with the breadth of vision of the Italian. The grander geometric clarity which informs the structure of the head, neck and shoulders, and the finely honed contours and smoothly worked planes of the face give a more monumental and idealized effect and invite comparison with sculpture. The portrait has the fineness and strength, the optimism and sophistication of Greek sculpture of the Transitional period. At the same time we are confronted with a highly individualized characterization, and there is a disarming seriousness about the man, as if he were holding very still to have his picture taken, with a hint of curiosity and restrained delight in those marvelously focused eyes. Antonello's portraits have a vivid presence and radiant life perhaps unequaled in the Renaissance.

The artist's formula is so steadfast that it is difficult to establish chronology among the undated portraits. All those which have survived, perhaps a dozen, are of men shown head and shoulders large in proportion to the picture space: some are positioned behind a

stone ledge and, with one exception (a landscape), all appear against a dark ground. P. Hendy (*Some Italian Renaissance pictures in the Thyssen-Bornemisza Collection*, Lugano-Castagnola, 1964, p.65) proposes a date for the portrait after Antonello's visit to Venice, in 1475–76, but the portrait seems decidedly earlier, more Netherlandish and less sophisticated than those works which are surely dated during and after his activity there. The portrait seems closest in style to the two portraits by Antonello in American collections: the one in the Philadelphia Museum of Art, the Johnson Collection, and the other in the Metropolitan Museum of Art, New York. The panel, transferred to plywood, has been cut at the bottom through the ledge, resulting in the loss of the lower half of the inscription. A fine crack runs through the right side of the face and through the eye.

FRA BARTOLOMMEO (BACCIO DELLA PORTA)

Florence 1472(?)–1517

2. HOLY FAMILY WITH INFANT SAINT JOHN IN A LANDSCAPE

Poplar, transferred, 62×47 cm.

Provenance: Duke of Lucca; Sir Henry Fairfax-Lucy, Charlecote Park, Warwickshire; Philip Vox, East Dean, Sussex; acquired 1956.

Literature: 1969 Catalogue, no.17.

St.John the Baptist is the patron saint of Florence, and a favorite theme in fifteenth- and sixteenth-century Florentine paintings was the meeting of the Infant St.John and the Christ Child. The encounter takes place in the desert or wilderness where the young St.John has gone to do penance and where he meets the Holy Family upon their return from Egypt. The children should, of course, be the same age, but the Christ Child is invariably shown as a babe, or decidedly younger than the saint. Fra Bartolommeo has clearly taken liberties with the setting and has added elements more usually associated with the Nativity, such as the ruin and the ass and ox in the background. Joseph is seated on a bank of rocks at the extreme left. His body is placed in three-quarter view and his head

turned in pure profile; he holds a staff in his left hand and his right is raised in wonder at the Child's recognition of St.John. Nestled in the folds of the Madonna's robes, the Child raises his arms to embrace the saint. The Madonna, kneeling on the ground, gathers her mantle about her with her right hand, looks down at the Child, and draws the Baptist forward with her left. St.John, shown nude, stands on Mary's robes and steps forward with his hands crossed over his chest in adoration. Both children are embraced within the protective folds of the Virgin's robes. The Baptist's reed cross, the banderole bearing traces of the inscription of his prophecy, lies on the ground before him. Three diminutive angels, their hands joined – another motif usually associated with Nativities – are suspended protectively over the holy figures. The landscape recedes very gently into the distance; the buildings to the right and the townscape by the shore of the lake would seem to be Netherlandish in inspiration. Color and light diminish in intensity rather abruptly over the mountains to create an effect of aerial perspective and depth, but they are also graded vertically in the foreground, from the rich hues and assertive chiaroscuro of Mary's and Joseph's robes to the thinner palette and more delicate light in the angels'. Such subtle adjustments are of course used primarily for emphasis, but they also reflect the relative contrast of the backgrounds against which the figures are seen: within the group of angels two are shown against the light sky, but the third is seen against the architecture and therefore is slightly stronger in color than his two companions. The continuous sweeping forms, dense *sfumato* and darkly founded colors of Mary's and Joseph's draperies indicate the example of Leonardo da Vinci. But at this early stage of his development Fra Bartolommeo's understanding of Leonardo is still limited; the more profound implications of the older master's art, as in the case of the later impressions of the Roman works of Raphael and Michelangelo, remain either inaccessible or incompletely assimilated. Only the drapery style has been abstracted from Leonardo's pictorial system and it seems conspicuously isolated, almost out of context within the still quattrocento fabric of the composition. The figures themselves are inconsistent with the monumentality and modernity of their

draperies; Mary and Joseph are simply posed, without any expressive torsion or decided *contraposto*. But if their gently eloquent expressions and gestures are less than organic manifestations of that continuous and indivisible interaction of spiritual and physical being, so essential a doctrine of Leonardo's art, they do convey a most exquisite and deeply felt emotion. The figures hug the foreground in clear relief against the background, and there is little interpenetration of surface design and spatial structure. Rather, near and far elements are compressed into a strict, although harmonious, diagram. Mary and Joseph, placed so as to gracefully encompass the Christ Child, are also calculated within the composition as the foundations of a symmetrically unifying arch which literally springs from the ruin to the right, continues through the group of angels and is completed in the tree behind Joseph. Christ's head is directly centered under the arch and the angle of Mary's glance exactly mirrors that of Joseph's staff. Such calculated and graphically insistent ordering of forms on the picture surface will remain a constant principle of his mature style, though spatially amplified, and it is such a mentality that will contribute to his singularly academic application of the tenets of the classical style of the High Renaissance. However, too little of the sensibility which informs the artist's early, intimate devotional pictures such as the one in the Thyssen collection, his tender regard for nature, a depth and delicacy of feeling, is retained in the heroic style of his ambitious and somewhat grandiloquent altarpieces.

According to Vasari, Fra Bartolommeo (as Baccio della Porta) was among the artists who brought their profane pictures and drawings to be burned in Savonarola's famous *"bruciamento delle vanità"* in 1486. In 1500 the artist joined the Dominican Order and abandoned painting, which he was not to resume again until around 1504. The Thyssen *Holy Family with Infant St. John* and the very beautiful *Noli Me Tangere* (Louvre, Paris), to which it is close in style, must both date from shortly after this time, around 1505. Fra Bartolommeo treated the subject of the Holy Family with the Infant St. John again around 1508-9 in the picture in the National Gallery, London, where St. John is seen in the distance approaching Mary, Joseph and

Jesus; and in a fully developed High Renaissance composition in the Galleria Nazionale, Rome, dated 1516, where Mary holds the Child who embraces St. John.

GIOVANNI BELLINI(?) AND WORKSHOP
Venice c. 1430/31–1516

3. NUNC DIMITTIS

Panel, 62×82.5 cm.

Provenance: Count Pourtalès, Paris; acquired 1964.

Literature: 1969 Catalogue, no. 26; *Catalogue Sammlung Schloss Rohoncz* (Addendum to 1958 Catalogue), 1965, no. 27a.

The imposing figures are presented immediately behind a stone parapet and before an extensive landscape; the Madonna inclines to the right to support the Christ Child, who is held by the bent old man. The infant appears to be frightened and tries to draw back into the folds of his mother's mantle. A female saint stands to the left, her hands gently touching and raised in adoration. Previously referred to simply as a *Sacra Conversazione*, the subject was identified by P. Hendy (*Some Italian Renaissance Pictures in the Thyssen-Bornemisza Collection*, Lugano-Castagnola, 1964, p. 77) as a *Nunc Dimittis*. The old man is the ancient Simeon, who appeared in the Temple at the Presentation to give thanks for the Child: "And behold, there was a man in Jerusalem, whose name was Simeon... And it was revealed unto him by the Holy Ghost, that he should not see death, before he had seen the Lord's Christ. And he came by the Spirit into the temple: and when the parents brought in the Child Jesus, to do for him after the custom of the law, then took he him up in his arms, and blessed God, and said, Lord, now lettest thou thy servant depart *(nunc dimittis)* in peace, according to thy word: For mine eyes have seen thy salvation...." (Luke 2:25–30).

Bellini is the first of the very great poets of landscape painting in Venice. It would seem that wherever possible, his religious subjects are set within nature (and certainly license is taken with the *Nunc Dimittis*), their meaning

thereby extended beyond the narrative and their poetry richly amplified. In his earliest Madonnas and in the great, moving *Pietà* in the Brera in Milan (c.1470), the figures are similarly placed behind a parapet but seen at a great height and distance from the landscape. In the *Nunc Dimittis* the point of view and scale of the landscape is more continuous with the figures, although they are still somewhat elevated, and the meadow immediately behind creates a visual pause before the foothills begin and the eye rises to the mountains in the distance. It is perhaps the special nostalgia of Venetians for the *terra firma* which so movingly informs their landscapes; Bellini approaches nature with the most tender regard and a sense of profound communion. He is extraordinarily sensitive to the effects of light and atmosphere, and the nuances of the different times of the day. Landscape and figures are one, embraced by a gentle, diffuse light and in the *Nunc Dimittis* informed by a lyric melancholy. Early morning light breaks behind the mountains beneath dark thinning clouds. The source of light comes from the left, and we are looking north to the Alps. The rolling hills of the Veneto are dotted with small farm houses and villas; a fortress climbs the hill just to the left of the Madonna and recalls the Rocca di Gradara which appears in Bellini's *Coronation of the Virgin* in Pesaro. Apart from the dark clouds the only ominous intrusion in this lovely prospect is the withered tree which stands behind the figures and can be seen between the Madonna and Simeon. Such a tree frequently occurs in Bellini's landscapes, but here, because of its conspicuous presence and placement, it might be an allusion to the death of Simeon and hence to the Resurrection through the Christ Child ("thy salvation") whom the old man holds.

There is a visually slightly disturbing element in the landscape: the tall trees, with elongated thin trunks, capped with full foliage at the very top. Certainly Bellini uses such trees in his landscapes, notably the famous example of the tall, thin trees flanking the Madonna and Child in the so-called *Madonna degli Alberetti* in the Accademia in Venice (c.1500). But the effect there is almost emblematic and, moreover, the trees are not so exaggerated in height as in the Thyssen picture. They are also brought further to the foreground, while

the trees in question in the *Nunc Dimittis,* incorporated within the landscape, are drastically out of scale. Such carelessness would seem inconsistent with Bellini's respect for nature, whatever poetic license he might take. There are other indications of the possible intervention, if not the extensive participation, of assistants in the Thyssen painting. It was originally published by F. Heinemann, who only knew the painting through photographs, as "Giovanni Bellini(?) *e bottega"* (*Giovanni Bellini e i Belliniani,* Venice 1962, no.119bis). He considered it a workshop composition with perhaps the participation of the master in the execution of the Madonna and the female saint, although he thought the latter might have been started by the *"belliniano"* Rocco Marconi. He observes that the figure of Simeon is taken from that of the high priest (reversed) in a Bellini composition of the *Circumcision,* the best version of which is in the National Gallery in London. R. Pallucchini defended the Thyssen picture as an autograph work although he conceded that the figure of Simeon might be by an assistant ("Una Nuova Opera di Giovanni Bellini," *Arte Veneta,* XVIII, 1964, pp.12–18). R. Heinemann *(1969 Catalogue)* reported that when F. Heinemann saw the original he attributed the painting to Giovanni Bellini. There is perhaps reason to reconsider F. Heinemann's original impression. Pallucchini compared the Thyssen picture to the so-called Giovannelli *Sacra Conversazione* in the Accademia, Venice (c.1505). The Thyssen picture is certainly very close in composition, with Madonna and Child flanked by St. John the Baptist to the left and a female saint to the right, all large figures close to the foreground behind a parapet with a landscape background. However, the female saints, though similar types, are not identical as Pallucchini claims: the figure in the Thyssen picture, swarthy and rather pasty in the painting of the face, the exaggerated contrast of one hand in light and the other in shadow, suffers by comparison. The figure of Simeon is surprisingly coarse in type: his head seems too big for his body and arms; he is not well articulated and his robe does not disguise the unconvincing join of head to shoulders. The figure is also awkwardly related to the Madonna and Child, and seems to be locked in profile position. The robe itself, elaborately decorated with orientalizing

motifs, is too sharply focused within the softer atmospheric effects of the rest of the painting. The Child is simply too heavily, too clumsily painted for the master, although condition may account for the especially unfortunate right leg and foot. The face of the Madonna is the most beautifully painted of the heads, but the line of her right shoulder is without form and unrelieved by any linear rhythm. Nonetheless, the picture is quite beautiful and even affecting, and Bellini may well have supervised its design and participated in the execution.

CANALETTO (GIOVANNI ANTONIO CANALE)
Venice 1697–1768

4. PIAZZA SAN MARCO IN VENICE

Canvas, 141.5×204.5 cm.

Provenance: Prince of Liechtenstein, Vienna, first mentioned in the inventory of 1806; acquired 1956.

Literature: 1969 Catalogue, no. 50; F.J.B. Watson, *Encyclopedia of World Art*, London, 1960, vol. 3, col. 53; M. Levey, "The Eighteenth Century Italian Paintings Exhibition at Paris: Some Corrections and Suggestions," *Burlington Magazine*, 103, 1961, p. 139; G. Martin, *Canaletto: Paintings, Drawings and Etchings*, London, 1967, pl. 1; P. Zampetti, *I Vedutisti Veneziani del Settecento*, Venice, 1967, p. 100; L. Puppi, *The Complete Paintings of Canaletto*, New York, 1968, no. 11, p. 90, fig. 11A; B. Hannegan, "Venice and the Veneto," in *Paintings in Italy in the Eighteenth Century: Rococo to Romanticism* (ed. J. Maxon and J.T. Rishel), Chicago, 1970, p. 54; J.G. Links, *Townscape Painting and Drawing*, London, 1972, pp. 174, 230, pl. 127; *Dizionario Enciclopedico Bolaffi dei Pittori e degli Incisori Italiani*, Turin, 1972, vol. 2, p. 441; W.G. Constable, *Canaletto*, 2 vols., 2nd ed. rev. J.G. Links, Oxford, 1976, vol. 1, no. 1, pp. 100–101, vol. 2, no. 1, pp. 187–188, pl. 11; W.L. Barcham, *The Imaginary View Scenes of Antonio Canaletto*, New York, 1977, pp. 66–68, fig. 69.

The rather high point of view looking east onto the Piazza is taken from the Church of San Geminiano, which was torn down in 1807 for the construction of the Napoleonic wing of the Palazzo Reale which today houses the Museo Correr. The Procuratie Nuove, to the right and against the light, casts its shadow across the bottom of the Campanile and onto the pavement. The façade of the Procuratie Vecchie is in full

light and less than dignified by a disorderly array of striped awnings and a bit of drying laundry. The Torre dell'Orologio rises at the far end, and the view to the east is closed by the Basilica of San Marco and the Doges' Palace to the right. There is a market at the far end of the Piazza which spills over into the street to the side of the Basilica. Figures from all walks of Venetian life dot the Piazza, stand in the arcades, and wander under the *tende* and large shade umbrellas of the merchants. A streamer of brightly lighted cloud rising up from behind the Basilica is overtaken by a bank of threatening dark clouds from the left.

Piazza San Marco dates from around 1723 and with its pendant, *View of the Grand Canal from Campo San Vio* (No. 5), represents Canaletto's earliest style. These pictures of the early 1720s immediately reflect his activity as a theater-painter: there is a preference for large canvases and deep, wide views with a concentration of abruptly foreshortened architectural elements at the sides. Topographical accuracy is subordinated to pictorial and dramatic effect; liberties are taken with the proportions and relative scale of buildings, which are freely drawn without the squared certainty and precisely delineated details of the later views. Light and shade are broadly massed and sharply contrasted. The paint surface is rich and fatty with occasional ragged and mottled effects and touches of heavy *impasti*. The façade of San Marco is a superb example of this still free and suggestive handling. The picture is darkly luminous and the light inconstant under the shifting masses of clouds; the colors are deeply saturated and shot with brilliant accents, as if seen through the dense and humid atmosphere which precedes a storm. Such a romantic treatment, borrowed in part from ruin-painters as well as from theater designers, would of course be superceded by the exacting and brilliant lucidity of the views of the 1730s. These early works must have been significant for the development of Marieschi's style and surely for Francesco Guardi when he turned to view painting in the 1760s.

Pallucchini observed that the present grey and white pavement in the Piazza, which was relaid by Andrea Tirali in 1723, is not shown in the picture (*La Pittura Veneziana del Sette-*

cento, Venice-Rome, 1960, p. 74). This would provide a *terminus post quem* of that date; but Michael Levey *(loc. cit.)* points out that the picture shows the pavement already laid on the right side of the Piazza so that a cautious date of around 1723, rather than much before, is advisable. While it does not affect the dating, the pavement is also shown laid on the left side and is incomplete only in the middle where the lines have been set for the two sections with geometric design and the solid section in the middle. Curiously, there is an indication of a geometric pattern – a rectangle with perpendicular lines at two sides – set midpoint in the middle section, which was eventually laid solid grey. This may be Canaletto's misunderstood anticipation of the design before it was actually laid, or a first design that was later changed.

Piazza San Marco and *View of the Grand Canal from Campo San Vio* are from a group of four paintings by Canaletto originally in the Liechtenstein Collection. The other two, *Grand Canal from Palazzo Balbi to the Rialto Bridge* and *Rio dei Mendicanti,* are presently in the collection of Mario Crespi in Milan.

CANALETTO (GIOVANNI ANTONIO CANALE)
Venice 1697–1768

5. VIEW OF THE CANAL GRANDE FROM SAN VIO

Canvas, 140.5×202 cm.

Provenance: Prince of Liechtenstein, Vienna, first mentioned in the inventory of 1806; acquired 1956.

Literature: 1969 Catalogue, no. 51; F. J. B. Watson, *Encyclopedia of World Art,* London, 1960, vol. 3, col. 53; M. Levey, "The Eighteenth Century Italian Paintings Exhibition at Paris: Some Corrections and Suggestions," *Burlington Magazine,* 103, 1961, p. 139; P. Zampetti, *I Vedutisti Veneziani del Settecento,* Venice, 1967, p. 100; L. Puppi, *The Complete Paintings of Canaletto,* New York, 1968, no. 12, p. 90, fig. 12A; W. G. Constable, *Canaletto,* 2 vols, 2nd ed. rev. J. G. Links, Oxford, 1976, vol. 1, p. 100, pl. 39, vol. 2, no. 182, p. 274; W. L. Barcham, *The Imaginary View Scenes of Antonio Canaletto,* New York, 1977, pp. 66–68; fig. 70.

As in No. 4, the point of view is again elevated and towards the east. The building to

the immediate right is the Palazzo Barbarigo; a woman, most likely a servant, stands on the balcony and a chimney sweep is at work above on the roof. Still on this side of the canal one can see a greatly foreshortened file of palaces with the Dome of the Salute rising in the distance, and further on, the Dogana with the statue of Fortuna just faintly indicated. The large, imposing building across the canal, following a group of small houses, is the Palazzo Corner della Ca' Grande; and in the farthest distance, closing the view, is the Riva degli Schiavone with the Campanile of S. Francesco della Vigna isolated against the sky. A rather scruffy group of men are gathered in the Campo, with two more properly dressed figures in conversation nearby. Barges are anchored near the quay, one is loaded with barrels; and two larger boats, the smaller with a tattered set sail and the other with two masts, are picturesquely silhouetted against the open canal. The canal itself is alive with the traffic of gondolas, and the two speedily crossing in the foreground suggest a *traghetto* service. The sky is again overcast as in the pendant *Piazza San Marco.* The effect of the light is similar although more evenly distributed, with less dramatic contrasts of light and shade. The dark forms of the large boats in the foreground give the composition some relief. The color is more monochromatic, gentler but slightly sallow, and the heavy red-brown ground color is perhaps more pervasive in this composition.

The picture must date fairly close in time to *Piazza San Marco.* Michael Levey has noted, however, that the scaffolding on the lantern of the Salute was put up in 1719, thus permitting a slightly earlier date for the picture than its pendant.

VITTORE CARPACCIO
Venice 1465/67–1525/26

6. YOUNG KNIGHT IN A LANDSCAPE (FRANCESCO MARIA DELLA ROVERE, DUKE OF URBINO)

Canvas, 218.5×151.5 cm.
Signed on label to the right:
VICTOR CARPATHIVS/FINXIT M.D.X.
Inscribed on label to the left:
MALO MORI/QVAM/FOEDARI

Provenance: Vernon-Wentworth Collection, Wentworth Castle, Barnsley, Yorkshire; Otto M. Kahn, New York; acquired 1934.

Literature: 1969 Catalogue, no. 56; T. Pignatti, *Encyclopedia of World Art,* London, 1960, vol. 3, col. 131, pl. 70; L. Vertova, "Carpaccio," *Kindlers Malerei-Lexikon,* Zurich, 1964, vol. 1, p. 649; *New International Illustrated Encyclopedia of Art,* New York, 1968, vol. 5, p. 883, illus. p. 882; D. Cast, "The Stork and the Serpent: A New Interpretation of the Madonna of the Meadow by Bellini," *Art Quarterly,* 32, 1969, p. 256, n. 27; *Dizionario Enciclopedico Bolaffi dei Pittori e degli Incisori Italiani,* Turin, 1972, vol. 3, p. 101 (as S. Eustache); T. Pignatti, *Carpaccio,* Brescia, 1970, p. 10, illus. p. 56.

In 1963, when the portrait was exhibited in the Carpaccio Exhibition in Venice, Roberto Weiss convincingly identified the young knight standing in the landscape as Francesco Maria della Rovere (1490–1538), Duke of Urbino. Weiss observed (as reported in the exhibition catalogue) that the ermine in the left foreground and the inscription *malo mori / qvam / foedari* ("die painfully rather than be sullied") on the paper propped on a plant just above are, respectively, the impresa and motto of the Neapolitan Order of the Ermine. Francesco Maria was not himself a member of the Order, but his grandfather Federigo da Montefeltro, the first Duke of Urbino, was made a founding member in 1474 and had used the ermine as his impresa before that date. The specific association of the ermine and motto with Urbino is confirmed by the livery worn by the mounted squire: black and gold, the colors of the Dukes of Urbino, which are also used in the decoration of the scabbard of the knight's sword and in the checkered pattern of the chain mail of his shoes. Francesco Maria was the son of Giovanni della Rovere and the nephew of Pope Julius II (Giuliano della Rovere); his mother was Giovanna da Monte-feltro, the daughter of Federigo and the sister of Guidobaldo da Montefeltro. Duke Guidobaldo was childless and adopted his nephew in 1504; and Francesco Maria was invested with the duchy by inversion. He succeeded as Duke upon Guidobaldo's death in 1508.

The date 1510 appears with the artist's signature on the *cartellino* attached to the tree stump in the right foreground. It is understandable that the young, newly installed duke would wish to stress his maternal line and the association with his illustrious grandfather, but no allusion to the della Rovere, the name he bore, has been observed, and this would be a curious omission. A Giorgionesque portrait in the Kunsthistorisches Museum in Vienna (inv. no. 554) is presumed to be a portrait of Francesco Maria della Rovere as a boy and, the difference in age considered, the sitter bears a strong resemblance to the young man in Carpaccio's portrait. Reassuring as this resemblance may be, the identification of the Vienna portrait depends on the decoration of gilt-bronze oak leaves on the large black helmet held by the youth. *Rovere* means "oak" in Italian, or more properly a scrub oak, and the leaf is an heraldic device of the family. Oak leaves also appear in Titian's portrait of the Duke, c. 1536, in the Uffizi. A cut branch with oak leaves is placed with military batons on a high ledge behind the Duke. Oak leaves also appear in Carpaccio's portrait and further confirm Weiss' identification. The leaves on the sparsely foliated tree, which stands so prominently behind and to the right of the knight, are indeed oak. Rather than greening or losing its leaves, it suggests a tree which has suffered but is reviving, sending forth leaves on only a few branches. It stands between the cut stump in the right foreground (whose different bark pattern, still compatibly oak, indicates a younger tree) and the flourishing tree in the distance, a sequence which suggests a regenerative progression. In 1502 Guidobaldo and Francesco Maria, then a boy of twelve who had been living in Urbino since his father's death in 1501, were expelled from the duchy by Cesare Borgia. Francesco Maria returned from his exile in France only after the restoration of his uncle in 1503 and shortly thereafter his succession was established. The sequence of trees might therefore refer to these trials and the revitalization

of the della Rovere through his accession. The oak also symbolizes endurance against adversity; it may be broken but it will not bend.

The prominent lilies and irises which incline toward him on either side are also devices of personal identification. They are the flowers most conspicuously associated with the Virgin Mary (see No. 25, Memling's *Still Life*), especially with the Virgin Annunciate. The Duke was born on 25 March, the Feast of the Annunciation, and was therefore given the name Maria. He stands surrounded by genealogical and personal devices insinuated in the landscape, but he is visually and personally most emphatically identified with the "della Rovere oak" behind him. Such a dynastic program would be commensurate with the scale and ambition of the portrait, the earliest extant full-length and independent portrait in Italy.

It was traditional for the squire to carry the lance and helmet of his lord, as does the young boy in the black and gold livery. But the configuration of the mounted squire, wearing the too large helmet, with the dog running beside the horse, recalls the knight setting forth in Dürer's famous engraving, *Knight, Death and the Devil,* of 1504. Dürer was in Venice from 1505 to 1507 and Carpaccio's portrait at one time actually bore the false monogram of the German painter, no doubt because of the highly naturalistic studies of flowers and plants. Though Francesco is not, like Dürer's hero, graphically beset by the temptations and dangers of the world, he stands at the ready to do similar battle in God's name. He was, in fact, already Captain General of the papal forces, appointed by his uncle, Pope Julius II. There is reason to believe, as in the case of the heraldic and personal devices in the portrait, that many other details in the landscape – the birds and other creatures, and the architecture – are symbolic, and that the landscape is an allegory of the struggle of the Christian soul between good and evil. In one clearly demonstrated instance, in the *Meditation on the Dead Christ* (Metropolitan Museum of Art, New York), Carpaccio painted such an allegorical landscape. Granted this is a highly didactic religious subject, but such a dimension of Christian allegorical meaning, the charac-

terization of Francesco Maria as the vigilant Christian knight, would only lend divine approbation to his military and political ambitions. This is not to suggest a pedantic inventory of every flower and plant in the painting. Carpaccio loved to embellish and embroider his compositions with such naturalistic and fanciful details, but certainly there is a more specific program in the portrait than has heretofore been observed.

In 1509 Francesco Maria had led the troops of Julius II against the Venetians to regain the papal cities in Romagna which the Venetians had occupied after the fall of Cesare Borgia. By 1510, however, the Venetians were once again allies of the Pope. The Duchy of Urbino was on long-standing good terms with Venice, and Francesco Maria was also condottiere – and, after 1523, Captain General – of the Venetian forces.

Francesco Maria need have sat for no more than a study of the head; the rest would have been completed in the studio. The large, strong hands gripping the sword seem inconsistent in scale and character with the small, fine face, and most likely another model posed in the armor. Carpaccio might very easily not have thought to resolve the discrepancy. There are other, rather disarming miscalculations in the picture, such as the peacock so placed as to appear to perch on the helmet rather than on the wall behind the squire. Such ambiguities result from the spatial construction of the picture by the dovetailing of clearly silhouetted vignettes of landscape and architecture which create a more insistent surface pattern than an illusion of continuous depth. This strong predisposition toward the decorative is manifest in the silhouetted horse juxtaposed, perhaps significantly, with the hanging sign of a "packhorse" above, the scattering of plants and flowers, and the falcon and heron fixed against the sky like the figures in a Chinese brocade. Light reveals detail from foreground to background with an almost shadowless constancy, yielding only in the farthest hills, behind the fortified city. No form or color is given too abrupt or strong relief: even the pattern of reflections on the suit of armor is gently incorporated into the fabric of the composition. Movement and time seem to be arrested, and the effect is of a most splen-

didly appointed diorama. The dreamy, lyric expression of the young man and the stilled enchantment of the landscape certainly reflect the example of Giorgione, who died the year in which the portrait was painted. In 1508 Carpaccio was charged with the inspection of Giorgione's deteriorating frescos on the façade of the Fondaco dei Tedeschi in Venice, and these full-length idealized figures might also have decided him in the format of the Thyssen picture.

L. Venturi (*L'Arte*, XXXIII, 1930, pp. 393–95) considered the picture an idealized *fantasia cavalleresca*, which is in part correct. Because of the stag in the background and the suggestion of Dürer's engraving, the subject has also been considered a "St. Eustace." Carpaccio's signature and the date were revealed only when the picture was cleaned in 1958.

GIACOMO CERUTI
Active 1720–1757

7. GROUP OF BEGGARS

Oil on canvas, 123.5×94 cm.

Provenance: Vincent Korda, London; acquired 1976.

Literature: *Apollo*, 90, 1969, illus. p. lxxviii.

Apparently forgotten shortly after his lifetime, the œuvre of this fascinating artist has only recently begun to take form. Notice first came when Ceruti's *Lavandaia* from the Pinacoteca in Brescia was included in the exhibition of Italian seventeenth- and eighteenth-century paintings mounted in Florence in 1922; and interest grew considerably with the more extensive representation of the artist's work in the 1953 exhibition in Milan, "I Pittori della Realtà in Lombardia," with the signal essay by Roberto Longhi in the accompanying catalogue. The first serious viewing of Ceruti's paintings outside Italy was in the exhibition "Peinture Italienne au XVIIIᵉ Siècle" (Paris, 1961). There is little biographical data and the painter is variously mentioned in documents as Milanese, Bergamesque or Brescian. Whatever his precise birthplace he must certainly have been from Lombardy, and he appears to have principally resided in Brescia and been most active in the

immediate region of that city. He was painting and living with his family in Padua in 1739, and there are records of payments for work in Venice, 1737, and Milan, 1757. Approximately twenty paintings by Ceruti were recorded in the collection of the Field Marshall von der Schulenburg, under the heading "Pittori Moderni Illustri" (A. Morassi, *Giacomo Ceruti*, Pantheon, 1967, pp. 348–367). It was von der Schulenburg who commissioned the series of Turkish scenes from Gianantonio Guardi (see Nos. 11, 12); ironically Piazzetta (No. 15), who supervised the Field Marshall's collection and probably was responsible for placing Ceruti among the "illustri," had considerably less regard for the now celebrated Guardi. Ceruti was active as a portrait painter and also received commissions for religious works, but it is as a painter of peasants and the downtrodden – beggars, cripples, dwarfs, vagabonds and idiots, the humblest and most wretched of sorts – that his originality lies. He himself received the nickname *"Il Pitocchetto"* (literally, "The Beggar"), referring to his special subject matter. His work in this genre is sometimes confused with that of G. F. Cipper, nicknamed *"Todeschino"* (from *tedesco*, or "German"), who was also active in the area of Brescia and Bergamo, although earlier than Ceruti.

The *Group of Beggars* is one of Ceruti's most monumental and powerful works. Three figures, two old men and an old woman, are gathered around a table in a shabby interior, its space vaguely defined by the plank in the foreground and the wall at the rear, with peeling stucco revealing the bricks. The old man to the left sits on a chair which sets unevenly on the floor, throwing the figure into a slight imbalance which he seems to check with his arm on the table. The incline of the chair is insistently repeated in the angle of the stick he holds and that of the standing figure to the right, as if to create a deliberately precarious effect. The old woman is seated behind the table with her arms crossed and, like the two men, her head slightly bowed. There is the suggestion of an occasion, of some dreary and painful reunion, each person lost in his own recollections. But their true bond is plainly their shared misery and endurance. The eyes of the seated man are bright but glazed, and the stance of the other is eloquent with weariness and resignation. The woman

seems the most actively reflective and the least shabbily dressed. The costumes of the men present a relentless inventory of depressing details; the silvery clear light searches out every torn and frayed edge of the heavy, dough-like homespun, every bit of cracked leather in their shoes. Even the crossed leg of the seated old man seems to be calculated to better show his bandage-like legging. The gnarled hands and lined, worn faces are described in the same exacting detail, and the textures of age and poverty, almost palpable, approach the fetishistic. The browns, greys, buffs, whites and listless blacks produce a monochromatic effect which contributes to the oppressiveness of the scene.

The scale of the figures overwhelms the space and they take on heroic stature and stoic dignity. The unyielding realism is tempered by the air of the studio in Ceruti's works, although less so than usual in the Thyssen picture. The figures here seem somewhat posed or arranged, but Ceruti's *pitocchi* are often closer to portraiture than genre, the figures placed against a summarily painted townscape or rural setting which sometimes looks like a photographer's drop. This candid approach to his subjects recalls the peasant genres of the Le Nain brothers of the previous century, although Ceruti's beggars and peasants, despite the artist's ostensibly objective realism, are more calculated in effect. The isolation of these "specimens," their "magical stillness" (Longhi), gives them a compelling but often disquieting intensity. The *pitocchi* pictures were most likely painted for the owners of villas in the countryside around Brescia and Bergamo and along the shores of Lake Garda; groups of these paintings are so recorded, some still in situ. Appropriately rustic, they also would have vicariously satisfied a sophisticated and morbid curiosity and perhaps even flattered a certain philosophical attitude.

With the exception of the date 1737 on the *Beggar* in the Bassi-Rathgeb Collection, Bergamo, there is no chronology for Ceruti's *pitocchi*. The Thyssen picture is close in style and ambition to the powerful *Old Beggar* in the Gnutti Collection, Brescia (L. Mallé and G. Testori, *Giacomo Ceruti e la ritrattista del suo tempo nell'Italia Settentrionale*, Turin, 1967, cat. no. 44, pl. 69), and the monumen-

tality of the two paintings and the depth and gravity of feeling would suggest that they might be late works.

FRANCESCO DEL COSSA
Ferrara 1435/36 – Bologna 1477

8. PORTRAIT OF A MAN HOLDING A RING

Poplar, 33.5×24.5 cm.

Provenance: Marchesi Boschi, Bologna; Sir William Abdy, London; Leopold Koppel, Berlin; von Pannwitz, De Hartekamp, Bennebrock; acquired 1954.

Literature: 1969 Catalogue, no. 70; M. Salmi in *Encyclopedia of World Art*, New York, 1961, vol. 4, col. 6.

If the portrait is indeed of a goldsmith, as the ring in his left hand might indicate, then it is painted in an appropriately precise and elegantly wrought style. It seems more drawn in color than painted, the definition of form resulting from the accumulation of a fine, close system of lines and hatchings. This is in part due to the properties of the egg tempera medium, although there is undoubtedly some admixture of oil, but it is also an aspect of Cossa's exacting style, especially pronounced in this small panel picture. E. Ruhmer (*Francesco del Cossa*, Munich, 1959, p. 76) dates the picture around 1472 at a time when Cossa places great emphasis on decorative, almost ornate forms and highly finished surfaces, as in the Osservanza Altarpiece, the main panel of which, the *Annunciation*, is in the Gemäldegalerie, Dresden. The coiled cloud to the left in the Thyssen portrait recalls the form of the large snail in the foreground of the *Annunciation* in Dresden. The concentric and spiral linear systems, particularly evident in the rock formations and clouds, the hair and even the structure of the face of the sitter, is accredited by Ruhmer to the influence of earlier works of Marco Zoppo in Bologna.

There is nothing comparable to this portrait in Cossa's surviving œuvre, but the face of the right angel which Cossa added to an earlier fresco in the Church of the Madonna del Baraccano in Bologna, executed in 1472, though more robust and more emphatically drawn, would not only reinforce the attribu-

tion to Cossa, but also Ruhmer's proposed date. The landscape with its elaborately invented rock formations is an especially Ferrarese phenomenon ultimately derived from Mantegna, and the particularly fanciful forms in the portrait recall such formations in Cossa's earlier frescoes in the Palazzo Schiffanoia in Ferrara; they appear slightly later in a more sober and architectural guise in the central panel, the St. Vincent Ferrer, of the Griffoni Altarpiece in the National Gallery, London. The pale, tawny tonality so characteristic of Cossa is here especially sympathetic with the light coloring of the sitter's hair and eyes. Even the expanse of black in the hat is subtly balanced within this delicate chromatic harmony. The blue band in the moulding of the parapet, repeating in a stronger key the color used in the distant mountains, is surprising and is perhaps so devised to call attention to the remarkably virtuoso foreshortening of the hand which appears to project out of the picture.

There is a tradition identifying the sitter as the Bolognese painter Francesco Francia, who started his career as a goldsmith. The young man is so named in a seventeenth-century engraving after the painting by Domenico Santi, and an engraving of 1763 by Carlo Faucci identified the picture as a self-portrait of Francia. It is not necessary here to go into all the arguments against such an identification and attribution, which in any case would seem to be a late invention. The idea of a self-portrait is suggested by the fact that the ring is held in the left hand. However, in Memling's roughly contemporary portrait of a medalist in Antwerp the young man holds a medal in his left hand, and in a portrait of around 1475, formerly in the Corsini Gallery, Florence, and variously attributed to Botticelli and Pollaiuolo, and probably a school piece of the former, the sitter also holds a ring in his left hand (the ring possibly signifying a member of the Medici family). Longhi (*Officina Ferrarese,* Rome, 1934, p. 164, n. 74) questions the identification of the sitter as a goldsmith; he feels the young man is too well dressed and wonders if he shouldn't have some identifying tool of his trade (the latter would not seem to be essential: witness Jan van Eyck's portrait of *The Goldsmith Jan de Leeuw* in the Kunsthistorisches Museum, Vienna) and suggests that the painting may be a betrothal portrait. This is an attractive idea and one for which the calm seas in the background would augur well. Given Cossa's close ties with the Court of Ferrara it is curious that the ring with the stone has not been considered, at least to our knowledge, as an Este device. In the portrait of Francesco d'Este by Roger van der Weyden in the Metropolitan Museum, New York, the sitter holds a diamond ring, although in his right hand. (He also holds a tool, a small hammer; this does not make him a goldsmith but instead refers to his motto.) Granted, the diamond in the Este ring, as in the similar device of the Medici, is characteristically pointed when shown heraldically, as on the obverse of coins, but it might simply be more naturalistically modified in Cossa's portrait. It would be tempting to identify the sitter in the portrait as Ercole d'Este, especially given the probable date of the portrait, as he succeeded as Duke of Ferrara in 1471 on the death of his brother, Borso, and was married to Eleanora d'Aragona in 1473, and either occasion would have justified a portrait. But medals of Ercole dated 1472 show him as much older looking – he was born in 1431 – and with a rather distinctive, long nose. Cossa's portrait is idealized, the man's physiognomy generally reflects Cossa's types, but not to such an extent that it might still be Ercole. There are, however, enough more modest members of the family, given all of Niccolo III's natural sons, and the sitter might be drawn from the ranks of such as Rinaldo d'Este (1435–1503). His portrait medal, attributed to Lodovico Coradino of Modena (G. F. Hill, *A Corpus of Italian Medals of the Renaissance,* London, 1930, p. 29, no. 104, ill. II, pl. 23) inscribed *RAINALDUS MAR CHIO ESTENSIS,* dated 1469, shows a man not unlike the one in Cossa's portrait (but of course in profile) with a similar hat and hairdo, although both were ubiquitous in type at the time. The obverse of the medal is decorated with the Este diamond ring, embellished, with other motifs. Admittedly the choice of Rinaldo is completely arbitrary but the possibility of a member of the Este family remains an intriguing one.

DUCCIO DI BUONINSEGNA

Active 1278, d. Siena 1318/19

9. CHRIST AND THE WOMAN OF SAMARIA

Panel, 43.5×46 cm.

Provenance: Siena Cathedral; Giuseppe and Marziale Dini, Colle di Val d'Elsa, Siena; Charles Fairfax Murray, Florence; Robert Benson, London; Duveen Brothers, New York; Clarence MacKay, New York, John D. Rockefeller II, New York; acquired 1971.

Literature: A. Venturi, *Storia dell'arte Italiana*, Milan, 1907, vol. 5, p. 568; Crowe and Cavalcaselle, *History of Painting in Italy*, London, 1908, vol. 3, pp. 8–11; B. Berenson, *Central Italian Painters of the Renaissance*, New York, 1909, p. 103; C. H. Weigelt, "Contributo alla reconstruzione della Maesta di Duccio di Siena," *Bulletino senese di storia patria*, 15, 1909, pp. 191–214; Società degli amici dei monumenti, *In Onore di Duccio di Buoninsegna e della sua scuola*, Siena, 1913, pp. 24–25, 28, fig. 41; Catalogue of Italian Pictures collected by Robert and Evelyn Benson, London, 1914, p. 3, no. 2; R. van Marle, *The Italian Schools of Painting*, The Hague, 1924, pp. 33–34, H. Comstock, "Panels from Duccio's Majestas for America," *International Studio*, LXXXVIII, Sept. 1927, pp. 63, 65, 67, illus. p. 66; E. T. DeWald, "Observations on Duccio's Maestà," *Late Classical and Early Medieval Studies in Honor of Albert Mathias Friend, Jr.*, Princeton, 1955, p. 367; P. d'Ancona, *Duccio*, Milan, 1956, pl. 30; E. Carli, *Duccio di Buoninsegna*, Milan, 1961, p. 22, pl. 28; F. A. Cooper, "A Reconstruction of Duccio's Maestà," *Art Bulletin*, 47, 1965, p. 170; B. Berenson, *Italian Painters of the Renaissance: Central Italian and Northern Italian Schools*, London, 1968, vol. 1, pl. 117; J. White, "Measurement, Design, and Carpentry in Duccio's Maestà, part II," *Art Bulletin*, 55, 1973, p. 566, fig. 80; "A Duccio for the Kimbell Art Museum," *Apollo*, 102, 1975, p. 224; J. H. Stubblebine, "The Back Predella of Duccio's Maestà," *Studies in Late Medieval and Renaissance Painting in Honor of Millard Meiss*, New York, 1977, vol. 1, p. 430, 435, illus. vol. 2, p. 144, no. 5; "Nouveau regard sur la collection Thyssen," *Connaissance des Arts*, 306, August 1977, p. 52, fig. 1; J. H. Stubblebine, *Duccio di Buoninsegna and his School*, Princeton, 1979, pp. 31, 32, 37, 56, fig. 95.

Exhibitions: Colle di Val d'Elsa, *Catologo degli oggetti d'arte antica presentata all mostra communale di Colle di Val d'Elsa*, 1879; London, New Gallery, *Early Italian Art Works from 1300–1550*, 1893–94; London, Royal Academy, *Winter Exhibition*, 1904, no. 1; London, Grafton Galleries, *Exhibitions of Old Masters on behalf of the National Collections Fund*, 1911, no. 5; Manchester, City Art Gallery, *Exhibition of the Benson Collection of Old Italian Masters*, 1927; Cleveland, Museum of Art, *Exhibition on the Twentieth Anniversary*, 1936, no. 123.

Christ and the Woman of Samaria is a panel from the Maestà, the retable of the high altar of the Cathedral of Siena. Duccio received the commission for the altarpiece on 9 October 1308, and it was carried to the Cathedral in joyous procession on 9 June 1311.

The episode of Christ and the Samaritan is told in John 4: While traveling in Samaria, the Apostles leave Christ at a well and go off to find food. A woman comes to the well and Christ asks her for water; she questions that a Jew should ask water from a Samaritan and during their discourse she recognizes him as the Messiah. The woman stands with a bucket in her left hand and a water jug balanced on her head. Her right hand is raised, perhaps in wonder at the revelation. Christ, seated on the edge of the polygonal well, raises his hand in response, in the gesture of a patient teacher. The Apostles, returning with food cradled in the folds of their robes, stand in the arch of the city gate like a mute chorus, apprehensive but moved by the scene which greets them. Their gently emotive faces are very different from Christ's, which is remote and fixed; his bearing, too, is more rigid and hieratic and his robes, edged in gold, are less softly and naturalistically modeled. Christ is frequently so distinguished throughout the scenes of the Maestà, to indicate his dual nature. There are instances where Christ's robes are rendered in schematic byzantine style with shading-in-reverse in gold to emphasize his Divinity, and others, for example on the Cross, when he is described in the softer, more naturalistically expressive gothic style, to show his humanity. The two modes are also juxtaposed in the setting. The walled town, the well and the rocky landscape elements are gothic in inspiration and despite inconsistencies in scale are described as solid forms, modeled in light and shade, the architecture drawn in convincing perspective. Most remarkable is the way in which the Apostles are contained within the space of the city gate. The sky, however, is still rendered in the byzantine style as a field of pure gold. The opposition of the dense geometry of the cityscape and the flat gold ground also separates the main protagonists, Christ and the Samaritan, from the Apostles. The narrative does not allow for dramatic action or expression, but rather a quiet eloquence, and the measured intervals at which the figures are placed lends a dignified restraint to the composition. The isolation of the single figure of Christ at the extreme left is balanced

by the deep red and blue of his robes against the other predominantly warmer and more delicate colors. The area around the paved stone road is the most conspicuously abraded; and because of a misunderstood restoration, the rocky substructure of the city wall, to the left of the bridge and clearly to be read in the distance, now encloses the right arm of the Samaritan. The uppermost part of the cityscape appears to be in excellent state and the pink, cream and pale green tones of the walls and the terra cotta roof tiles are wonderfully fresh.

The Maestà was a large and elaborate altarpiece, free standing and painted on both sides. Its tortured history need only concern us here in brief. In the early sixteenth century it was moved from the high altar and placed in another part of the Cathedral. It was dismembered in the late eighteenth century, the main panel sawed in seven vertical sections, and the backs and fronts separated; in the late nineteenth century it was transferred to the Opera del Duomo. It may be seen there today, deprived of its unity and setting, but still so awesomely beautiful and moving as to make its fate incomprehensible. The loss and dispersal of several of the panels in the various misadventures of the Maestà have frustrated a precise reconstruction of the altarpiece, but a general description might help to place the Thyssen panel in context. The main body of the front panel showed the Madonna and Child Enthroned, surrounded by the heavenly court of saints and angels; hence the name *maestà*, or majesty. Immediately above was a row of half-length figures of Apostles and above that, pinnacles with scenes of the Death and Later Glorification of the Virgin, surmounted in turn by gables with angels. The predella immediately below the Madonna Enthroned was painted with scenes of the Infancy of Christ, alternating with figures of the Prophets. The predella is the earliest extant in Italian painting and it projected beyond the main panel of the altarpiece. The back of the altarpiece was divided into rectangular fields of varying sizes to accommodate the extensive narrative of the Passion and Resurrection of Christ which continued into the back pinnacles, again surmounted by gables with angels. The back predella was devoted to scenes of Christ's ministry and included *Christ and the Woman of Samaria*. According to Stubblebine (1977), the predella was painted on all four sides. He proposes that single scenes on the short ends began and ended the Ministry of Christ on the back face. On the basis of the measurements of the existing panels from the back predella and the projected length of the front, he calculates nine scenes on the back which, with the additional scenes on the sides, would make a total of eleven dealing with Christ's teaching mission. Such a number would be consistent with the closely followed narrative of the Passion scenes.

He posits three missing scenes at the beginning of the cycle: the *Baptist Bearing Witness* on the left short end, followed on the back face by the *Baptism* and the *Temptation in the Wilderness*. Then in sequence thereafter: the *Temptation in the Temple* and the *Wedding at Cana* (Opera del Duomo, Siena); the *Temptation on the Mountain* (The Frick Collection, New York); the *Calling of Peter and Andrew* (National Gallery of Art, Washington, D.C.); *Christ and the Woman of Samaria* (Thyssen-Bornemisza Collection, Lugano), and the *Healing of the Man Born Blind* and the *Transfiguration* (The National Gallery, London). *The Raising of Lazarus* (Kimbell Art Museum, Fort Worth) was on the short right end.

Christ and the Woman of Samaria and a number of other panels were at some point separated from the rest of the altarpiece and began to appear in private hands shortly after the transfer of the Maestà to the Opera del Duomo in 1878. In 1879, the Thyssen panel along with three others from the back predella were lent to an exhibition in Colle di Val d'Elsa by the brothers Giuseppe and Marziale Dini. They were then acquired by Charles Fairfax Murray, who sold them to Robert Benson of London. They were bought by Lord Duveen in 1927 and in turn sold to Clarence MacKay of Roslyn, New York. *Christ and the Woman of Samaria* and the *Raising of Lazarus* then entered the collection of John D. Rockefeller II, and the former was briefly in the Nelson Rockefeller Collection before it was acquired by Baron Thyssen in 1971.

Duccio originally contracted to paint the Maestà with his own hand but certainly

workshop assistance would have been customary, especially if the altarpiece – an extremely ambitious undertaking – was to be completed in such a short period of time. The participation of assistants, of different hands in the execution of the altarpiece, has long been recognized, but recently J. H. Stubblebine ("Duccio and his Collaborators on the Cathedral Maestà," *Art Bulletin*, 55, 1973, pp. 185–204) has made the more radical proposal that assistants were not only responsible for the manual execution of the majority of the scenes but also played a considerable role in their conception. He divides the Maestà into workloads, groups of scenes, which he identifies with eight different artists other than Duccio, among them Simone Martini and Ambrogio and Pietro Lorenzetti, the leading Sienese masters of the next generation; and he gives the design and execution of only the main front panel and the front predella to Duccio himself. He ascribes the back predella to Pietro Lorenzetti on the basis of some of the architectural settings which he believes already demonstrate Pietro's interest in the articulation of deep space – a conception of space, according to Stubblebine, fundamentally different from Duccio's. Stubblebine's observations of the stylistic differences and several modes in the Maestà are valid and add significantly to our understanding and appreciation of the complexities of the work as a whole. But the degree to which these subtle differences reflect the initiative and independence of assistants, and the extent to which they constitute the basis for specific attributions, raises many historical and practical questions and remains controversial. Whatever latitude Duccio may have allowed his assistants, the encompassing genius of the master throughout the Maestà is undeniable.

The inscription on the footstool of the Madonna on the front of the altarpiece reads: *MATER SCA DEI SIS CAUSA SENIS REQUIEI SIS DUCIO VITA TE QUIA PINXIT ITA* ("Holy Mother of God, be the cause of peace to Siena of life to Duccio because he has painted thee thus").

GIOVANNI DI PAOLO
Active 1420, d. Siena 1482

10. SAINT CATHERINE BEFORE
POPE GREGORY XI AT AVIGNON

Poplar, 28.5×28.5 cm.

Provenance: Ramboux Collection, Cologne, 1862; Stoclet Collection, Brussels; acquired 1966.

Literature: 1969 Catalogue, no. 107; H. W. Van Os, "Giovanni di Paolo's Pizzicaiuolo Altarpiece," *Art Bulletin*, 53, 1971, pp. 289, 292, fig. 9.

St. Catherine of Siena was born in 1347 and canonized in 1461. In 1376 she was sent to the Papal Court in Avignon to make peace between the Republic of Florence and Pope Gregory XI. If her immediate mission was not successful she convinced Gregory, who was impressed and charmed by her, to return to Italy and restore the Holy See to Rome. The Thyssen panel shows St. Catherine before the Pope and the Curia in Avignon. The saint is shown with a gold halo and wearing the black and white robes of the Dominican Tertiaries; she and her companion appear diminutive, surrounded by the imposing and intimidating figures of the cardinals and secretaries. The two behind her look especially displeased and stern but Gregory, already warmed to the argument and sweet discourse of the undaunted little saint, looks on admiringly and blesses her.

The story is told with childlike conviction and emphasis. The chamber, seen through a painted architectural framework, is extravagantly rich: the imagined luxury of the Avignon court. The ceiling is decorated with but one row of blue coffers, painted with the heads of putti surrounded by foliage, and supported by two elaborately scrolled gold and white beams or consoles. The back wall is hung with a gold brocade cloth, the lines of the folds scored into the surface. Gregory's throne is draped in black and gold cloth, sumptuous in combination with the fine punched and gilded decoration on his robes. An oriental carpet in yellow, rose, and green with white characters covers the dais. The delicate rose color in the rug is repeated in the robe of the first secretary, but those of the cardinals and his colleague provide robust notes of orange-red and blue.

The robes of the two women are softly modeled in fine folds, but those of the cardinals and secretaries are painted with great sweeping, sharp-edged folds consistent, as are their massive forms, with their characterization; Gregory's robes are less aggressively drawn, in keeping with his more sympathetic role. The heads are strongly structured and expressive; especially fine are those of the two secretaries and the Pope.

The composition suggests a monumentality which probably would not be successfully sustained beyond the small scale of the panel. The sensibility of the miniaturist prevails but the vigor of the draughtsmanship and the force of the design is quite exceptional for the artist, who favors a more delicately decorative style, and distinguishes the panel within the series of which it is a part.

The Thyssen picture is one of ten with scenes from the life of St. Catherine. Eight others are in private and public collections in the United States and the whereabouts of the last in the series, the *Death of St. Catherine*, is unknown. They are from the altarpiece which the guild of the Pizzicaiuoli commissioned from Giovanni di Paolo for the altar of the Purification of Santa Maria della Scala, a church attached to the hospital in Siena. The artist was occupied with the commission from 1447 to 1449. By the eighteenth century the altarpiece was dismembered: the main panel, a *Presentation in the Temple*, is in the Pinacoteca in Siena, and other panels convincingly associated with the altarpiece are a *Crucifixion* (Archiepiscopal Museum, Utrecht) and four small panels of single standing saints, two again in Utrecht and two in New York (The Metropolitan Museum, Robert Lehman Collection). The four last are attributed to Pellegrino di Mariano, a follower of Giovanni di Paolo, but all other panels are given to the master. The description here follows the most recently proposed reconstruction of the altarpiece by H. W. van Os, *op. cit.*, who also gives an excellent summary of earlier scholarly contributions and opinions regarding the altarpiece. Van Os's reconstruction differs from previous attempts by the inclusion of a hypothetical panel with the figure of a single standing saint to either side of the Presentation, with Saint Catherine in the place of honor to the

viewer's left. These panels would have been narrower than that of the central image but similar in height, the figures larger in scale. Such an arrangement follows a tradition of fourteenth-century altarpieces in Siena, which was conservatively followed in the fifteenth and survives in Giovanni di Paolo's altarpiece in the Museum in Cherbourg, with its two standing male saints flanking a Nativity in the center. Van Os's interpretation of the documents is also convincing in support of such panels in the Pizzicaiuoli altarpiece.

The altarpiece would have been framed at the sides by pilasters decorated with small panels of single saints, three to each pilaster, of which only the four in Utrecht and New York survive. The width of the altarpiece, including the two proposed panels, would allow for a predella wide enough to accommodate the ten panels from the Catherine series with the *Crucifixion* in Utrecht in the center. *St. Catherine before the Pope* would have been ninth in the sequence, preceded by *St. Catherine Dictating her Dialogues* (Detroit Institute of Arts) and followed by the last panel in the predella, the missing *Death of St. Catherine* (see H. B. J. Maginnis, Letter to the Editor, *Art Bulletin*, December 1975, LVII, no. 4, p. 608, which clarifies the confusion between the original *Death of St. Catherine*, ex-Stocklet Collection, Brussels, and a later copy, ex-Minneapolis Institute of Arts, and resolves a weak detail in Van Os's reconstruction). The other panels are in order from the left: *St. Catherine Invested with the Dominican Habit, a Girdle and Lilies by SS. Dominic, Augustine and Francis* (The Cleveland Museum of Art); *Mystic Marriage of St. Catherine* (New York, Mrs. R. Heinemann Collection); *St. Catherine Giving Her Mantle to a Beggar* (The Cleveland Museum of Art); *St. Catherine Exchanging Her Heart with Christ* (New York, Mrs. R. Heinemann Collection); *St. Catherine Receiving the Stigmata* and *St. Catherine's Prayer and Christ Resuscitating Her Mother* (New York, The Metropolitan Museum of Art, Robert Lehman Collection), *Miraculous Communion of St. Catherine* (New York, The Metropolitan Museum of Art, Michael Friedsam Collection); and *St. Catherine Dictating Her Dialogues* (Detroit Institute of Arts).

GIOVANNI ANTONIO GUARDI
Vienna 1699 – Venice 1760

11. SCENE IN A GARDEN OF A SERAGLIO

12. SCENE IN A HAREM

Canvas, each 46.5×64 cm.

Provenance: Knoedler, New York; acquired 1956.

Literature: 1969 Catalogue, no. 122; R. Pallucchini, "Note alla mostra dei Guardi," *Arte Veneta*, 19, 1965, p. 223, fig. 281; J. Cailleux, "Les Guardi et Pietro Longhi," *Problemi Guardeschi, Atti del Convegno di Studi Prommosso dalla Mostra dei Guardi, Venice, September, 1965*, Venice, 1967, p. 53, fig. 78; D. Mahon, "The Brothers at the Mostra dei Guardi: Some Impressions of a Neophyte," *Problemi Guardeschi*, Venice, 1967, pp. 79, 108, 145, Fig. 78; T. Pignatti, "Linguistica e Linguaggio dei Fratelli Guardi," *Problemi Guardeschi*, Venice, 1967, p. 177, fig. 78; T. Pignatti, *Disegni dei Guardi*, Florence, 1967, p. 8; A. Morassi, *Antonio e Francesco Guardi*, Venice, 1973, vol. 1, pp. 61–62, 114, 120, 169–72, 327, nos. 101 and 102, pl. XXVII; vol. 2, figs. 121, 122; A. Morassi, "Four Newly Discovered Turkish Scenes," *Apollo*, 99, 1974, p. 274; A. Morassi, *Guardi: Tutti I Disegni*, Venice, 1975.

Turqueries, like *chinoiseries*, were fanciful evocations of exotic cultures reflected in dress, furniture and interiors, extremely fashionable in eighteenth-century Europe. They were especially popular in France, where the vogue for things Turkish was stimulated by the arrival in Paris of embassies from Persia in 1714 and from the Sublime Porte in 1721, as well as by the early eighteenth-century translations of the *Thousand and One Nights*. (Sir Francis J. B. Watson, "A Series of 'Turqueries' by Francesco Guardi," *The Baltimore Museum of Art News*, XXIV, no. 1, Fall 1960, pp. 3–13). There was less interest in such subjects in Italy and it was in fact a foreigner, the Field Marshall Johann Matthias von der Schulenburg, who commissioned a large number of "Quadri Turchi" from Gianantonio Guardi. (A. Morassi, "I Guardi nei Servigli del Feldmaresciallo von der Schulenburg," *Emporium*, CXXXI, 1960, p. 204). This is not without some irony, as Watson points out, since von der Schulenburg, general of the Venetian forces, was the great enemy of the Turks and the hero of the defense of Corfu. Between 1742 and 1743 the Guardi workshop produced forty-three Turkish scenes for the Field Marshall. They actually were all recorded in a particular room of his

residence in Verona, perhaps decorated *à la mode turque*. After his death in 1745 the pictures were sent to Germany and only slightly less than half have been recovered. It is reasonably assumed that the Thyssen *turqueries* were a part of the series painted for von der Schulenburg.

Francis Watson has identified a series of engravings after paintings by Giovanni Battista van Mour, after 1725 court painter at Constantinople, as the source for compositional and exotic motifs in several of the Guardi Turkish scenes: *Recueil de cent estampes représentant différentes nations du Levant tirées sur les Tableaux peints d'après Nature en 1707 et 1708 par ordre de M. de Ferriol Ambassador du Roi à la porte et gravées en 1712 et 1713 par les soins de M. le Hay*. The publication, which appeared in 1714, was extremely important in the early eighteenth century in disseminating a knowledge of Turkish and Levantine life and customs. *Scene in a Harem* (or *Greek Favorite in the Harem*) depends on the engraving by G. Scotin, *Novi ou Fille Grecque dans la cérémonie du Mariage*, for the general arrangement of the interior, the dais backed with cushions and the barred windows, as well as the seated figure of the young girl. She appears to be toying with her jeweled belt buckle, perhaps a recent gift, a gesture adapted from the engraving, where the young woman seems more seriously intent and may be engaged in some action of the marriage ceremony. The woman standing nearest to her, holding a package, is taken from another engraving in the series by F. Simmoneu, fils, which shows a Jewish merchant-woman who brings her wares to the young Turkish girls restricted to the harem. The Guardi composition is then a rather imaginative pastiche of elements thematically interwoven from different plates of the *Recueil*. The engravings – vertical in format, with usually only one or two figures, and somewhat prosaic in character – were freely adapted and greatly embellished, in part because of the extended horizontal format of the paintings, but also to create a more magical and story-like effect. In the Thyssen harem scene the great hanging is drawn to the side to reveal the prettiest of gilded cages. The bare walls in the engraving are here covered with blue-patterned tiles, and the stone window frames are painted with swags of

flowers like eighteenth-century Venetian furniture. The floor is rather capriciously pitched forward to give the fullest effect of the design of the pavement. The only furnishing is a small table with a long-stemmed pipe propped against it; a basket with flowers is placed at the angle of the dais. The fur-lined robe and veiled, disc-like hat of the Favorite are again drawn from the engraving but here changed so as to give a greater sense of luxury. The colors, predominantly shades of rose, silvery blues and white with touches of green, are perfectly attuned to the fragile spell cast by this enchanting little scene.

There is a preparatory drawing for the composition, black chalk on blue paper, in the Accademia Carrara, Bergamo (inv. 1014), the *verso* of a sheet which has the half figure of an angel, also in black chalk, on the *recto* (Morassi, 1975, no. 55).

The tempo is greatly accelerated in the *Scene in the Garden of the Seraglio*. The lyric *adagio* of the ḫarem scene has broken into an infectious *prestissimo*. The three fountains which set the stage are the most extravagant and ethereal of confections, like great sugar table ornaments which risk dissolving in the jets of water. The two to the side, gleaming white, pretend to some architectural design if not substance, but the fountain in the center is the most marvelous bit of excess, all rocailles and latticework and gold statuary. So deftly and lightly is it painted that the more elaborate upper part seems to float over the substructure which is suggested in shadow by just a few touches of the brush over the ground color. The sultan is placed directly in front of this fountain, reclining on a cushion and smoking a long pipe. A richly dressed young woman, rather archly posed, approaches from the left. A turbaned blackamoor and another dark-skinned attendant holding steaming dishes flank these principal figures. An important looking man, perhaps a vizier, wearing a plumed turban and holding a pipe, reclines on the rim of the basin of the fountain to the right. A huddled group of onlookers to the left, a page with a dog in the foreground, and another, busying himself with flowers, are all arranged in a loosely linked circular procession. The little tableau suggests what must have been the effect of an eighteenth-century *surtout de table*, those elaborate ensembles of porcelain (or perhaps of glass in Venice) used to decorate the dining table, comprised of a large centerpiece and thematically related figurines set amidst the dinner service. Unlike *Scene in a Harem*, no motif has been identified from the *Recueil* for the *Scene in the Garden of a Seraglio*. The fountains are purely European inventions, rather French in feeling, and Watson cites a description from a catalogue of the Salon of 1740 of a painting by la Joue which recalls the composition of the Thyssen picture. The picture by la Joue is lost and does not seem to have been engraved, and the likelihood of the Guardi having seen the painting is highly improbable. If there is some connection it is possibly through a common engraving, or literary or dramatic source. In the case of the last two, von der Schulenburg himself might have made some suggestions. Morassi (1973, p. 121) has remarked on the stage-like effect of the garden scene, and possibly a reading of the *Thousand and One Nights* would reveal the inspiration for many of the Turkish scenes which seem so explicit in their narrative.

Both pictures are of superb quality and breathtaking virtuosity and despite their unity of effect present somewhat different approaches in handling. The passages of paint in the harem scene are more continuous and fluid, and the surfaces more cohesive; such linear details as the borders on the cushions and the patterns on the tiles are finely and precisely drawn. The garden scene is painted in a restless, calligraphic style, with short staccato touches and fast, sometimes ragged swipes of the brush; the colors are accordingly less stable and shot with surprising accents. The small tables in the two compositions provide telling details: the one in the harem sits soundly on the dais, defined by clearly lighted, squared planes and the edges by long, sure strokes of the brush; the other, placed before the sultan, is rather wobbly, as if quickly jotted down, and beaded with small touches of color. Such distinctions pertain throughout the two pictures: the surface in the harem scene is more shimmering in effect; in the garden, rather more scintillating. The figures in the former are more integrally and substantially conceived and the group of three women may even claim, diminutive as they are, a certain monumentality. Those in

the latter are rather kinetically structured, their contours are angular and bristling with spiky attenuations; their poses are mannered and agitated, while in the harem the figures are more subdued and contained. The differences between the two pictures might of course be explained in part by the spirit of the subjects or the sources for the compositions. The composition, setting and figures in the harem scene are largely determined by the somewhat dry engravings after van Mour, and there is a greater structural clarity inherent in the architectural setting, the pitched floor notwithstanding. The more exuberant execution of the garden scene may also reflect the degree to which it might have been more freely imagined or invented. However, within the special province of Guardi studies and connoisseurship, such stylistic distinctions as have been drawn here may constitute for some scholars the basis for attributions to either Gianantonio Guardi or his younger brother, Francesco; the descriptive language is often confusingly interchangeable.

It is only through comparatively recent scholarship that the artistic personality of Antonio has emerged, so long overshadowed by the *vedute,* the celebrated views of Venice painted by Francesco after his brother's death in 1760. It is now clear that Antonio was principally responsible for the history or figure paintings which issued from the Guardi workshop, but it is often difficult to determine the extent to which the brothers collaborated on these works, the range of Antonio's style and the individual figure style of Francesco.

The attribution of the various Turkish scenes remains one of the most vexing and perhaps irresolvable of the *"problemi Guardeschi."* As the eldest brother and head of the workshop, it was Antonio who contracted with von der Schulenburg for the pictures, but it is clear from those known today that one hand was not responsible for the whole series. The Guardi workshop held a very modest place in the artistic hierarchy of eighteenth-century Venice and though Antonio had painted a portrait of the Field Marshall (he seemed to be in steady need of portraits of himself) and received a monthly retainer from him, the Guardi were mostly employed by him in making copies of works by earlier and con-

temporary masters. They were not highly paid for the Turkish series (Morassi, 1973, p. 114), which must have constituted something of a wholesale production and probably involved more hands than those of just Antonio and Francesco. The autograph value of individual pictures was probably not of great issue to either the artists or the patron but rather a general uniformity of style, especially if they were intended as a decorative ensemble, which would seem to be the case. The reader is referred to the general discussion of the *"Quadri Turchi"* and the separate catalogue entries in Morassi for some idea of the controversial attributions of these embattled little pictures. Morassi himself has been thoughtfully wrestling with the problem for many years, and his personal dilemma results in discrepancies between his opinions expressed in the text and the identification of one or the other brother accompanying the reproductions. He attributes the two Thyssen pictures to Gianantonio, although in his discussion of the preparatory drawing for the harem scene in Bergamo, which he gives to Antonio, he leaves the possibility of the execution of the painting open to Francesco. Others believe that both are by Francesco or that the garden rather than the harem scene is by Francesco. Given the nature of the beast it would seem foolhardy and gratuitous for the present writer to offer yet another and less informed opinion. However, the present designation of Gianantonio as the author of both Thyssen compositions simply represents the verdict based on the most recent count of votes.

Morassi (1973, p. 327) cites a replica of *Scene in a Harem,* attributed to Francesco, ex-collection Fauchier-Magnan, sold in Paris, June 1968, now in a private collection in Venice.

PIETRO LONGHI
Venice 1702–1785

13. IL SOLLETICO

Oil on canvas, 61×48 cm.

Provenance: Unknown; acquired 1971.

Literature: A. Rava, *Pietro Longhi,* Florence, 1973, ill. p. 78; V. Moscini, *Pietro Longhi,* Milan, 1956, p. 20; T. Pignatti, *Pietro Longhi. Paintings and Drawings,*

complete Edition, London, 1969, p.106, fig.53
(engraving repr.); N. Schwartz, "Norton Simon Collection and Old Masters for Sale at Parke-Bernet," *Arts*, 45, May 1971, p.8, illus.; T. Pignatti, "Aggiunte per Pietro Longhi," *Arte Illustrata*, 5, 1972, p.3; fig.5, p.29; *Connoisseur*, 179, Feb. 1972, illus. p.143; T. Pignatti, *L'opera completa di Pietro Longhi*, Milan, 1974, p.93, no.91; E. W. Palm, "Ein Grazien-Gleichnis, Goyas Familie Karls IV.," *Pantheon*, 34, 1976, p.39, illus.

Longhi's considerable success during his lifetime and the affectionate reputation he enjoys today rest on his small canvases which delightfully inventory the incidental life and small pleasures of eighteenth-century Venice. His studies with the Bolognese painter, G. M. Crespi, seem to have decided him on a career as a genre painter, although there is the occasional portrait or religious subject, as well as a foray or two into monumental history painting. Early works, peasant scenes, show the influence of Crespi's *tenebroso* style but already indicate a lighter sensibility and a more discreet and fastidious realism. He must certainly have been influenced by French and English genre painting, such as the works of de Troy and Lancret and the conversation pieces of Hogarth, undoubtedly known from engravings (the French engraver Flipart was associated with Longhi in Venice), though he lacks the flourish of these masters. His restrained, often rather bare little scenes recall the pictures – especially the interiors – of the English painter Devis, though very different in intention and spirit. While Longhi's rounds of Venice introduce us to the broad, colorful spectrum of society, surprisingly little of that celebrated city is revealed en route. Rather, we are invited into small corners, whether on the street or in the interiors he favors. There are glimpses of the gambling casino, servants' quarters, boudoirs and sitting rooms, sideshows, and even an alchemist's den; there is a stop at a milliner's in order to approach one of the pretty young things who work there on behalf of a nobleman or rich foreigner. There are also visits to church, and these are treated as simply another fashionable stop on this charmingly mindless itinerary.

Il Solletico ("The Tickle") is presented in the most familiar of Longhi's settings, a patrician apartment. The high-ceilinged room with damask-covered walls is sparsely furnished with a settee and two chairs; the window is heavily draped with a porcelain garniture atop the valence. The wall is hung with an etched mirror in an elaborately carved frame and a painting, in the style of Amigoni, of three voluptuous nude women, perhaps the Graces, and the antithesis of Longhi's doll-like creatures. There is a basket of fruit on the floor and the young man has placed his *canzoniere* or *gazzettino* on a chair before dozing off; sufficient touches to create an air of indolence and set the stage for mischief. Enter the soubrette and her accomplices. She has thrown her shawl and fan on the settee and raises her finger to her lips to caution us to be silent. The servant girl behind her, bursting with excitement, caresses the pretty little practical joker while the other watches intently for the first start of the sweetly dreaming young man. The goddesses in the painting within the painting perhaps inspire his dreams and his sprawl and deshabille lend a delicious erotic edge to the game. Such is life on the *mezzanino* in the eighteenth-century Venice of Longhi's little tableau.

Everything is softly defined; there are no sharp contrasts in light or color and only the principal figures, dressed in shades of pale yellow and green, are gently spotlighted within the darker surround. The visually limited range of values creates a somewhat close and langorous atmosphere. *Il Solletico* is like an intermezzo or *divertimento* that would be given between the acts of a more serious drama or opera. And Longhi's settings have something of stage scenery about them, like painted backdrops with just enough props – often rather insubstantial – to set the scene. His figures are usually posed as if addressing or at least presented to an audience. Certainly the theatricality and elaborate etiquette of Venetian life might have suggested such a self-conscious presentation, but it is possible that Longhi's pictures reflect a more intentional and direct sympathy with the theater. Goldoni himself wrote: "O Longhi, you who call my comic muse the sister to your brush" and hailed the painter "as a man who is looking for the truth." It seems that Goldoni, intent on breaking with the old stylized masked comedies and reforming the theater with a greater naturalism, saw Longhi, give or take a little rhetorical flattery, as sharing his goals and his counterpart in painting. It is possible that Longhi's genre scenes actually antici-

pated the playwright in this respect, although the painter's genial barbs at the vapidity of the society he recorded are hardly comparable to the penetrating bite of Goldoni's characterizations. (F. Haskell, *Patrons and Painters*, New York, 1963, p. 323). Longhi was also highly thought of in the more advanced and enlightened intellectual circles of Venice, and it is only within the general polemics of the time and politically reactionary climate of Venice that one can understand how the artist's matter-of-fact realism and mild, even affectionate indictments might be considered to be in the vanguard. On the other hand, his descriptive and anecdotal pictures were happily collected by conservative patrician families who were able to recognize themselves, their deadly ennui, petty intrigues and byzantine code of manners, with little cause for concern or self-reflection. Longhi never cuts too deep and some of the sting might be removed by the painter's charming ineptitudes, his rather woolly perspective, slightly unsteady settings, and puppetlike figures. He was a stronger draughtsman than painter, and was master of the life-drawing classes in the newly founded Academy of Fine Arts in Venice. Hence one wonders if some of the awkward aspects of his painting style were a disarming and wiley affectation.

There is a drawing, a sheet of preparatory studies, for *Il Solletico* in the Museo Correr, Venice (no. 448, Pignatti, 1969, plate 55) which includes a drapery study for the figure leaning on the chair, a study for the head of the principal young woman and others of hands. The study of a hand touching that of a child is for another composition. Pignatti (1974) dates the painting around 1755 and places it close in style to the *Family Group* in the Palazzo Querini Stampalia and the one in the Ca'Rezzonico, Venice. His initial impression (1969), based on an engraving before the picture came to light in 1971, was that it was earlier than 1749, and he observed that the painting of the Three Graces in the Thyssen picture appears again in *Milord's Visit* in the Metropolitan Museum of Art, New York. The latter is closely related to another composition in the Metropolitan, *The Visit*, which is inscribed: *Petrus Longhi 1746*. There is a later version of *Il Solletico* in the Rubin de Cervin Collection, Venice (Pignatti, 1969, pl. 214).

PALMA VECCHIO (JACOPO NEGRETTI)
Serina (Bergamo) c. 1480 – Venice 1528

14. PORTRAIT OF A WOMAN, "LA BELLA"

Canvas, 95×80 cm.
Inscribed on parapet: AM.B/ ND

Provenance: Archduke Leopold Wilhelm, Governor of the Netherlands; Sciarra Colonna, Rome; Baron Edouard de Rothschild, Paris; acquired 1959.

Literature: 1969 Catalogue, no. 244; G. Mariacher, *Palma il Vecchio*, Milan, 1968, pp. 19, 74–75, no. 51, pl. 51.

"La Bella" is perhaps the finest, and certainly the most splendid, of Palma's representations of those half-length female figures for which he enjoyed a special fame. Presented as a Vanitas with her box of precious trinkets, she is more emphatically a celebration of sensuous beauty, and as is the case with so many gorgeous Dutch seventeenth-century still lifes, one begins to doubt the moralizing intention. Her glance seems to take the measure of her effect and she caresses her hair as if to insure this. As a type she derives from Titian's allegorical beauties, who, however sensuous their appeal, are never so frank in their invitation and are held at a more poetically elusive remove. When *"La Bella"* was in the Sciarra Collection in Rome it was ascribed to Titian, largely due to the resemblance between the sitter and the figure of "Beauty Adorned" in his *Sacred and Profane Love* in the Borghese Gallery, Rome. The same model may also appear in Palma's *Woman in a Blue Dress* in the Kunsthistorisches Museum, Vienna; but even if there is a common model in these works, perhaps one of the famous courtesans of Venice, the choice and the persistence of type simply reflects a contemporary canon of beauty and a local taste. Her skin is milk-white and luminous and her fine, abundant hair a deep gold. The décolleté of her gown reveals the voluptuous line of her shoulder, and her hands are long and softly plump. The sumptuous gown amplifies the Beauty's aura of physical luxury; yards of billowing red, white and blue taffeta are heaped over her shoulders and arms and spill over the parapet. The slashed and parti-colored sleeves are the extravagant masterpiece of a very expensive Venetian dressmaker; and they appear

again, at least the lower part, in Palma's *Woman in Blue* in Vienna. The fine, gathered white chemise is a brilliant foil to all this splendor and promises more intimacy than fanfare. The device of the stepped parapet again derives from Titian and has a long tradition in portraiture. The letters *AM.B / N D* have not been deciphered; they read *TAM.B / E N D* before the additional letters were removed when the picture was cleaned. The woman is enclosed behind by two walls meeting at an angle; the perpendicular wall is in ruins and is set with a marble relief of a horseman trampling a nude man. The relief may simply be a fashionable classical detail or, in the crumbling wall, an aspect of the Vanitas theme.

The painting was documented in the famous collection of the Archduke Leopold Wilhelm, Governor of the Southern Netherlands, in *Theatrum pictorium Davidis Teniers Antwerpiensis,* an edition of engravings based on Teniers' painted copies and published in Antwerp in 1658.

There are no signed or dated pictures by Palma Vecchio, but *"La Bella,"* to take a concensus of the dates proposed, must have been painted around 1520.

GIOVANNI BATTISTA PIAZZETTA
Venice 1683–1754

15. PORTRAIT OF GIULIA LAMA

Canvas, 69.5×55.5 cm.

Provenance: Eugen Miller von Aichholz, Vienna; Leo Planiscig, Florence; Clive Pascall, London; aquired 1967.

Literature: 1969 Catalogue, no.248; G. Fiocco, "Aggiunte di Francesco Maria Tassis alla guida di Venezia di A. M. Zanetti," *Revista mensile della città di Venezia,* VI, 1927, pp.165–166, fig.24; G. Fiocco, *La Pittura Veneziana del Seicento e Settecento,* Verona, 1929, p.52; G. Fiocco, "Il ritratto di Giulia Lama agli Uffizi," *Rivista d'Arte,* XI, 1933, nos.3–4, pp.399, 400, 411, fig.2; W. Arslan, "Studi sulla pittura del primo settecento veneziano," *La Critica d'Arte,* I, 1936, p.194, no.53; *Apollo,* 85, 1967, p.233; fig.2, p.234; *Connoisseur,* 164, 1967, illus. p.122; *Art at Auction, The Year at Sotheby's and Parke-Bernet,* 1966–67, New York, 1967, fig.14; R. Pallucchini, "Miscellanea piazzetesca," *Arte Veneta,* 22, 1968, pp.108–10; fig.151; M. Cionimi-Visani, *Dizionario Enciclopedico Bolaffi dei Pittori e degli Incisori Italiani,* Turin, 1975, vol.9, pp.17, 20.

Exhibitions: Venice, Palazzo Ducale, *Dal Ricci al Tiepolo,* 1969, pp.122, 132, no.56, illus. p.133.

While Giulia Lama is usually referred to as the favorite pupil of Piazzetta, there is, according to Leslie Jones (verbally), no documentary evidence of any professional association between the two artists. Her work is strongly influenced by Piazzetta, and his moving portrait of her would seem to indicate a sympathetic relationship between the two artists – especially in view of the fact that Piazzetta painted very few portraits. Giulia Lama's major works are the *Apostles Adoring the Crucifixion* (San Vitale, Venice), *A Martyr Saint in Glory* (Parrochiale, Malamocco), and the recovered *Madonna and Two Saints* in Santa Maria Formosa, Venice.

The artist appears here with palette and brush as if turned from her work, but there is no easel or unfinished canvas and her right hand is so posed, so crooked, as to prohibit convincing action. Palette and brushes are simply her attributes and, rather than an effect of spontaneity, she is cast in an attitude of poetic reverie and abandon. Piazzetta stresses the imaginative and inspirational powers of the artist rather than the act of painting itself. The stilled, pensive mood, though given a decidedly melancholy cast in the portrait, is common to figures in Piazzetta's subject pictures and the character heads in his marvelous black chalk drawings. Giulia Lama is to a great extent transformed into a Piazzettesque type, and though recognizable from her self-portrait in the Uffizi (no.670), the heavy mask of the face and the depth of characterization, almost tragic, is remarkable in contrast with Lama's own rather prosaic and somewhat mincing likeness in Florence. Her actual appearance must have fallen somewhere in between the two, but clearly her looks were not her strong point, as we learn from a letter written by the Abbot Antonio Conti to Madame de Caylus (1 March 1728) in the Biblioteca Marciana: "Il est vrai qu'elle a autant de laideur que d'esprit mais elle parle avec grace et finesse, ainsi qu'on lui pardonne aisement son visage. Elle travaille en dentelles...." (Pallucchini, *op. cit.,* p.128, n.10).

Piazzetta always favors a warm tonality and dramatic chiaroscuro, but the pervasive, hot reddish-brown tonality and the especially dense chiaroscuro in the portrait suggest a fairly early work by the artist, around 1720, and the strong influence of G. M. Crespi, with whom he studied in Bologna, is still clearly apparent. Piazzetta, however, consolidates light and shade into heavier, more firmly defined patterns with little interpenetration. The hair, worn the same as in the Uffizi self-portrait, is summarily treated and deliberately underplayed; the embroidery on the dark green robe is subdued to a deep, burnished gold. The line of the white collar and the thumb through the palette, the only details heightened in value, compositionally link the more intensely lighted face and hand. There are indications at the corners that the painting was designed as an oval and might have been cut down at one time. If so, this is a pity, as Giulia Lama's pose, the cast of her head and hand and the sweep of her sleeve would, it would seem, sit more effectively within an oval format. This speculation is encouraged by the information, again through the kindness of Leslie Jones, that Piazzetta's portrait drawings were engraved as ovals.

Though Piazzetta would develop a more fluid, richer style in the years immediately following the portrait of Giulia Lama, he remained throughout his career faithful to a still baroque mode of composition and handling, somewhat resistant to the strains of the rococo gathering about him. It would be the young Tiepolo, early in his career so strongly influenced by the *tenebroso* style of Piazzetta, who within the next decade would bring the rococo to such magnificent fruition in Venice.

TINTORETTO (JACOPO ROBUSTI)

Venice 1518–1594

16. PORTRAIT OF A VENETIAN SENATOR

Canvas, 118.5×100 cm.

Provenance: Corsini Collection, Florence; acquired 1967.

Literature: 1969 Catalogue, no. 306; P. Rossi, *Jacopo Tintoretto*, Venice, 1974, vol. 1, *I. Ritratti*, pp. 62, 111, illus. no. 148.

Unlike Titian, it is impossible to get the full measure of Tintoretto's genius from his portraits. Nor was Tintoretto as interested as Titian in giving so full a measure of his sitter. Perhaps only in the portraits of aged men, of which his self-portrait in the Louvre is among the noblest, does the artist seem truly engaged. But he was incapable of refusing a commission; the portraits must have cost him little in time and energy, and he and his workshop produced a great many. They are uneven in quality, rarely inventive or penetrating, but many are superbly painted. The Venetian magistrate or senator was his most frequent client; the Emperor, the Pope, princes, condottieri and doges went to Titian. The unidentified Venetian senator in the Thyssen portrait is dressed in his official robes of deep wine velvet lined with ermine, a brocaded stole over his right shoulder. He strikes a conventional but subdued rhetorical attitude, with his left hand extended and a handkerchief in his right. His bearing is distinguished; his expression reassuringly sober and thoughtful. The background is hung with a heavy swag of gold and crimson brocade, draped to frame the head. The face is broadly modeled, but the head resists the enveloping background only by the sheer density of the paint and the abrupt force of the highlights. A favorite device is the long swath of dark color in the shadowed side of the face which runs down from the inside of the eye and throws the lighted side of the nose into very strong relief. A fine brush is applied to highlight individual hairs in the beard. Tintoretto's reckless, and perhaps indifferent, facility is apparent throughout: in the fitful path of the light which skates over the right sleeve, in the run of the brush down the front of the robe, in the slurred fur lining and the flat, broadly blocked pattern on the stole. The greater care taken with the modeling of the richly lighted drapery in the background might be a perverse touch by the artist, or might betray the hand of an assistant. According to Heinemann (1969 Catalogue), "some authorities" believe the work to be by Tintoretto's daughter Marietta, but the brilliant slapdash manner would seem to recommend the father. Because of the breadth of

execution – never a dependable criterion in dating Tintoretto's portraits – the painting is considered a late work. Heinemann dates the picture about 1575 but Rossi somewhat earlier, about 1570, on the basis of a *Portrait of a Venetian Senator* in the Musée des Beaux-Arts, Lille.

TITIAN (TIZIANO VECELLIO)
Pieve di Cadore (Dolomites) c. 1488/90–1576 Venice

17. PORTRAIT OF DOGE FRANCESCO VENIER

Canvas, 113×99 cm.

Provenance: Prince Trivulzio, Milan; acquired before 1930.

Literature: 1969 Catalogue, no. 309; A. da Mosto, *I Dogi di Venezia*, Milan, 1960, p. 262; A. Morassi, *Encyclopedia of World Art*, London, 1967, vol. 14, col. 146; R. Pallucchini, *Tiziano*, Florence, 1969, vol. 1, pp. 136, 159, 303, 341; illus. vol. 1, XLIV; vol. 2, pp. 400, 401; F. Valcanover, *L'opera completa di Tiziano*, Milan, 1969, no. 381; H. Wethey, *The Paintings of Titian*, vol. 2: *The Portraits*, London, 1971, pp. 46, 148; illus. nos. 184–186; P. Rossi, *Jacopo Tintoretto*, vol. 1, *I Ritratti*, Venice, 1974, p. 47, no. 3.

Francesco Venier was born in 1489 and elected Doge of the Venetian Republic 11 June 1554. He was Ambassador of the Republic to the Holy See during the reign of Pope Paul III who, impressed with Venier, foresaw his election and jokingly referred to him as *piccolo doge* or "little doge" (A. da Mosto, *op. cit.*, p. 260). He was a physically fragile man, often in poor health, and in his later years he could not walk without the help of two men. A contemporary remarked that "while he was not able to physically support himself, he was that much more able to raise himself to high things with his intellect" (*ibid.*, p. 259). He seems to have been a responsible and able governor, and Venice was completely at peace during his short reign (he died 2 June 1556). Unfortunately, there was a famine during his dogeship, and while the populace had been joyful at his nomination, they blamed him for their hardships and rejoiced at his death. He seems to have had a sharp tongue; certainly he did not please the crowd by declaring that the situation was really not so serious, since the merchants' wives still had their wedding rings (*ibid.*, p. 260f.). He was also a very frugal man.

As Painter to the Republic, Titian received the commission for the official portrait of Venier which was to be added to the series of dogal portraits forming a frieze under the ceiling of the Sala del Gran Consiglio in the Ducal Palace. The Thyssen painting was probably the model for the final portrait, which would have been of larger size and plain background. Titian received payment for the latter in March 1555. In 1557 the frieze of portraits was destroyed by fire and Jacopo Tintoretto was commissioned to replace them. This must have been a workshop enterprise under the supervision of Jacopo's son Domenico, and the Thyssen portrait might again have served as a model for the one which presently hangs in the Hall identified with the Doge's name. One wonders if the Thyssen portrait would have passed to Venier or remained in Titian's studio. Venier had also commissioned two large votive pictures from Titian, one commemorating his immediate predecessor, Marcantonio Trevisan, as was customary, and the other, Andrea Grimani, who was doge earlier in the century. The former was destroyed in the great fire and the latter, finished by assistants, was installed only after the fire and after the deaths of both Titian and Venier. It now hangs in the Sala delle Quattro Porte.

Venier is also represented in a picture by Palma Giovane which hangs in the Sala del Senato and which shows the doge presenting to the Republic the cities of Brescia, Udine, Padua and Verona, where he was governor. Francesco also commissioned the bronze wellhead which bears his arms in the Cortile of the Ducal Palace, but the most splendid monument associated with his name is his tomb, designed by Jacopo Sansovino with sculptures by Alessandro Vittoria, and located in the Church of San Salvatore in Venice directly next to Titian's late *Annunciation*.

Given the state of his health, Venier was unlikely to have posed for long, if at all, standing in his state robes, heavy with gold brocade, fur and large gold filigree buttons. Venier was the last of the doges Titian was to paint, and if he did not know how to paint the dogal robes by heart they would have been placed on an armature in the studio and the portrait so completed after the necessary studies from life for the head. He does, how-

ever, account for the slight physique of the man by the slack folds of the belted robe. Venier's face is drawn and there is a raised artery clearly pronounced on his temple; his color is high and the tip of his nose red with broken capillaries. But although he appears physically debilitated the expression in his eyes is alert, shrewdly appraising and consistent with the description of an anonymous chronicler: "of the greatest intelligence, cultivated, learned, and of subtle invention and full of guile" (da Mosto, p. 260).

Titian's portrait is remarkably simple in its means, with the axis of the figure centered in the near square format of the canvas and Venier, in three-quarter view, both in length and pose, set directly against a background wall hung with a drapery to the right and a window with a seascape to the left. The head of the doge is set off most effectively against the dark ground between the drapery and window.

The use of color is as uncontrived but as knowing and effective as is the composition. The rich range of tones in the gold robe are accented in a crimson which is repeated in a deeper hue in the drapery, and the saturation of these deep, warm colors is balanced by the sudden clear, cool blue in the sky. The sail of the boat is a play on the shape and color of the *rensa*, the untied white cap which Venier wears under his heavily embroidered *corno*. The illusion of reality and the depth of penetration is startling; we have before us, to quote Hendy (*Some Italian Renaissance Pictures in the Thyssen-Bornemisza Collection*, Lugano, 1964, p. 113), "the whole man, a life history," but it is perhaps the more telling tribute to the artist that we accept the truth of the portrait so readily.

As in the psychological characterization of the man, we are immediately convinced of the actuality of the various materials and textures; yet at the same time we are constantly reminded of the means by which this illusion is created, of the surface of the paint, heavily impasted and thinly glazed, and of the touch and sweep of the brush. But the emphasis of the actual paint and handling, while an undeniable part of the sensuous experience of the work, is perhaps something of an anachronism here, exaggerated by more recent his-

torical enthusiasms. The sense of the paint and the traces of execution never detach themselves from the illusionistic fabric of the painting. The painting is in a marvelous state with the glazes intact, too often not the case in Titian, and the face, in which all the artist's skill and intelligence is so intensely concentrated, is such a remarkable counterfeit of nature, conceived so wholly as light, that it defies such tactile analysis and one simply wonders at how it was painted. And these are the qualities which his contemporaries so highly prized: "Titian is Nature's companion – his every figure is alive and moving, and its flesh trembles... he has demonstrated Nature's softness and tenderness: and in his works the lights and darks always counterpoint and play one against the other; they fade and die away in exactly the way Nature herself arranges it." (L. Dolce, *Dialogo della Pittura*, 1557, translation, Alistair Smith, "Titian's Portraiture," *The Connoisseur*, 192, August 1976, p. 257)

The window with the view is exceptional in Titian's dogal portraits and it would be curious if the burning building did not refer to a specific incident important to Venier. P. Hendy (*op. cit.*, p. 113) suggests that, although Venice was not at war during his tenure as Doge, Venier raises his right hand admonishingly to a burning fortress on the lagoon, as a reminder of Venice's struggle with the Turk. There are no warships on the water, but instead a small sailing boat, and it is possible that, given the grave issue of famine prices during Venier's dogeship, the burning building might be a granary or warehouse whose destruction resulted in the loss of some staple and thus aggravated the situation. If so, the vignette would be offered by way of an explanation of the unfortunate conditions.

NETHERLANDISH
AND FLEMISH

BURGUNDIAN MASTER
c. 1405–15

18. POSTHUMOUS PORTRAIT OF WENCESLAS
OF LUXEMBOURG,
DUKE OF BRABANT (1337–1383)

Panel, transferred to plywood, 34.4×25.4 cm.

Provenance: Possibly in the collection of the Duchess Margaret of Austria, heiress of the Dukes of Burgundy (inv. of 1516, 1524, 1530); Prince von Liechtenstein, Castle Siebenstein, Lower Austria (already recorded in 1800); Hammel Collection (1941); acquired 1956.

Literature: 1969 Catalogue, no. 101; C. Sterling (R. Heinemann, ed.), *Sammlung Thyssen-Bornemisza*, Lugano-Castagnola, 1971, no. 101, pp. 136, 137, pl. 297; M. Meiss and C. Eisler, "A New French Primitive," *Burlington Magazine*, 102, 1960, p. 234; M. Laclotte, "Peinture en Bourgogne au XVe siècle," in *Art de France*, vol. I, Paris, 1961, p. 287; G. Troescher, *Burgundische Malerei*, Berlin, 1966, pp. 25, 108, fig. 99.

Exhibitions: Vienna, Kunsthistorisches Museum, *Europäische Kunst um 1400*, 1962, p. 90, no. 17, fig. 5; Kaiserburg, Nürnberg, *Kaiser Karl IV., 1316–1378*, no. 39, p. 47f.

It was Charles Sterling who so brilliantly illuminated the fascinating historical circumstances surrounding this portrait (*Critica d'Arte*, Nov./Dec. 1959, pp. 289–312). Before the panel was transferred, an inscription on the back read: *Wenchaius dux Brabanciae in antiquitate 34 tum annorum*. The name, somewhat tortured, is that of Wenceslas, the younger brother of Charles IV, Emperor of Germany and King of Bohemia. Wenceslas was elevated by Charles to 1st Duke of Luxembourg in 1354, and in 1355 he became Duke of Brabant as well, when his wife Jeanne inherited that duchy. His combined domains were among the richest in Europe. A portrait recorded in the collection of Margaret of Austria may be identical with the one in the Thyssen Collection. The several inventories refer to a portrait of Wenceslas, Duke of Brabant, dressed in blue. The inventory of 1516, possibly done under Margaret's supervision, refers to "Ung autre tableul du chief (of the head) du Duc Bleu de Brabant." The "Blue Duke" is an allusion to the romance *Méliador* which Froissart composed for Wenceslas, a chivalric fantasy of the sort which had taken such vivid hold in the "wan-

ing middle ages" and to which Wenceslas seems to have been especially susceptible. The Duke was a patron of letters and Froissart spent sixteen years at his court. He was also something of a man of letters himself and contributed both ideas and lyric poems to the romance, in which the descriptions of the heroes were couched as flattering allusions to Wenceslas. The arms of Méliador were blue – "on l'appelle li chevalier Bleu armé au clair soleil d'or" – and these words are echoed in a later English tract on armory and blazon: "Blew doth represent the Sky in a clear Sun-Shining day... and signifyeth Piety and Sincerity." The Duke took blue as his special color and his duchess, who seems to have been an indulgent partner in these romantic fantasies, fitted out a room for him completely draped in blue cloth worked with gold thread.

The age given on the inscription, thirty-four, would date the portrait to 1371, but the vigorous realism of the painting precludes such a possibility and indicates a date in the fifteenth century. The representation of the sitter, head and shoulders in profile, occurs in portraits of the early fifteenth century and the style of the costume, specifically the chaperon with tails draped to the back rather than to the front, would date from around 1405 to 1415. The portrait is therefore posthumous and because of the upturned head and the cast of the eyes the likeness was probably taken from a representation of Wenceslas in which he appears in an attitude of prayer or adoration before a sacred image. The physical evidence of the painting, the extension of the preparatory ground on all four sides, indicates that the Thyssen picture is not a fragment of such a larger image but rather that just the head was copied from an earlier original, with the addition of contemporary costume. Taking up the idea of F. Lyna ("Portretten van Wenceslaus van Brabant," *De Kunst der Nederlanden*, March, 1931), who was unaware of the Thyssen portrait and was discussing other drawn, posthumous portraits of the Duke, Sterling proposes that the present portrait might have been taken from a triptych by Jean de Woluwe painted for the Duchess the year after her husband's death, in which Wenceslas would have been shown, most likely on one of the wings, kneeling with his hands folded in prayer. If both Wen-

ceslas and Jeanne were included, each on a wing of the triptych, than his position, praying to the right, would be unusual. In the *Parament de Narbonne*, which Sterling cites as an earlier example, Charles V is shown in the heraldically correct position on the viewer's left and his queen to the right. The Thyssen picture might then have been taken from another earlier image (Wenceslas is shown at age thirty-four), which might also have served Jean de Woluwe if the Duke was indeed portrayed in the triptych.

The posthumous portraits of Wenceslas reflect the circumstances of the succession of the Duchy of Brabant and the dynastic ambitions of the Dukes of Burgundy. Wenceslas and Jeanne of Brabant had no heirs; Jeanne was the aunt of Margaret of Flanders, the wife of Phillip the Bold, Duke of Burgundy, and by agreement the duchy passed to Antoine, one of Phillip's sons, and Brabant then became part of the Grand Duchy of Burgundy. Antoine would have wished to confirm his ancestral line through Wenceslas and would very likely have commissioned the portrait, especially as he is known to have had a portrait collection. It is possibly Antoine who commissioned Wenceslas's tomb in the Abbey Church of Orval. The young duke died at the battle of Agincourt in 1415, and if indeed he commissioned the commemorative portrait, then that date would provide a *terminus post quem* for the Thyssen picture which would agree with the evidence of style and costume. Margaret of Austria was the heir of the Dukes of Burgundy, which would support the identification of the Thyssen picture with the portrait mentioned in the inventories of her collection.

Though a posthumous portrait, Wenceslas is vividly realized. The artist, no doubt a leading Burgundian court painter, has not only created a palpably physical presence but, as Sterling has so beautifully written, something of the psychological contradictions of the man: "Voici que Méliador laisse entrebailler son masque littéraire et révèle le visage de Wenceslas, le prince fourbe. Une sorte de double personnalité se lit dans ce regard teinté de vague rêverie et dans ce profil obtus, ce front têtu, ce menton effacé qui trahissent un homme faible, capable de se complaire dans une sentimentalité chevaleresque et ca-

pable de basse indignité. Homme type de cette féodalité décadente, crûment matérialiste et cultivant des fictions romanesques, que ressuscita le talent de Huizinga." (Sterling, *op. cit.*, p. 306)

"*The Blue Duke,*" one of the most advanced achievements in Northern portraiture of the very early fifteenth century, anticipates the *ars nova*, the powerful realism of the portraits of Robert Campin.

PETRUS CHRISTUS
Baerle c. 1410 – Bruges 1472/73

19. OUR LADY OF THE BARREN TREE

Oak, 14.7 × 12.4 cm.

Provenance: Private Collection, Belgium; Ernst Oppler, Berlin (1919); Fritz Thyssen, Mülheim (Ruhr); Konrad Adenauer, Bonn; acquired 1965.

Literature: 1969 Catalogue, no. 61; C. Cuttler, *Northern Painting from Pucelle to Bruegel*, New York, 1968, p. 134; G. T. Faggin and E. de Bonnafos, *Petrus Christus*, Paris, 1968, Color plate IV; C. Sterling, "Observations on Petrus Christus," *Art Bulletin*, 53, 1971, p. 19; J. Upton, "Petrus Christus," Bryn Mawr College, PhD Diss., 1972, pp. 44, 110, 143–154, 180–184, 338–343, fig. 16; P. Schabacker, *Petrus Christus*, Utrecht, 1974, pp. 34, 46, 49, 55, 74, 106–108, fig. 14; A. de Gaigneron, "Nouveau regard sur la collection Thyssen," *Connaissance des Arts*, 306, 1977, p. 54, fig. 6.

The Virgin stands in the groin of a barren tree, encircled by the limbs which join together above her. Fifteen golden "a"s are randomly suspended by chains from the spiky branches. Mary is dressed in an ample, softly flowing robe, deep red in color and lined in olive green; this over a blue gown trimmed in ermine. She wears a black diadem with pearls in her hair. She gazes down at the Christ Child whom she holds with her right hand; with her left, she gently supports his outstretched right foot. The Child is dressed in swaddling clothes, his right arm hanging free, while with his left he steadies a gold orb surmounted by a cross resting on his upraised left knee. Light falls from slightly to the left, casting soft highlights on the greenish-grey tree; the gold letters are turned to catch the light at different angles. The trunk of the tree is abruptly truncated at the bottom, and the

image is so painted as to give the illusion of a tangible object fashioned of precious materials but removed from time and place against the void of the black background. The image of the Virgin standing in a dry tree is founded on Ezekiel 17:24: "And all the trees of the field shall know that I the Lord have brought down the high tree, have exalted the low tree, have dried up the green tree and have made the dry tree to flourish." The dry tree is the Tree of Knowledge which the Lord caused to wither when Adam and Eve ate of its forbidden fruit. In the *Pélerinage de l'âme* of Guillaume de Déguilleville (died c. 1360) the author explains how the Lord grafted a green branch from the Tree of Life onto the dry Tree of Knowledge, thus explaining how the Virgin Mary was conceived by the barren St. Anne. The artist has represented the Virgin in all her glorious colors as new life springing from the trunk of the dead tree. The Immaculate Conception of the Virgin begins the process of redemption; if the dry tree is revived by the conception of the Virgin, it flourishes with the birth of Christ, the mystical apple and fruit of salvation which grows from the green tree. Mary holds the Christ Child who in turn holds the orb crowned by the cross, a symbol of his sovereignty over the world and the redemption of mankind through his sacrifice. The resemblance to the crown of thorns, one of the principal instruments of Christ's Passion, in the circular form of the limbs and spiky branches of the tree has frequently been observed. The dry tree here symbolizes both the Fall of Man and his Redemption. (For the most extensive discussion of the iconography of the Thyssen panel see Upton, *op. cit.*) The golden "a"s probably stand for the opening word of the *Ave Maria* and their number would correspond to the fifteen decades or *pars pro toto,* the one hundred and fifty Hail Marys of the Rosary. The first of the Confraternities of the Rosary was not established until the 1470s, at a date later than the painting under discussion, but the use of the Rosary had already been widespread for some time. The invocation *Ave* is especially significant within the context of the iconography of Christus' image, as it was understood, according to Medieval interpretation, as the reverse of *Eva* (Eve), the woman through whom man fell from grace, and here addresses Mary as the new Eve, through whose son man may

achieve salvation. Mary's role as intercessor is therefore stressed, as is the efficacy of prayer.

The picture was surely painted as a private devotional image for a member of the Confraternity of the Dry Tree, and Grete Ring, who first published the picture ("Onse Lieve Vrauwe ten Drooghen Boome," *Zeitschrift für bildende Kunst,* N.F. XXX, 1919, 75ff.), related it to this brotherhood, a charitable organization which among other things distributed bread to the poor. There is a tradition that Philip the Good enjoyed a victory over the French after a vision of the Madonna in a dry tree and that he founded the brotherhood upon his victorious return to Bruges, but the origins of the confraternity go back to the fourteenth century. Petrus Christus and his wife are listed as members of the brotherhood in a register of admissions of the confraternity, and the date 1463 written next to the name of another member several names down the list may provide a *terminus ante quem,* although imprecise, for their membership (often given incorrectly as 1462, Upton, *op. cit.,* p. 44). Ring (*op. cit.,* p. 78f.) proposes that an altarpiece painted for the Confraternity of the Dry Tree by Pieter Claeyssen the Younger, dated 1620, and still to be seen in the Church of St. Walburge, Bruges, preserves an earlier fifteenth-century prototype to which Christus' is also related. The central section of Claeyssen's triptych shows the Madonna and Child standing in the dry tree in a landscape. There are no gold letters suspended from the branches and the iconography is elaborated by scenes of Moses and the Burning Bush and Gideon and his Fleece in the landscape, Old Testament types of the virginity of Mary traditionally used in conjunction with images of the Immaculate Conception (M. Levi d'Ancona, *Iconography of the Immaculate Conception,* 1957, pp. 47ff.). Claeyssen's altarpiece is strongly archaizing for its date and well might reflect an earlier cult image, and given its function, probably does so more faithfully than Christus' small *Andachtsbild,* or private devotional picture.

The Madonna in the Thyssen panel is related in type to those in Christus' *Madonna and Child with Saint Barbara and a Carthusian Donor,* the so-called *"Exeter Madonna"* (Staatliche Museen, Berlin-Dahlem), and the

Madonna and Child (Szépumüvészeti Múzeum, Budapest); all three derive from late Eyckian compositions such as the small *Madonna by the Fountain* (Musée Royal des Beaux-Arts, Antwerp) and the so-called *"Maelbecke Madonna"* (Warwick Castle, Private Collection). The hanging right arm of the Christ Child is probably a vestigial reflection of the pose of the Child in the *Maelbecke Madonna* where he holds a banderole in his right hand (Ebbinge-Wubben, 1969 Catalogue, p. 69). The Thyssen picture is generally considered to be a late work by Christus. The date 1463, inscribed on the same page of the register of the Brotherhood of the Dry Tree as the names of the artist and his wife, provides no sound basis for dating the painting. It is possible that, as a member, Christus might have painted this devotional image for himself.

JAN VAN EYCK
Maaseyck, near Maastricht? c. 1390–Bruges 1441

20a. ANGEL OF THE ANNUNCIATION
(left side of diptych)

Oak, 39×24 cm. (each side of diptych)
The top of the painted imitation marble frame bears the inscription: AVE . GRA . PLENA . D . NS . TECV . BNDCTA [C and T entwined] . TV . I . MVLIER .

20b. THE ANNUNCIATE (right side of diptych)

The top of the painted imitation marble frame bears the inscription: ECCE . ANCILLA . DOMINI . FIAT . MICHI . SCDM . VBV . TVVM .

Provenance: French Noble Collection; acquired 1933.

Literature: 1969 Catalogue, no. 94; C. Cuttler, *Northern Painting from Pucelle to Bruegel*, New York, 1968, pp. 89–90; R. Hughes, G. T. Faggin, *The Complete Paintings of the Van Eycks*, New York, 1968, no. 24, pp. 95–96, pl. LIV-LV; D. Coekelberghs, "Les Grisailles et le Trompe l'Œil dans l'Œuvre de van Eyck et de van der Weyden," in *Mélanges d'Archéologie et d'Histoire de l'Art Offerts au Professeur Jacques Lavalleye*, Louvain, 1970, pp. 25, 29, pl. V-VI; J. Maurin Bialostocki, *Jan van Eyck*, Warsaw, 1973, p. 45, fig. 27; J. Snyder, "The Chronology of Jan van Eyck's Paintings," in *Album Amicorum J. G. van Gelder*, The Hague, 1973, pp. 294, 297; *Die Parler und der Schöne Stil 1350–1400*, Exhibition Catalogue, Cologne, 1978, I, p. 87.

Gabriel and the Virgin Annunciate are painted on separate panels, in grisaille, as *trompe l'œil* sculptures standing in flat niches. The trefoil decorated bases of the fictive statues actually appear to project beyond the limits of the architectural framework and therefore the picture plane, as does the tip of Gabriel's wing. The inscriptions along the top flat sections of the mouldings are the canonical salutation and response of Gabriel and Mary: "Hail, thou that art Highly favored, the Lord is with thee, blessed art thou among women" (Luke 1:28), and "Behold the handmaiden of the Lord; be it unto me according to Thy word" (Luke 1:38).

The outermost moulding was until recently also painted the same grey stone color but examination of the panels by Marco Grassi uncovered the original deep red color of simulated porphyry, which was also painted on the backs of the panels. The source of natural light is from the viewer's right, in opposition to the Divine Light directed to Mary from her right in the form of the Dove of the Holy Ghost. The statues are reflected in the highly polished surfaces of the black marble at the backs of the niches. These reflections are placed to the right side of the figures, which presupposes a similar position for the viewer: they could not be seen from a frontal position, as they would be directly behind the figures, and Van Eyck makes the adjustment with characteristic logical consistency and refinement of observation. The architectural elements are all seen from a perspective slightly to the right of center and commensurate with the position of the reflections; the octagonal bases of the statues are more foreshortened on the left side, and we see a bit of a fourth side on the right. Even the mouldings, most apparent in the innermost section, are ever so slightly narrower on the right.

Grisaille was used on the exterior of wings or shutters of altarpieces and Van Eyck seems to have been the first to represent figures in this technique as sculptures: this again ingeniously resolves the naturalistic contradiction of figures painted in grey. There is such an example in Van Eyck's œuvre in the small triptych of 1437 in the Gemäldegalerie in Dresden which, as in the Thyssen panels, shows a sculptural "Annunciation." The panels are, however, painted with figural subjects on the backs (the inside of the shut-

ters), which would have been displayed when the triptych was open.

The panels in Lugano are painted on the reverse in imitation of porphyry and not with subjects, and as there is no evidence that they were ever cut or bisected, they could not have served as altar wings. They were perhaps begun as such but never so employed and were instead made into a diptych, probably used for private devotions. Though they are facing one another there is little interaction between the figures. Gabriel's pointing finger is rather perfunctory and the two are statically posed and self-contained, almost transfixed as if turned to stone. Such a conceit is neither seriously suggested nor worthy of Van Eyck; the sculptural illusion is not the determining factor and the comparable group on the wings of the Dresden triptych is, within Jan's restrained expressive range, charmingly animated and responsive. The Thyssen panels also differ from those in Dresden in the treatment of the draperies, which are more voluminous, angular and weighty in the former. The figures in the Thyssen *Annunciation* reflect the static monumentality and psychological isolation of those in Van Eyck's great *Canon van der Paele Madonna* in Bruges and must date from around the same time, 1436. The *Annunciation* and the altarpiece in Bruges are, of course, works of very different intention and scale, and despite their stylistic affinities the former is a work of great intimacy, and the figures of Mary and Gabriel sweetly appealing. They have the dignity of beautiful, solemn children; Mary, the humble handmaiden of the Lord, is less pretty than Gabriel, the heavenly messenger, with his abundant cork-screw curls.

The drama of the *Annunciation* does not lie in the action or expression of the figures but in their presence, revealed by a light which seems to penetrate the mysteries of creation and transcend both illusion and reality.

JAN GOSSAERT, called MABUSE
Maubeuge in Hainault 1470/80 – Breda 1532

21. ADAM AND EVE

Oak, 56.5×37 cm.; round on top.

Provenance: Herzog von Anhalt-Dessau, Gotisches Haus, Wörlitz (inv. 1324); acquired before 1930.

Literature: 1969 Catalogue, no. 109; M.J. Friedländer and H. Pauwels, *Early Netherlandish Painting*, vol. 8: *Jan Gossaert and Bernard van Orley*, Leiden, 1972, no. 8, pp. 24–25.

Exhibitions: Brussels, Palais des Beaux-Arts, *Albert Dürer aux Pays-Bas*, 1977, no. 350, pp. 164–165.

The figures of Adam and Eve are taken almost exactly from Dürer's engraving of the same subject (1504) in which the figures reflect the German artist's study of Renaissance and Antique models and embody his highly pragmatic theory and canon of ideal human proportions. There are variations in the anatomy and poses of the figures: in the Gossaert the heads have been turned from strict profile to three-quarter view and Adam is bearded. His torso is slightly longer in proportion than in Dürer's figure and his shoulders and chest are more compact and less splayed. The *contraposto,* the opposition of the hips, shoulders and head and the weight-bearing and disengaged leg, is more emphatic, and Gossaert's Adam appears to have a greater sense of potential movement. He no longer holds the branch with the parrot and the tablet, and the vestigial position of his right hand has been adapted by raising the index finger in a pointing gesture. Apart from the three-quarter turn of her head there is little change in the figure of Eve, although her shoulders are less square and reduced in proportion, her arms are brought closer to her body and her sense of movement seems more limited. If Adam is more naturally posed than in the Dürer, Eve actually appears less stable than her model. Gossaert has completely changed the landscape: Eve stands before a shallow pool, the bottom dotted with shells, which exactly divides the foreground with the grassy, flower-strewn turf before Adam. A deep, tree-lined meadow under a high-vaulted sky extends behind him, dividing the background, again equally, with the dense foliage behind Eve. The animals symbolizing the four temperaments in the Dürer

have been omitted, and while there may be a residue of symbolism in the divisions of the landscape and the plants (for example, the orange tree behind Eve, because its fruit contains so many seeds, may symbolize lust in the context of the Fall of Man), such symbolic content is incidental to Gossaert's primary interest and the First Parents are presented with a very clear emphasis, as a male and female nude in a landscape. Julius Held (*Dürer's Wirkung auf die niederländische Kunst seiner Zeit,* 1931, pp.115–119) believes that *Adam and Eve* was painted after the artist's stay in Italy and that the changes made in Dürer's figures constitute a more correct canon of proportions based on Gossaert's first-hand knowledge of the Antique and Cinquecento. In Italy Gossaert made drawings after antique sculpture, and it is possible that he wished, on his return, to challenge Dürer's preeminence as the greatest exponent of classical art in the North; or perhaps he merely found, upon his return, that despite his Italian studies the idealized nude was still more accessible to him through the interpretation of another northern artist. The margin of difference, however, need not reflect a knowledge of southern or ancient art; in the Thyssen painting Eve is, if anything, more gothic in appearance than she is in the Dürer. Nor does it support such pedantic intention on Gossaert's part, although with an artist of Gossaert's sophistication, often self-consciously assimilating northern and southern, fifteenth- and sixteenth-century elements in a single work, it is difficult to dismiss the possibility of a more complicated commentary than Held suggests. It would seem likely that Gossaert was indeed dependent on the Dürer and that the changes or "improvements" in the anatomy and poses of the figures and the simplification of the setting were effected to relieve them of their didactic function, both theoretical (as models of Dürer's canon of human proportions) and religious. Gossaert freely quoted Dürer's Adam and Eve from his engraving of the *Small Passion* (published in 1511) shown on the exterior of the wings of the Malvagna Altarpiece in the National Museum in Palermo. The 1504 engraving is freely recalled, the figures intertwined, in that most perversely sophisticated of Gossaert's works, the *Neptune and Amphitrite* of 1516 (Staatliche Museen, Berlin-Dahlem). He is the first artist to introduce classical subjects

with nude figures into Netherlandish painting. The Thyssen *Adam and Eve* is the artist's earliest and most restrained treatment of the subject, like a primer, which he will repeat several times in drawings and paintings. In the later versions the figures are more mannered and grandiose, more complex in pose and movement. They are graphically naturalistic and appear naked rather than nude, and the liberation of "the first pair of lovers from the chaste atmosphere of religious symbolism" (Friedländer, *op. cit.,* p.34) which begins rather modestly in the Thyssen *Adam and Eve* takes on an emphatically lascivious tone. The interaction of two nude figures becomes one of Gossaert's central and most compelling interests, in which biblical and mythological subjects seem no more than interchangeable pretexts.

MAERTEN VAN HEEMSKERCK

Heemskerk, near Alkmaar 1498 – Haarlem 1574

22. PORTRAIT OF A LADY WITH SPINDLE AND DISTAFF

Panel, 105×80.5 cm.

Provenance: Collection of the Earl of Caledon, County Tyrone, Eire; acquired 1969.

Literature: 1969 Catalogue, no.129.

The woman and the spinning wheel loom large in the foreground. Her heroic scale, and it is that, is exaggerated by the ambiguous perspective of the interior and the sudden diminution of the hanging basket with shears, which is inconsistent with the distance suggested. The shadow she casts on the wall to the left seems enormous next to the winder for skeining yarn which hangs above. She sits with her right hand on the wheel, drawing wool or flax from the distaff with her left. The span of her arms practically embraces the width of the composition and contributes to the grandeur of her presence, as do the generous and imposing forms of her costume. The great billowing white sleeves, the heavy green skirt and the tight black bodice with deep rose collar are all broadly modeled and strongly defined. The finer details – the embroidery at the collar, the pearl buttons and the tied belt with metal pendants – are rendered in an equally assertive manner. The

woman wears a white cap which closely frames her face. Her features are strong and somewhat heavy, and the gaze of this good woman of the comfortable burgher class is direct but not bold.

The spinning wheel has a vitality all its own and seems to have bounded into the woman's lap, as is perhaps suggested by the springing dolphin which supports the wheel. A marvelously exuberant invention, the spinning wheel is richly carved with acanthus leaves, fluting and finials, and is luxuriously gilded. J. Bruyn ("Vroegge portretten van Maerten van Heemskerck," *Bulletin van het Rijksmuseum,* 1955, II, p.31) interprets symbolic meaning in the spinning wheel based on Proverbs 31:13 and 19: "She seeketh wool and flax, and worketh willingly with her hands" and "She layeth her hands to the spindle, and her hands hold the distaff." The subject of chapter 31 is Lemuel's lesson of chastity and temperance and the praise and properties of a good wife.

A woodcut, circle of Lucas van Leyden (Hollstein, no.111), shows a woman seated at a spinning wheel in a ruinous open stone chamber. She is attentive to her work despite a babe seated on the ground who offers her what seems to be an apple, perhaps symbolizing the Temptation and the Fall of Man. There is another tradition which associates such virtues with spinning. In Plutarch's "Roman Questions," question no. XXX asks: "Why when they fetch the bride home, do they bid her say 'Where thou art Gaius I am Gaia?'" The answer: "Or is it in memory of Gaia Caecilia, a fair and virtuous lady, the wife of one of Tarquin's sons (actually Tarquin's wife), whose bronze image stands in the temple of Sanctus (sic: Sancus)? Her sandals and her distaff also were long preserved there, signifying respectively her industry and her housewifery." (H.J. Rose, *The Roman Questions of Plutarch,* Oxford, 1924, p.133) An engraving of the statue of Gaia Caecilia, with her slipper and distaff in the background and an appropriate accompanying verse appears in the *Hecaton-Graphie* of Gilles Corrozet, Paris 1543, NVIIIb (A. Henkel and A. Schöne, *Emblemata,* Stuttgart, 1967, col. 1173), which while later than Heemskerck's portrait would indicate that such a tradition was still current.

In Heemskerck's portrait of Anna Codde (Amsterdam, Rijksmuseum, along with the pendant portrait of her husband, Pieter Bicker) the woman is also occupied at her spinning wheel and the painting is similar to the Thyssen portrait in composition, pose, costume and setting. But the similarities make the differences all the more striking. It is not only that Anna Codde is more demurely and perhaps more movingly characterized than the sitter in the Thyssen picture, but the Amsterdam painting is also formally more modestly conceived, less powerfully drawn and modeled, and not as richly painted. The portrait of Anna Codde is closer in style to Jan van Scorel and was at one time given to that painter. This was also the case with the Lugano portrait, but both paintings seem now to be securely placed within Heemskerck's œuvre. Heemskerck worked in van Scorel's studio in Haarlem from 1527 to 1529. The frames of the portraits of Anna Codde and Pieter Bicker bear the date 1529, and whether the frames are original or not the style of the paintings, the approximation of van Scorel's style, would be consistent with such a date. The Thyssen portrait must surely be later and reflects the more fully developed independent style of the artist after he left van Scorel's studio. It can only be slightly later, as Heemskerck left for Italy in 1532. The Lugano portrait exhibits none of the Romanist mannerisms of the artist's style on his return and it takes its place as one of the most harmonious and monumental works of Heemskerck's first Haarlem period. In the Thyssen painting, the letters *AEN* embroidered on the cloth wrapped around the wool on the distaff, as in the Anna Codde portrait, have not been deciphered but C.H. de Jonghe, who first attributed the portrait to Heemskerck ("Maerten van Heemskerck, Portreet eener jonge vrouw," *Oud Holland,* LVIII, 1941, pp.1–5), proposed that the meaning was *AEN (Denken),* or "memento." There is another letter, or perhaps ornamental flourish, in the shadowed left side of the wrapper. The coat of arms to the right, black chevrons on a red field and a black lion on a gold field, has not been identified.

JUÁN DE FLANDES
Netherlands; first recorded in Spain 1496
Died before 16 December 1519

23. PIETÀ WITH JOHN THE EVANGELIST AND MARY MAGDALENE

Oak, 23×30 cm.

Provenance: Duc de Blacas, France; acquired 1956.

Literature: 1969 Catalogue, no. 148.

As recently as 1956, the *Pietà with John the Evangelist and Mary Magdalene* was attributed to Hugo van der Goes. However, it is probably a variant of an early composition by Hugo which according to Winkler is more faithfully recorded in a Pietà in the Gomez Moreno Collection (*Das Werk des Hugo van der Goes*, 1964, p. 103, ill. p. 105); and in the Thyssen panel there are even echoes of the Pietà by Hugo in the Kunsthistorisches Museum in Vienna. But whatever the formal dependency on a composition by Van der Goes, the comparison is a burden the little picture need not bear; Juán de Flandes' style is more akin to the manner of Gerard David. Such influences would suggest Juán's familiarity with the art of Ghent and Bruges, and the small scale of his earliest works in Spain suggest his activity as a manuscript illuminator, perhaps in the circle of miniaturists working for the Burgundian court.

Small as the *Pietà* is, the tentative approach to what is essentially a monumental composition implies the adjustment of an artist used to working in an even more intimate format and the hand of a miniaturist. The figures are slightly unstable and somewhat randomly, almost decoratively distributed. St. John, no more than an accumulation of lovely rose colored draperies, is ambiguously located in relation to Christ, at once near and far. The landscape is a series of vignettes which fill the background spaces but lack cohesion. If the picture is less than soundly structured, it is exquisitely unified by the delicacy of the colors and the light and the gentle pathos of the figures. Especially beautiful is the low sun striking the side of the thief on the cross.

Bermejo (*Juán de Flandes*, 1962, p. 31) considers the *Pietà* close in style to the miniature retable with scenes from the Lives of Christ and the Virgin which Juán de Flandes executed in collaboration with Michael Sittow for the private chapel of Queen Isabella at Toro, and he gives a date of around 1500. It is not known if the panel was originally part of an altarpiece or a single devotional picture. No works by Juán de Flandes before his activity in Spain are known, and the Thyssen panel is intriguing in this respect.

LUCAS VAN LEYDEN
Leyden 1494?–1533

24. CARDPLAYERS

Panel, 29.8×39.5 cm.

Inscribed on the border of the woman's bodice the initials: FM.

Provenance: Sir John Philipps, Picton Castle, Pembrokeshire, South Wales; Sir Richard Philipps, created Lord Milford; Sir Charles Edward Gregg Philipps; Sir Henry Erasmus Edward Philipps; Lady Dunsany, Dunsany Castle; acquired 1971.

Literature: N. Beets, "Lucas van Leyden," *Niederländische Malerei im XV. und XVI. Jahrhundert*, Amsterdam, 1941, pp. 293–295, fig. 218; M. J. Friedländer, *Lucas van Leyden*, Berlin, 1963, p. 52; *Christie's Sales Catalogue*, "Important Pictures by Old Masters," 26. November 1971, no. 72, p. 57, fig. 72; M. J. Friedländer and G. Lammens, *Lucas van Leyden and Other Dutch Masters of His Time*, vol. X, *Early Netherlandish Painting*, Leyden-Brussels, 1973, pp. 88, 94, pl. 111; C. Eisler, *Paintings from the Samuel H. Kress Collection, European Schools Excluding Italian*, Oxford, 1977, p. 86, n. 8 (where the Thyssen painting is referred to as two separate works: first as in the collection of Lady Dunsany; and second as in the collection of Hon. Mrs. Randall Plunkett, who is in fact Lady Dunsany), R. Vos, *Lucas van Leyden*, Bentveld-Maarssen, 1978, p. 110, no. 160, p. 187, no. 199.

Exhibitions: London, Royal Academy of Arts, *Dutch Pictures 1450–1750*, 1952–53, no. 20, pl. 11; Dublin, Municipal Gallery, *Paintings from Irish Collections*, 1957, no. 49; Amsterdam, Rijksmuseum, *Middeleeuwse Kunst der Noordelijke Nederlanden*, 1958, no. 130, p. 109.

Two men and a woman are seated at a table in the outdoors playing a game of cards. The woman seems to have already played her card, a knave of spades, which lies on the table before her. She looks to the young man, who shows a king of spades and whose gaze is fixed on the older man, who draws an eight of the same suit. Gold coins are scattered on the table around the cards of the young man

and woman, but there are none around the neatly stacked cards of the older man. The game is played with a seriousness which Friedländer found comically disproportionate to such a genre subject. It is, however, unlikely that a pure genre scene was intended. Except as a pastime for kings and princes, games of chance were considered the product of idleness and a vice, and such subjects were certainly always moralizing or symbolic. A game of cards might be used to represent a contest of love and, in the case of the Thyssen picture, possibly a competition between the young and old man for the favors of the woman. Though not a game of cards, there would seem to be such ulterior motives in *A Game of Chess,* an early work by Lucas in the Staatliche Museen, Berlin-Dahlem. In *La Tireuse des Cartes,* another early work in the Louvre, a young woman, seated at a table surrounded by standing men and another woman offering drink, consults her cards and offers a flower to a well-dressed young man. Two later compositions, *The Card Players* (Wilton House, Earl of Pembroke collection), and *A Game of Cards* (National Gallery of Art, Kress Collection, Washington, D.C.), the latter after Lucas, show actual games of cards between men and women with others gathered around the tables. There are companies of eight figures in the former and nine in the latter composition, and both are set within interiors. The Thyssen picture differs not only in the landscape setting and the fewer figures but also in the more deliberately formal composition with the two men, in almost pure profile, symmetrically opposed.

There has been informal speculation identifying the two men with historical figures: the young Charles V on the left, and Cardinal Wolsey on the right. The initials *FM* are painted on the black border of the bodice of the woman's dress. Alternate squares of the tablecloth contain the fleur-de-lis, an heraldic device which would not be used lightly in the early sixteenth century; and perhaps the gravity of the game which Friedländer found so amusing reflects a concealed meaning. The man on the left certainly resembles Charles V as a young man, familiar from the many portraits of him in various media; and the almost rigid attitude suggests a source in a profile portrait. Though he does not wear the *toison*

d'or, the card he holds is a king. A likeness of Wolsey would have been less accessible to Lucas, although it is possible that there were popular images of the cardinal – ephemera such as broadsheets. There is a drawing of Wolsey in the Municipale d'Arras made during his visit to Flanders in 1513, and although he appears younger in the drawing, there is a favorable, if general, resemblance to the man in the painting (repr. as frontispiece in G. Cavendish, *Thomas Wolsey,* ed. by Roger Lockyer, London, 1973). The bright red bonnet the old man wears under his black hat is perhaps a clue to the cardinal's identity. There was an occasion when Lucas van Leyden might have actually seen both men, when they met in Bruges in August of 1521. Wolsey arrived in great state as the representative of Henry VIII of England and was met by Charles at the city gate. We know that Lucas was traveling at that time; he met Albrecht Dürer in Antwerp in July of 1521 when Dürer made a portrait drawing of the young Lucas, noted their meeting in his diary, and even bought engravings from the younger artist. Lucas might certainly have been drawn to Bruges by such an event. Wolsey had absented himself from a congress in Calais between the ambassadors of Francis I and Charles V, under the mediation of Henry VIII, to meet privately with Charles. As a result of these meetings, a secret alliance was arranged between the Emperor and the King of England against France. Charles' future marriage to Henry's daughter, the princess Mary, was also agreed upon, and Charles reassured Wolsey of his support in securing the papal tiara. The only woman who was a party to these negotiations was Charles' aunt, Margaret of Austria, daughter of the Emperor Maximilian and Regent of the Netherlands. She had rushed to Bruges to use her influence on her nephew to effect an armistice between Charles and Francis. The match between Charles and Mary Tudor was a cause very dear to her, and she, in fact, not Charles, pressed for Wolsey's election to the papacy on the death of Adrian VI in 1523. The woman in the painting is less distinctive than the two men, and the initials *FM* might have been added to her costume as a means of identification. If there is any application of this narrative to the painting, and if she is intended to represent Margaret of Austria, the initials might identify her as the daughter of

the Emperor Maximilian – *Filia Maximiliani*. A game of cards played on a cloth decorated with the fleur-de-lis of France is a pretty conceit for the representation of such power plays and political intrigue, and one could easily imagine that such an event might even have inspired a popular broadside in a similar spirit. There is of course no internal evidence for such an interpretation. An explanation of the game, as well as the possible emblematic meaning of the cards, would be helpful; but still, attractive as this scenario might be, it is only a house of cards and purely speculative.

There is an embarrassment of possibilities, and another equally seductive plot may be substituted with the change of only one character, Erard de la Marck for Cardinal Wolsey. The Prince Bishop of Liège was only a year older than Wolsey, a man of similar imposing girth and ambition. His appearance is known from his portrait by Vermeyen (Amsterdam, Rijksmuseum, Cat. no. 2529 A.M.), which was engraved (probably by Vermeyen himself) and, again allowing for artistic license, generally agrees with that of the old man in the painting (repr. M. J. Friedländer, *Early Netherlandish Paintings*, 1975, XII, pl. 206, no. 390, and pp. 85, 129, where a drawing in the Arras Codex [no. 525] is also mentioned). In short: Erard de la Marck, a former ally of the French, had joined forces with Charles V who promised him, where Francis I had disappointed him, support in his election to the cardinalcy. Charles received military advantages in the strategically located principality of Liège, which had previously been neutral, as well as trade concessions. Such agreements had been established as early as 1518, and de la Marck might have been influential in securing Charles' election as Emperor in 1519. Margaret of Austria would again have most likely been involved, for as Regent she had been treating with Erard de la Marck for years. She also owned two portraits of the Prince Bishop by Jan Vermeyen, who had been in her service from 1525–30 and who, after her death, submitted a petition in 1533 for payment due in which he lists the two portraits and a portrait of the Empress which Margaret had given to de la Marck (J. Houdnoy, *Gazette des Beaux Arts*, vol. 5, 1872, p. 517). Margaret was also very active as a collector and as a patron of

the arts, and one can easily imagine her wishing to thus commemorate such an occasion. In any case, the two men met in Bruges in August of 1521, the same month in which Charles met with Wolsey. At that time, de la Marck's cardinalcy was announced. The red bonnet might then, in this case, refer to de la Marck's winning in the game. If either historical situation should apply, a date around 1521 would be plausible for the picture on stylistic ground; although if the picture refers to the incident with de la Marck, then 1518 is also possible (Vos gives a date of 1515, which seems quite early).

HANS MEMLING
Seligenstadt (near Frankfurt) c. 1435 – Bruges 1494

25. PORTRAIT OF A YOUNG MAN

Oak, 29.2 × 22.5 cm.
On the back a still life with majolica-pot with flowers on a rug.

Provenance: Duchess of Montrose, Brodick Castle, Isle of Arran, Scotland; acquired 1938.

Literature: 1969 Catalogue, no. 214; M. Corti and G. Faggin, *L'Opera Completa di Memling*, Milan, 1969, nos. 101 A&B, pl. LXIV; K. B. McFarlane, *Hans Memling*, Oxford, 1971, p. 14, no. 64 (beg. p. 13); p. 42, no. 53; figs. 144–145; A. de Gaigneron, "Nouveau regard sur la collection Thyssen," *Connaissance des Arts*, 306, 1977, p. 55, fig. 7.

The portrait of the young man turned to the right, his hands folded in prayer, is generally assumed to be the left half of a diptych with an image of the Madonna and Child on the right. The still life on the back, with flowers symbolically associated with the Madonna, would have been seen when the diptych was closed. The sitter, his hands joined in supplication, must have addressed a holy image, almost certainly the Madonna, but it is possible that the portrait formed part of a triptych rather than a diptych. According to Panofsky (*Early Netherlandish Painting*, Cambridge, 1953, p. 294f., n. 16) the devotional diptych, an innovation of Roger van der Weyden's, was a fusion of representations of the Madonna interceding with Christ, and double portraits of man and wife; in both types of representation the figures are shown bust length. In the devotional diptych, comprised of a portrait and image of the Madonna, the

sitter, his hands joined in supplication, takes the position of the Madonna in relation to Christ: *i.e.* to the viewer's right, but to the left, the "sinister" or subordinate position, from the point of view of the figures in the image.

In matrimonial portraits the rules of heraldry grant the man the position on the left and the woman that on the right when they are shown on the wings of a triptych. Therefore when a Netherlandish portrait shows a man praying to the right, the panel, according to the rules observed by Panofsky, should be the left wing of a triptych or a fragment of a unified composition, in which the same conditions would prevail. K. B. McFarlane *(loc. cit.)* questions Panofsky's rule and specifically in the case of the Thyssen portrait, but the evidence he offers, in which the man is placed to the left in a devotional diptych, is of the sixteenth century. The wings of a triptych by Memling in the Morgan Library, New York, which McFarlane does not discuss, has the woman on the left wing and the man on the right, but this is probably not an exception to the rule because the woman is much older and therefore the heraldic conditions of matrimonial portraits might not apply. Other intact devotional diptychs by Memling, comprised of a male portrait and image of the Madonna and Child (e.g., the Nieuwenhove diptych in the Memling Museum, St. John's Hospital, Bruges; and the diptych with unidentified sitter in the Art Institute, Chicago) would seem to confirm Panofsky's observations. In Memling's paired matrimonial portraits such as those of the Portinari (Metropolitan Museum of Art, New York) and the Moreel portraits (Musée Royal des Beaux-Arts, Antwerp), where the position of the hands in prayer or adoration would indicate a central devotional image (missing in both cases), the man is placed to the left. There is a very good chance, then, that the Thyssen portrait was indeed part of a triptych, in which case the right wing would have shown a portrait of the man's wife and another still life or coat of arms would most likely have been painted on the back.

The type of comfortable corner space in which the sitter is placed ultimately derives from the spatial settings of Petrus Christus and the extension of that space through a window onto a landscape more immediately from Dirck Bouts as in his *Portrait of a Young Man* (National Gallery, London). But the plain casement window in Bouts' portrait has been characteristically transformed in the Memling by such rich embellishments as the marble colonette and an oriental rug over the sill. More importantly, the view into the landscape in the Bouts is seen from a considerable, detached height and that in the Memling is from a lower level so that it is more continuous with the space of the interior. Memling was to elaborate on this idea by placing his sitters directly against a landscape background, an innovation in the north probably influenced by contemporary Italian portraits. The conditions of portraiture, the observation from nature, provided a substantive balance to the often over-refined and decorative stylizations of Memling's more wholly invented compositions. The elegant park-like landscape seen through the window in the Thyssen portrait with trees as prettily coiffed as the young man, gives some inkling of the often too-sweet blandishments of his narrative style. In portraiture he achieved, to quote Panofsky, "a genuine synthesis of stylization and verisimilitude, a happy medium between Rogerian character and Eyckian individuality." The Thyssen portrait is one of Memling's most seductive. The relation of the sitter to the space is especially graceful and harmonious. The gentle diffuse light from the right, in effect emanating from the missing panel of the Madonna, softly illumines the handsome, quietly intent face. The artist strikes the happiest balance between detail and mass in the delicately highlighted hair, and the carefully described white blouse, elaborately trimmed with gold ribbon, is brilliantly complemented by the deep black expanse of the fur collar.

The painting on the back of the panel is one of the earliest examples of such isolated, if not yet truly independent, still lifes, usually included as details in larger religious compositions. Another example of such a device is the chalice of St. John the Evangelist painted on the back of Memling's *St. Veronica* in the National Gallery in Washington, but the composition there is more hieratic and emblematic and quite different in feeling from the more self-sufficient and intimate still life on the back of the Thyssen panel.

The still life on the Thyssen panel is of course symbolic: the flowers here are those most familiarly associated with the Virgin Mary, and the little bouquet gives a précis of her life. The white lily, *lilium candidum,* is usually included in Annunciations, it symbolizes the Virgin's purity and most recently has been identified with Joseph's flowering rod. The iris, or *fleur-de-lis,* which may also be included in Annunciations, is a symbol of royalty and refers to Mary as the Queen of Heaven. Because of its alternate name, *gladiolus,* or "sword lily," it also refers to the Madonna as the Mater Dolorosa, her heart pierced by seven swords of sorrow during Christ's Passion. The small blue columbine is most frequently associated with the Holy Ghost.

PETRUS PAULUS RUBENS
Siegen (Westphalia) 1577 – Antwerp 1640

26. THE TOILETTE OF VENUS (AFTER TITIAN)

Canvas, 137×111 cm.

Provenance: Ch. Léon Cardon Sale, Brussels, June 27–30, 1929, no.97, with illus.; acquired 1957.

Literature: 1969 Catalogue, no.266; J. Held, "Rubens Het Pelsken," *Essays in the History of Art Presented to Rudolf Wittkower,* London, 1967, p.192, fig.6; C. McCorquodale, "Painting in Focus: The Rokeby Venus," *Art International,* 20, 1976, pp.44–45; illus. p.44.

Exhibitions: London, National Gallery, *The Rokeby Venus,* 1976.

Rubens was an inveterate copyist and made many studies, drawings and paintings after works of art of the Renaissance and the Antique. But of all the masters he studied in this manner the one who influenced him most and with whom he must have felt the greatest spiritual kinship was Titian. Both artists took their considerable places in the world with a natural and graceful confidence; they stood as the great *exempla* of the colorist tradition for future generations of painters and they shared a sound and profoundly sensuous response to nature.

Rubens' *The Toilette of Venus* after Titian joins them in another great bond, a love of the Antique. It was Titian who revived the Hellenistic theme of the "Toilette of Venus" in the Renaissance. He painted at least three versions, but the only one by his hand to survive is the one in the National Gallery in Washington which shows Venus for the most part nude with her hands in the position of a Venus Pudica, her right hand drawing a fur-trimmed cloak around her lower body. One cupid holds a mirror for the goddess while another reaches out to crown her with a wreath. Rubens' copy is of the Venus Pudica type but with some elements of the Venus Genetrix in that she appears draped. A copy of the composition in the Staatsgalerie, Augsburg, is the closest to Rubens' and because of the many details it has in common with variants by members of Titian's circle, it is probably closer to the original. In the Augsburg copy, probably of the early seventeenth century, there is a draped column in the left background; Cupid stands on a bed, and a yellow cloth covers the hand with which he supports the bottom of the mirror. The figures are also seen at closer range and in larger scale. Venus does not wear a pearl bracelet. Rubens then would seem to have taken some liberties and this is characteristic of his copies.

Venus is seated facing out, with her legs drawn to the left and her head turned to the right, gazing into the mirror held by Cupid. She gathers her fur-lined, wine-red velvet cloak about her with her left hand and with her right secures her white chemise, which covers but one breast. Cupid, seen from behind, turns to gaze at Venus. His wings are variegated in color and he grips the edge of a pedestal with the toes of his left foot as if to stabilize himself under the weight of the mirror. His bow and quiver, richly decorated, are just behind him and the straps of the latter hang over the ledge of the pedestal and across the carved frieze. A dark green drapery hangs across the right background. From copies it would seem that Rubens was faithful to the original in Venus' hairdo but the full, rounded face is very much his own type. The flesh tones are highly finished and, in the case of Cupid, glistening as if oiled. They are set to the greatest advantage against the few colors and the dark, simple background. The modeling of the chemise and cloak seems a convincing approximation of Titian's handling.

The Thyssen picture is probably identical with the painting mentioned (under no. 48) in the inventory of Ruben's estate as "Venus qui se mire avec Cupido," under the heading: "Peintures faictes par feu Monsieur Rubens en Espagne, Italie et aultre part tant après Titien qu'autres renommez maistres" – the last of eleven pieces Rubens copied after the Italian masters. According to Stephan Poglayen-Neuwall (*Art Bulletin*, 16, 1934, p. 376) the Titian Rubens copied was probably one of two versions of the "Toilette of Venus" which were painted for Philip II and which according to L. Burchard's "acceptable hypothesis" (verbal?) Rubens copied in Madrid, while on his diplomatic mission there in 1628–29. Poglayen-Neuwall gives a reference to Francesco Pacheco (*Arte de la Pintura su Antiquedad y Grandezas*, Madrid, 1866, I, p. 132) who mentions "la Venus y Cupido" by Titian which Rubens copied. Curiously, the catalogue *Sammlung Schloss Rohoncz*, Lugano, 1958, gives Burchard's dating of the picture as 1610–1615. Julius S. Held ("Rubens Het Pelsken," *Essays in the History of Art presented to Rudolf Wittkower*, London, 1967, p. 192) dates the picture in the 1620s. Rubens treated the theme of Venus at her toilette, looking into a mirror, in a more elaborate composition of his own invention in the Liechtenstein Collection in Vaduz. And he employed the device of a fur-lined cloak around a nude woman to devastating effect in a portrait of his young wife, Hélène Fourment, entitled *Het Pelsken* (Kunsthistorisches Museum, Vienna). The latter was most likely directly influenced by Titian's *Woman in a Fur Cloak*, also in Vienna, which Rubens would have seen in the Collection of Charles I during his visit to London, 1629–30.

The journey to Spain in 1628–29 would seem to provide the likely occasion for the copy after Titian, and the relative density of the modeling might be explained by the fidelity to the sixteenth-century model. There is, of course, the trip to Spain in the embassy of Vincenzo Gonzaga, Duke of Mantua, to Philip III in 1603, but in this case the grandeur and breadth for such an early work might then be accounted for by the example of Titian. We are, however, not absolutely sure that the Titian Rubens has copied here was in Spain.

GERMAN

ALBRECHT ALTDORFER
Regensburg c. 1480–1538

27. PORTRAIT OF A WOMAN

Pine, 59×45.2 cm.

Provenance: Germany, unknown private collection; acquired before 1930.

Literature: 1969 Catalogue, no. 1; L. Baldass, *Albrecht Altdorfer*, Vienna, 1941, pp. 134, 136, 202, 212, pl. on p. 292; G. and K. Noehles, "Albrecht Altdorfer," *Encyclopedia of World Art*, New York, 1959, I, col. 221; G. von der Osten and H. Vey, *Painting and Sculpture in Germany and the Netherlands, 1500 to 1600*, Baltimore, 1969, p. 211; F. Winzinger, *Altdorfer, Die Gemälde, Tafelbilder, Miniaturen, Wandbilder, Bildhauerarbeiten: Werkstatt und Umkreis*, Munich, 1975, p. 46, no. 52, pp. 103–104, pl. 52.

Donor portraits appear in several religious paintings by Altdorfer, but the painting in the Thyssen collection was the only accepted independent portrait by the artist until Stange proposed a male portrait in a private Swiss collection ("Das Bildnis im Werke Albrecht Altdorfers," *Pantheon*, XXV, 1967, II, pp. 91–96), which Winzinger (*op. cit.*) has also accepted. A date for the picture has ranged from 1515 to the end of the second decade. Von Rettburg (*Nürnberger Briefe zur Geschichte der Kunst*, Hannover, 1846, p. 165, note I) recorded a *Portrait of Barbara von Blomberg* by Altdorfer, dated 1522, in the Kränner collection, Regensburg, in 1846. Benesch (*Der Maler Albrecht Altdorfer*, Vienna, 1943, p. 23f.) thought this reference might be to the portrait in the Thyssen collection, but Stange disagreed because he believed the Thyssen picture to be later than 1522, an example of Altdorfer's full maturity and painted towards the end of the second decade.

The woman is turned to the right in three-quarter view, her hands loosely joined before her. She is dressed in the costume of the comfortable burgher class. Her head is covered in a wimple of the sort which appears in a variety of shapes in Altdorfer's religious pictures. She wears a white blouse with two bands of embroidery down the front and shirred sleeves banded at the wrists. The pinkish-

orange and green changeant taffeta of the bodice is the loveliest passage of painting, set off with great effect by the banding of deep black velvet. Her full red skirt falls in soft folds and she wears a loose belt, perhaps embroidered, which fastens at the side. On her fingers are four rings with red stones. Her expression is consistently described as gently or sweetly smiling, perhaps due to the long, slightly asymmetrical line of her mouth, which actually seems rather fixed. There is a sweet docility about the eyes and, indeed, the sitter is so tenderly characterized that one can understand E. Hanfstaengl's proposal (*Art News*, 16 August 1930, p. 18) that the woman is Altdorfer's wife – especially considering the exceptional place of the portrait in Altdorfer's œuvre. The background prompts other speculations. It is completely unexpected; sensibly it would seem to be a cloth or drapery, although as such it has no correspondence elsewhere in Altdorfer's work, except perhaps in the green drapery behind Lot and his daughter in the late mannered picture in the Kunsthistorisches Museum, Vienna. But the scale of the highlights is much greater in the Thyssen picture, and the handling broader and more agitated. The background rises up like a wall of dark green shifting water, so at odds with the sweet composure of the woman that it calls her quietly contained bearing into question. It would be interesting to know the personal history of Barbara von Blomberg.

CHRISTOPH AMBERGER
Augsburg c. 1500–1561/62

28. PORTRAIT OF MATTHEUS SCHWARZ

Pine, 74×61.5 cm. (2.3 cm. added on top of the panel)
Inscribed in horoscope: *1542*, and in astrological calendar: *MATHEVS · SVVARTZ · SENIOR CIVIS AVG SIBI IPSI*
FF

Provenance: Ferdinand August Hartmann, Dresden (?); Mrs. von Ritzenberg, Nischwitz near Wurzen (Vienna); Freiherr von Friesen, Dresden; Martin Schubart, Munich; Collection Leopold Hirsch, London; acquired 1935.

Literature: 1969 Catalogue, no. 2

Amberger was presumably a pupil of the Augsburg painters Hans Burgkmair and Leonhard Beck. Though he painted religious subjects and murals on the façades of buildings in Augsburg, now all lost, he was principally active as a portraitist. As such he might have been influenced by the court painter Jan Vermeyen who was in Augsburg in 1530, the year Amberger became a master there. Around 1540 he came under the sway of Venetian art, and there is an old tradition that Paris Bordone was in Augsburg at about that time, working for the Fuggers. There is also the possibility that Amberger made a journey to Venice. If so, then the careers of both painter and sitter would have been strongly influenced by their respective sojourns in that city. In 1515 Mattheus Schwarz, then a young man of eighteen, went to Italy to learn the new system of double-entry bookkeeping devised there. After unsuccessful attempts in Milan and Genoa, he found a master, Antonio Mariafior, in Venice, where he remained for one year. On his return to Augsburg he joined the Fugger banking house and in 1518 wrote his *Musterbuchhaltung*, the first treatise in the German language on the modern system of bookkeeping, based on the model of Luca Pacioli. It was only through such a sophisticated method that Schwarz was able to oversee the bookkeeping of the vast and complicated financial empire of the Fuggers. Despite the enormous sums of money Schwarz dealt with daily, he himself accumulated no great fortune, according to tax records. His taxes increased considerably from 1562, when he retired, until his death in 1574, due to a large annuity he received from the Fuggers for his long and invaluable service (P. Wescher, *Grosskaufleute der Renaissance*, Basel, pp. 111–114). Perhaps he spent all his money on clothes; certainly he was uncommonly interested in costume, which plays a singularly conspicuous role in his life. In 1522 he commissioned a large watercolor on vellum, a *"Geschlechtertanz,"* in which a long, double file of couples dressed in costumes dating from 1200 to 1522 are shown as a procession of dancers in a landscape. It is a sort of genealogical table of costume which includes, as they approach modern times, many contemporary portraits among the figures (A. Fink, *Die Schwarzschen Trachtenbücher*, Berlin, 1963, p. 31 ff.). A more personally consuming and longer project was his *Trachtenbuch*, an autobiography in which his life is documented in 137 watercolor illustra-

tions on vellum, portraying Schwarz in his most memorable costumes – from childhood to the mourning garb he wore in 1560 on the occasion of the death of Anton Fugger. An earlier watercolor, dated 4 March 1527, shows him dressed for the wedding of Anton Fugger. The illustrations, annotated by Schwarz himself, give some biographical detail and descriptions of the clothes. The manuscript (in the Herzog-Anton-Ulrich-Museum in Braunschweig) is a valuable contribution to the history of costume in the German Renaissance as well as a fascinating personal document. There are several hands involved in the illustrations and the finest miniatures are attributed to Amberger.

In the Thyssen portrait Schwarz is dressed in a splendid black taffeta jacket, worked with deep red stripes on the breast; this over a fine white shirt with a red stomacher. His hair is gathered in a close bonnet or snood, black with metallic embroidery. He wears gold rings, some set with stones; a gold toothpick hangs from his jacket and a dagger ornamented with silver from his belt. According to Fink (p. 168), in the *Trachtenbuch* Schwarz wears the same costume, though mostly concealed by a mantle, in a miniature dated 14 May 1542, the same year as the Amberger portrait. The commentary to this illustration refers to a vow, taken with two friends, to abstain from drinking. There were frequent prohibitions against drinking issued by the city of Augsburg from 1497 on (coincidentally, the year of Schwarz's birth) and there was also a considerable body of literature written against this vice. In the next illustration Schwarz, gallantly dressed, and also with an elegantly slim figure, raises a glass and absolves himself, according to the text, from the oath. The emphasis on drink in these two miniatures so closely related to the Thyssen portrait might explain the neglected glass of wine on the windowsill in the latter; perhaps Schwarz wished to present himself as a sober and forthright citizen. The painting is a formal portrait (painted as companion to the portrait of Schwarz's wife which is now in the Detroit Institute of Arts) and would therefore require such a respectable tone. Schwarz is posed with his right hand on his hip and his left arm resting on a table. Behind him we see two books: these might relate to his work but more likely concern the horo-

scope, drawn in gold and dated 1542, which appears against the cloud-filled sky through the window. The elaborate astrological calendar on the windowsill, which gives the year, month, day, hour and meridian for the portrait, for Schwarz's birthdate and for his age – 45 years, 30 days and 21¾ hours – also informs us that Schwarz, a citizen of Augsburg, made the horoscope for and by himself. His sign is Pisces, and the deluge over the craggy landscape might refer to this water sign. The glass of wine, as well as signifying abstinence or moderation, might also allude to the weakness for alcoholic beverages associated with Pisces. (A horoscope also appears in the portrait of his wife, although the background there is simpler and there is no astrological calendar.)

One has the feeling that just as he cast his own horoscope he also determined the program and, to some extent, the projection of his own image in the Amberger portrait. For the painter's part, Amberger's tempered Venetianism suits Schwarz perfectly; though of a good size, the portrait makes a grander impression than its scale might suggest. There is a sense of style but moderated by an appropriately dignified sobriety, less opulent than Amberger's more fully Venetian portrait of Christoph Fugger (1541), in the Alte Pinakothek in Munich. The wonderfully generous, ample sense of form is nonetheless clearly defined and the colors, while rich, are employed with a certain precision and restraint; the handling of the black is especially masterful. The characterization is both strong and ambiguous, and one feels the enormous intelligence, pragmatism and force of character of the man as well as something of the dreamer about him.

HANS BALDUNG, called GRIEN
Schwäbisch Gmünd 1484/85 – Strassburg 1545

29. PORTRAIT OF A LADY

Pine, 68×52 cm., reduced at the top and on the right margin. Inscribed on the left, above: *HB* [joined] *1530*

Provenance: Said to come from Schloss Neuburg on the Danube; Count Dumoulin Eckert, Munich; acquired 1934.

Literature: 1969 Catalogue, no. 15; G. Bussman, *Manierismus im Spätwerk Hans Baldung Griens, die Gemälde*

der Zweiten Strassburger Zeit, Heidelberg, 1966, pp. 93f., 176, 184f., no. 28, pl. XVI.

The half-length figure of a young woman, richly dressed, with a broad-brimmed plumed hat, sits large within the compositional field; she is turned in three-quarter view to the left, glancing directly toward the viewer. The face is mask-like, almost completely smooth of line and shadow, an effect exaggerated by the close-fitting gold and pearl snood which encloses her hair. The almond-shaped eyes are heavy lidded, the nose small, the Cupid's-bow mouth somewhat pouty; the ear is large and prominent. The soft lines of the shoulders and the slight swell of the breasts are negated by the flat, decorative bands of the gold brocade bodice. The jeweled collar and gold chain, while casting shadows and highlights, seem more decoratively applied than illusionistically integrated; the undulating double black cord about her neck is a trace of pure line. The few, clearly defined areas of color, only slightly modulated by highlights, emphasize the highly decorative effect and strong design. Most astonishing is the cold, greyed white used for the flesh tones, heightened in effect by the black ground and dark green velvet costume. Pattern and self-conscious artificiality determine the image, an example of Baldung's highly mannered, pictorial willfulness. The artifice of this seductress has become Baldung's formal theme, perhaps the exaggeration of a canon of beauty which to modern eyes seems to reflect ambiguously on the model. The influence of Lucas Cranach, and most likely his *Salome* of circa 1530 in Budapest, seems fairly certain, although the Thyssen picture is more archly stylized. Given the license of Baldung's style, it is possible that the picture is a portrait. A princess of Baden-Durlach has been proposed, but Bussman disagrees, as the house of Baden-Durlach was not established until 1565 and the picture is dated 1530. The painting is most likely a fanciful costume piece, perhaps a deliberate essay in the style of Cranach.

LUCAS CRANACH THE ELDER
Kronach 1472 – Weimar 1553

30. THE MADONNA WITH THE BUNCH OF GRAPES

Panel, 71.3 × 44.3 cm.
Signed on the coping of the wall on the left with Cranach's crest, the winged serpent.

Provenance: R. Langton Douglas, London; Henry Schniewind, New York; acquired 1936.

Literature: 1969 Catalogue, no. 77; W. Schade, *Die Malerfamilie Cranach*, 1974, p. 41; D. Koepplin and T. Falk, *Lucas Cranach*, Basel, 1976, vol. 2, no. 372, pls. 280, 281.

The crest of the winged serpent which appears on the stone wall to the left was granted to Cranach by the Elector Frederick the Wise of Saxony in 1508, and was used by the artist as a signature in this form until the death of his son Hans in 1537, when he adopted the form of the serpent with lowered wings. The *terminus post quem* is of little use in this instance, as the style of the picture would indicate a date considerably earlier than 1537. Friedländer-Rosenberg (*Die Gemälde von Lucas Cranach*, Berlin, 1932, p. 35, no. 29) related the Thyssen painting to the *Venus and Amor* of 1509 in the Hermitage, Leningrad, based on the similarity of types of the Madonna and the Venus, a curious comparison, and dated it 1509–1510. Salm (1969 Catalogue) more convincingly related the picture to the *Madonna and Child and Infant Saint John*, dated 1514, in the Certosa di Galuzzo near Florence. The extensive and beautifully painted landscape still reflects Cranach's earlier activity as a member of the so-called Danube School. Apart from the wonderful invention of the landscape, the castle atop the craggy hill and the extravagent fir tree, great care is still taken with the effects of light and atmosphere. The rich variety of detail in the landscape, the infinite touches of the brush and the intricate silhouettes are directly contrasted with the large, simple form of the Madonna and the regular, firmly drawn contours and broad, uniformly painted surfaces in which she and the Child are described. The face of the Madonna and the Child are softened by a delicate *sfumato*. The figures have an almost Italianate quality. A melancholy hangs about Mary and the Christ, in her side-

long introspective glance and his sadly accepting, distant expression as he lifts the grape, a symbol of his sacrifice, to his mouth.

JOHANN KOERBECKE
Münster 1400/10–1491

31. THE ASSUMPTION OF THE VIRGIN

Oak, lined with canvas, 93×65 cm.

Provenance: A castle near Bückeburg; Private Collection, Westphalia; acquired before 1930.

Literature: 1969 Catalogue, no. 155; C. Eislér, *Paintings from the Samuel H. Kress Collection: European Schools Excluding Italian,* Oxford, 1977, pp. 4–6, text fig. 1.

The Assumption of the Virgin is one of sixteen panels painted by Koerbecke for the wings of the altarpiece for the High Altar of the Cistercian Abbey Church at Marienfeld, Münster. The donor was the Abbot Arnold von Bevern. Partial payment was made to the artist in 1456 when the painted panels were finished, and the altarpiece was installed on 6 February 1457 and consecrated 25 January of the following year.

According to J. Sommer ("Johann Koerbecke: Der Meister des Marienfeld-Altares von 1457," *Westfalen,* 5. Sonderheft, 1937, p. 19) the central section of the altarpiece was a reliquary shrine which contained a small statue of the Madonna and Child in a niche in the center (like the Abbey, the High Altar was dedicated to the Virgin) and twenty-four busts containing relics of St. Ursula and her companions. The statue of the Madonna, dating from earlier in the century, is still in Marienfeld and was originally gilded, as were the reliquary busts. When the altarpiece was open the wings showed eight scenes from the Life of Mary, four to either side of the reliquary shrine, painted on gold grounds; when closed, scenes from the Passion of Christ, painted with naturalistic backgrounds, could be seen. Twice restored in the sixteenth century, the altarpiece was removed and dismantled between 1661 and 1681 and the front and back panels of the wings sawed apart. On 20 February 1804, a year after the abbey was secularized, the panels of the High Altar along with over three hundred other paintings were removed for auction, and

while the Koerbecke panels were withdrawn and intended for the Berlin Academy, they were somehow waylaid and dispersed.

All but one of the panels is known. According to the most recent reconstruction (P. Pieper, "Westfälische Maler der Spätgotik 1440–1490," *Westfalen,* 30, 1952, p. 93, ill. pls. 16–19, with revisions of his reconstruction of the exterior panels of the wings in *Westfalen,* 32, 1954, p. 84f.) the Passion scenes on the exterior were arranged in two rows, which continued narratively across the wings when they were closed. The cycle begins on the bottom row and includes, from left to right: the *Arrest of Christ* (private collection Dortmund), *Christ Before Pilate* and the *Mocking of Christ* (Landesmuseum, Münster), *Flagellation* (whereabouts unknown), and continues on the top row with the *Road to Calvary* and the *Crucifixion* (Staatliche Museen, Berlin-Dahlem), the *Entombment* (Landesmuseum, Münster) and finally the *Resurrection* (Musée Calvet, Avignon). Supposedly there is technical and physical evidence for this reconstruction as well as iconographic, but the eight Passion scenes on the exterior of the wings of the Langenhorster Altar (Landesmuseum, Münster), most likely an earlier work by Koerbecke and presumably in their original order, are not arranged as a continuous narrative across the wings but rather from top left to right and then from bottom left to right on each wing, as in the case of the panels on the inside of the of the Marienfeld Altar depicting the Life of Mary. In support of Pieper's reconstruction is the fact that the upper row would have presented a continuous landscpe although, as Stange has pointed out, the *Crucifixion* would have been to the left of the celebrant. When open, the altarpiece would have presented the splendid prospect of the reliquary shrine with the gilded busts and statue and the panels with the scenes of the Life of the Virgin painted on gold grounds. The upper left panel of the left wing would have shown the *Presentation of the Virgin* (Museum Narodowe, Cracow); to the right, the *Annunciation* (Art Institute, Chicago) which includes the arms of the donor, of Münster and of the Cistercian order on cushions on the bench behind Mary and Gabriel; to the lower left the *Nativity* (Germanisches Nationalmuseum, Nürnberg); and a lost *Adoration of the Magi*

to the lower right. The upper left panel of the right wing showed the *Presentation in the Temple* (Landesmuseum, Münster); to the right, *Christ and Mary Enthroned in Heaven* (private collection, Rhineland); the *Ascension* (National Gallery, Washington) at the lower left and the *Assumption* (Thyssen Collection, Lugano) to the lower right. The Thyssen panel concludes the series and, following Pieper, the *Mocking of Christ* would have been on the outside of the panel.

The Assumption is the principal feast of the Virgin. The account of Mary's corporeal assumption into heaven originates in an apocryphal treatise of the fourth or fifth century bearing the name of St. John but is retold in such a popular work of the thirteenth century as the *Golden Legend* by Jacobus de Voragine. The description there tells of Christ's appearance to the Apostles gathered round the tomb of the Virgin, of the reunion of Mary's soul with her uncorrupted body, and of her being taken up into heaven, amidst the heavenly host, to sit at the right side of Christ for eternity. Koerbecke characterizes the reactions of the Apostles to the miracle with a lively variety and a powerfully expressive physical and emotional intensity. The angular, vigorously realistic style in which they are painted compensates in force and conviction for what it lacks in nuance and sophistication. The figures are compressed within a minimally suggested landscape setting, more an adjunct of the figures than a space which contains them. A flat area of green against the gold ground indicates the slope of a hill which connects the two groups of Apostles as does the tomb. The foreground is embroidered with delicately stylized plant forms immediately juxtaposed with the density of the lid of the tomb, set at an abrupt and assertive angle. The aggressive realism of the lower part of the composition leaves off suddenly in the heavenly realm where the painter's style becomes more decorative and the mood more lyric. Christ, shown in half-length and emerging from a glory of adoring angels, reaches down to draw Mary to his side, tenderly embracing her with his left hand, his right hand interlocked with hers. They are surrounded by four groups of angels on banks of clouds, playing musical instruments. The angels, too, are shown half-length, as if emerging from the clouds, the latter painted like ruffled ribbons with scalloped edges. Tooled lines radiate from the heads of those Apostles seen against the gold ground, from the heads of Christ and Mary and from beneath the clouds and Mary's robes.

The decoratively stylized cloud motif is again used to define spandrels filled with small angel heads at the upper corners of the composition. The colors as well as the strong realistic style in which the Apostles are painted have been delicately tempered in the heavenly scene. This softer, sweeter style characterizes other panels in the Marian cycle and the differences must surely be determined in part thematically, as well as by the artist's stylistic development, through the chronological sequence of the execution of the panels. The Thyssen *Assumption* and the *Ascension* in Washington, the panel originally to its left in the altarpiece, introduce a sudden and markedly greater degree of monumentality and force of expression in the Marian panels which are in turn more pictorially advanced than those scenes of the Passion on the exterior of the wings. Because of this, Stange (*Deutsche Malerei der Gotik*, Munich-Berlin, 1954, VI, p.16) considered the Washington and Lugano panels, which iconographically conclude the Marian cycle, the last to be executed. And their position on the bottom tier of the right wing would indicate that they were indeed the last, on the assumption, stylistically reinforced, that the artist proceeded according to the tradition of working from top to bottom and from left to right.

The sources of Koerbecke's style seem to be complex. The composition of the *Assumption* depends on or at least was painted in concert with that of the adjacent *Ascension*, which in turn derives from the lost wings of Lochner's *Presentation Altar* (L.B. Philip, *Stefan Lochner's Hochaltar von St. Katharinen zu Köln*, Freiburg, 1938, pp.63–5); the *Presentation in the Temple* in the Marienfeld Altar (Landesmuseum Münster) is based on the central panel of the same altarpiece (Germanisches Landesmuseum, Nürnberg). P. Pieper (*Westfalen*, 30, 1952, p.89) proposes that Koerbecke was in Cologne around 1450 and was influenced by Lochner's late works. He also suggests that the motif of the angel orchestra in the *Assumption* derives from a work by that Cologne master (*ibid.*, p.94). Whatever

the influence of Lochner, Koerbecke's harsher, essentially provincial realism would depend on other sources, and the importance of Conrad von Soest has been generally recognized. The emphatically realistic, as well as some of the softer, more decorative elements in the Lugano panel must derive from such a work as Soest's *Wildungen Altar* (Pfarrkirche, Nieder-Wildungen). The ribbon-like, stylized cloud motifs also appear as an arch motif in Soest's *Last Judgment* panel, and in the aureole around Christ in the *Ascension* where the expressionistic contortions of the Apostles recall those in the Lugano *Assumption*. Certainly the work of other earlier masters, such as Meister Francke, would have exerted an influence on Koerbecke (Francke's influence being especially evident in the Passion series on the wings of the Marienfeld Altar), as would Netherlandish and more contemporary Westphalian art. Sculptural sources for Koerbecke, especially in the *Assumption* and *Ascension* panels, might also be considered and might in part account for the monumentality which this artist introduces into contemporary Westphalian art.

NÜRNBERG MASTER
Painted c. 1525

32. PORTRAIT OF A YOUNG WOMAN

Panel, transferred, 49.6×37.8 cm.
On the left above, an inscription over three lines:
*ANNA SEINE HAVS/FRAW IRES ALTERS/XXIII
IAR (or XXII)*

Provenance: French Private Collection; acquired 1935.

Literature: 1969 Catalogue, no. 160; K. Löcher, "Nürnberger Bildnisse nach 1520," in *Kunstgeschichtliche Studien für Kurt Bauch zum 70. Geburtstag von seinen Schülern*, Munich-Berlin, 1967, p. 122; A. Stange, "Der Maler Ruprecht Heller," *Anzeiger des Germanischen Nationalmuseums*, Nürnberg, 1970, pp. 77–78, fig. 10; K. Löcher, "Ein Bildnis der Anna Dürer in der Sammlung Thyssen-Bornemisza," *Wallraf-Richartz Jahrbuch*, 39, 1977, pp. 83–91, figs. 2, 3.

The woman is shown half-length, turned to the left in three-quarter view with her arms folded in her lap. She wears an elaborately shaped, heavy grey-black hat and a tight-fitting jerkin of blue-grey, highly finished cloth with a pale orange-gold design. The sleeves are red, rose in the light, and the cuffs and collar are trimmed with brown fur. Her wide belt, embroidered with gold thread, is edged with white fringe and she wears a gold ring with a single stone on the index finger of her left hand. The background is green with an inscription placed to the left of the sitter's face. The colors for all their variety lack body and cohesion and the strength of the portrait is in the drawing, especially in the face; the contours of the full, ripe features, the deep set eyes, are strongly defined by the artist's limpid and fluid line. The placement of the figure is sure and implies a comfortable sense of space. The thoughtful, dreamy expression seems the very natural extension of her settled, easy bearing. The inscription presumes a male pendant portrait and Löcher (1978) proposes the *Portrait of Hieronymus Fleischer* in the Staatsgalerie, Stuttgart. The sitter there is turned to the right, the background is again green and the inscription, according to Löcher, is the same size and is placed to the right of the sitter's face, corresponding with that in the Thyssen portrait.

In photographs the two portraits appear compatible although there are discrepancies in scale and in the placement of the figures, which Löcher acknowledges but which he also reasonably justifies and which occur in other identified German sixteenth-century pendant portraits. Hieronymus Fleischer's wife, whom he married in 1525, was Anna Dürer, the daughter of Ursula Hirnhofe, whose second marriage was to Endres Dürer, brother of the famous Albrecht.

The unusual cap the woman wears appears in very similar form in Albrecht Dürer's portrait drawing of Veronica Formenschneider in the British Museum, London, signed and dated 1525 by another hand; the sitter there also wears a tight-fitting, high-necked costume. Löcher gives other examples of costume details which would localize the Thyssen portrait in Nürnberg and would date it to around the year – or slightly later – given for the Formenschneider drawing. Encouraged by his proposed identification of the sitter, and the great quality of the drawing in the head, Löcher very gingerly suggests that the painter might actually have worked from a drawing by Dürer. Since the birth dates of Hieronymus Fleischer and Anna Dürer – if that is

indeed the identity of the woman in the Thyssen portrait – are unknown, the dates of the portraits cannot be calculated from their ages, which are given in the inscriptions as 26 and 22 or 23 respectively. Löcher would date the portrait not earlier than 1525, the year of the marriage, and the woman's costume would place it closer to 1527.

Löcher believes the portrait to be by a Nürnberg-trained artist working closely within the Dürer tradition but not one of the identifiable portrait painters of that city: perhaps a Nürnberg artist not usually active as a portrait painter, or an artist no longer working in the city who returned only in passing. The description fits the painter Hans Dürer, another brother of Albrecht, and would be very plausible in light of Löcher's identification of the sitter in the Lugano painting. It also makes the hypothetical model of an Albrecht Dürer drawing more feasible. Hans Dürer worked in his brother's studio as a young man and is last mentioned in Nürnberg in 1510. In 1527 he received payment for work done in Cracow where after 1529 he was court painter. However, there is no evidence on which to base such an attribution and Löcher scrupulously draws no conclusion. E. Buchner (as reported by Salm, 1969 Catalogue) also attributed the Thyssen portrait to Hans Dürer because he believed the woman's hat was Polish, but J. Bialostocki (by letter, 1965) rejected the idea. Friedländer (letter, 1935) related the portrait to Hans Baldung Grien and dated it around 1510. Salm tentatively attributed it to Hans von Kulmbach or an artist in his circle on the basis of the *Portrait of a Young Man,* dated 1520, in Berlin-Dahlem (Staatliche Museen).

SOUTH GERMAN MASTER
Third quarter fifteenth century

33. WEDDING PORTRAIT
OF A WOMAN WEARING
THE ORDER OF THE SWAN

Pine, 44.5×28 cm.

Provenance: Benedictine Convent Admont (Styria); Landesbildergalerie Graz; acquired 1935.

Literature: 1969 Catalogue, no. 35; C. Salm (R. Heinemann, ed.), *Sammlung Thyssen-Bornemisza,* Lugano-Castagnola, 1971, no. 39; A. Stange, *Kritisches*

Verzeichnis der deutschen Tafelbilder vor Dürer, Munich, 1970, vol. 2, no. 1021, p. 232.

Turned to the left in three-quarter view with her arms folded, she holds a pink, a symbol of fidelity, in her left hand. She wears an elaborate headdress of white cloth with a high, finely pleated or shirred crown, long train and red tassle, which according to Salm is a sign of her marital status; she is probably shown as a new bride. The left sleeve, collar and right cuff of her tight-fitting black dress are heavily embroidered with pearls and gold sequins, with the center of the elaborate pomegranate motif in red. A zig-zag pattern embroidered in gold thread encircles her waist. She wears the collar of the Order of Our Lady of the Swan.

The order was founded by Frederick II of Brandenburg in 1441, in the Church of St. Mary's on the Harlunger Mountain in Brandenburg. In 1459 Albert Achilles, Frederick's brother and successor, established what was to become an independent south German seat of the order in the Chapel of St. George in St. Gumbertus at Ansbach. Women were allowed to become members, but according to the new statutes instituted by Albert Achilles in 1485 only wives of members of the order could join. The identity of the woman in the Thyssen portrait is unknown, but clearly she was someone of considerable rank. Salm finds the lack of a coat of arms difficult to explain and states that indeed there should also be a portrait of her husband, as she could not have belonged to the order alone. But the date of the portrait is not surely established and if it is before 1485, then she could have joined without being the wife of a member. The pink in her hand would suggest that there was a companion portrait.

Made of heavy gold or silver-gilt, the decoration she wears is comprised of a medallion of the half-figure of Mary holding the Christ Child on the crescent moon surrounded by the rays of the sun, Mary as the Apocalyptic Woman; attached below is a swan with spread wings enclosed in a circle of twisted gold with pendant swags and tassles. These are attached to the collar by a device of three interlocking circles. The chain itself is of a curious design of linked bar sections com-

prised of what look like opposed saw blades, the bottom row set with red, heart-shaped stones in the middle. The short, upturned collar of her dress is fastened by fine gold chains. The figure is severe in pose and the contours throughout are highly regularized and precise. The train of her headdress falls in sharp, sculptural folds in marked contrast to the blandly modeled face. The flesh tones are remarkably fresh and the white headdress is brilliant against the clear, blue background, the color of the woman's eyes. The rich unmodeled black of her dress is a perfect foil for the heavily encrusted embroidery and the gold collar of the order. Underdrawing shows through in the shaded area beneath the jawline and in the headdress.

The picture was recorded in the Benedictine Convent at Admont and was for a long time regarded as a posthumous image of St. Hemma, the founder of the Abbey (died 1045, canonized in 1938). A label on the back bearing a nineteenth-century inscription reads: *Portrait of Saint Hemma. Saint Hemma lived at the end of the tenth century and in the first half of the 11th.* Because of its provenance the picture was considered a work of the Styrian School. Hugelshofer (*Belvedere*, VIII, 1929, pp. 417ff.) considered it so and related it to the *Portrait of a Woman of the Hofer Family,* National Gallery, London, which is considered a work of the Swabian School, fifteenth century (M. Levey, *The German School,* National Gallery Catalogue, London, 1959, no. 722). The relation to the London portrait is not convincing but E. Buchner (*Das Deutsche Bildnis der Spätgotik und der Frühen Dürerzeit,* Berlin, 1953, p. 64) attributed the National Gallery painting, with a query, to the Master of the Sterzing Altarwings. Whatever the merits of the latter attribution, the Thyssen portrait would seem to have some affinity with the work of the Sterzing master. Buchner published the Thyssen portrait as Franconian, with a query, around 1460, and related it to the Master of the Tucher Altarpiece. A. Stange agreed that the portrait was somewhat Franconian and attributed it to Sebald Bopp, who was born in Bamberg and trained in Würzburg, but established himself in Nördlingen and worked for the court in Ansbach. Sophie of Brandenburg-Ansbach, pleased with Bopp's work, highly recommended him to

the town council of Kitzingen (*Deutsche Malerei der Gotik,* 1957, Munich-Berlin, VIII, p. 96–100).

Stange grouped the Thyssen portrait with a *Portrait of A Woman* in the Bayerisches Nationalmuseum (inv. 282) and a male portrait in a private collection dated 1483 (p. 99f). The similarities between the two female portraits is striking. Apart from the general closeness of composition (the women are posed in the same way with their arms folded) and style (severe, simplified outlines and broadly defined form) there is a persistence of method in such distinctive details as the hands, the mouth, and the set of the head to the neck. There are differences: there is a greater sense of volume in the Munich portrait and the figure, less formal in bearing, is placed within a niche; the headdress is more softly modeled and the face more forcefully. Stange also comments on the difference in color between the two works, violet-brown, green and white in Munich, which he accredits to the respective ages and stations of the sitters. He also suggests ten to fifteen years between the two portraits, but whatever the difference in time, the Munich portrait is convincing as a further developed and more mature work by the same hand. Buchner (*op. cit.,* pp. 122f, 207) considered the Munich portrait a Swabian work by the "Konterfetter of 1472." Salm accepts the attribution of the Thyssen portrait to Sebald Bopp. Stange dates the portrait closer in time to the male portrait in his group dated 1483, but this third portrait seems less to the point, given the very close relation of the other two, as does the attribution of all three to Bopp. Clearly the attribution is in part suggested by the artist's association with the House of Brandenburg-Ansbach and the Order of the Swan worn by the woman in the portrait, but the connection is tenuous and the visual evidence, at least to the extent that it is published, is less than convincing. Also, Stange published the Thyssen portrait as that of Beatrice Frangipani. (A copy of the Thyssen portrait is reproduced and identified as Beatrice Frangipani in R. Stillfried and S. Haenle, *Das Buch vom Schwanenorden,* Berlin, 1881, pl. 12.) She is, however, not connected with the House of Brandenburg-Ansbach until her marriage to George the Pious in 1509, and according to Stange, Bopp died in 1503. Salm rejects the

identification of Beatrice Frangipani on the basis of style and costume and places the portrait around 1485.

Elaborate pearl-embroidered costumes appear in two works by the "Ulmer Konterfetter of 1500" (Buchner, nos. 76 and 77). However, the costumes, dresses and headdresses are different in style, and the portraits are less severe and seem later in date. P. Strieder (Review of Buchner, *Kunstchronik,* 7, 1954, p. 48) cites such decoration on the costume of one of the daughters of Albert Achilles on the back of the Altar of the Knights of the Order of the Swan at Ansbach, 1486, and compares the Thyssen portrait stylistically, on the basis of color, to an altarwing with the Birth of the Virgin on one side and the Death of the Virgin on the other which he believes is probably from the Ansbach altar. It is certainly sensible to look for the painter of the Thyssen portrait among artists and works of art associated with the Order of the Swan and the court at Ansbach, but this approach has resulted in somewhat forced comparisons.

BERNHARD STRIGEL

Memmingen (Swabia) c. 1460–1528

34. THE ANNUNCIATION TO SAINT ANNE AND SAINT JOACHIM

Panel, 58×30 cm.

Inscribed on a scroll issuing from the angel's mouth: *Ego sum angelus domini ad te missus;* and on a scroll at bottom: *Anna Joach[ino] iusto evecta; Prece lacrimosa furata / E[x]pectat dona cel (...): U (...) confusionem: / Ambo capiunt for amen: Et (...).*

Provenance: R. Traumann, Madrid, 1912; in the collection of Robert von Hirsch by 1925; acquired 1978.

Literature: A. L. Mayer, "Madrider Privatsammlungen II. Die Gemälde der Sammlung R. Traumann," *Cicerone,* 1912, p. 97, fig. 7; A. Stange, *Deutsche Malerei der Gotik,* Munich, 1933, reprinted 1969, vol. 8, p. 143 (wrongly described as an Annunciation to the Virgin); J. Baum in U. Thieme and F. Becker, *Allgemeines Lexikon der Bildenden Künstler,* Leipzig, vol. 32, 1938, p. 188; G. Otto, *Bernhard Strigel,* Munich, 1964, pp. 30, 95, no. 18, pl. 61; A. Stange, *Kritisches Verzeichnis der deutschen Tafelbilder vor Dürer,* Munich, 1970, vol. 2, p. 203, no. 985a; Sotheby Parke Bernet, *The Robert von Hirsch Collection,* vol. 1, 1978, p. 191, no. 118; *Art at Auction: The Year at Sotheby Parke Bernet 1977–78,* London, 1978, pp. 12, 24, illus.

St. Anne is seated in the foreground weeping. She wears a deep red gown bordered in black at the neck, cuffs and hem, and a white wimple with which she dries her tears. She has a halo of two fine concentric gold lines. An angel with vigorously coarse features and a great head of fine golden curls, dressed in yellow and carrying a staff, approaches her from the right. A banderole issuing from his open mouth is inscribed with his salutation, but he tugs at her wimple to tell her the rest of the comforting news – that she will bear the child of which she had despaired in her old age. The view through the window shows the angelic annunciation to Joachim, who stands with shepherds and his flock in a landscape with a punched gold sky. The stone chamber is sparsely furnished with a cupboard and a wooden bench – with its neatly dovetailed construction shown – on which St. Anne is seated. The pavement is steeply pitched and the exaggerated angle at which St. Anne and the angel are joined to the rising ground, as well as the compressed volume of their complicated draperies, recall the condensed space and volumes and figure-ground relationship of late gothic carved altarpieces, or *Schnitzaltare.* The panel is cut at the bottom through the step in the foreground and the scroll with the legend. The subject is taken from *The Golden Legend,* chapter 131, by Jacob de Voragine.

The panel would seem to be part of an altarpiece; Stange (1969) originally connected the panel with the Schussenrieder altarpiece by Strigel in the Staatliche Museen, Berlin-Dahlem (nos. 24a and b), along with a pair of panels, *The Holy Family with Angels* and *The Infant St. John the Baptist* in Kunsthistorisches Museum in Vienna (nos. 1430a and b), from Strigel's workshop, but more recently (1970) only with the latter two which he suggests might be by Martin Schaffner around 1510. Otto *(loc, cit.)* supposes that the Thyssen panel is part of an altarpiece but does not relate it to other works. She does compare its iconography with a Marian cycle by Strigel or an assistant, painted on the wall of the tower of the Frauenkirche in Memmingen; although it is not clear if she considers the *Annunciation to Anna* in general or the detail with the annunciation to Joachim the rarer iconographic motif. She dates the picture in Lugano to 1506–07.

DUTCH

JAN VAN DE CAPPELLE
Amsterdam c. 1623/25–1679

35. CALM SEA WITH MANY SHIPS

Canvas, 60.1×68.9 cm. (Painted surface 58.8×67.3 cm.)
Signed lower left: *J. V. Cappelle*

Provenance: Jan de Kommer Sale, Amsterdam, 15 April 1767, no.51; Jane Seymour, Knoyle House, Salisbury; H. E. ten Cate, De Lutte near Oldenzaal, Holland; acquired 1964.

Literature: 1969 Catalogue, no.54; "A Notable Exhibition," *Burlington Magazine,* LXXI, 1937, p.90, illus. p.91; M. Russell, *Jan van de Cappelle: 1624/6–1679,* Leigh-on-Sea, 1975, no.741, p.71, fig.80.

Van de Cappelle, whose family owned a dye works, was a man of considerable wealth and property. He amassed a remarkable and extensive art collection with a concentration in marine pictures and drawings, especially the works of Simon de Vlieger, Jan Porcellis and Jan van Goyen. He also owned paintings by Rubens, Hals, Van Dyck, Brouwer, Hercules Seghers, Averkamp and Rembrandt, as well as more than 500 drawings by Rembrandt. He seems not to have studied with a particular master and his training was perhaps based on the study of paintings in his own collection, especially the "parade" compositions of de Vlieger. Rather than the open sea, van de Cappelle chose scenes of ships at rest in harbors and in the mouths of wide rivers which he must have sailed, making studies and notations, in his own pleasure yacht. He preferred the delicate half light of early morning and evening and the almost palpable calm which comes at those times of day. These are the fairly constant conditions of his finest marine paintings. The composition of the Thyssen picture at first glance gives the impression of an almost casual ease, of a random grouping of ships floating on the silky, still waters. The picture is, however, very carefully, tectonically structured. The long, low horizon, if partially obscured, is also reinforced by the concentration of ships and dramatized by the great height of the sky. This emphatic horizontality is then balanced by the persistent verticality of the masts. Despite the alley between the ships in the center of the composition the viewer's eye travels a path that is indirect and plotted by a succession of darker forms alternating from right to left. Similarly, there is a controlled calculation in the heights of the masts, which are perhaps exaggerated in the distance in order to slow the visual progression towards the horizon. The light emanates from the deepest space between the banks of ships – one of van de Cappelle's characteristic Avenues of Light. While some of the ships are turned so that their sails are saturated with the softly diffused sunlight, others are seen contrejour, in shadow, the light gently filtered through the weathered cloth of their sails. While there are variations in the quality of light in van de Cappelle's marine pictures, a golden light is most characteristic; the silvery grey tonality here, warmed by the yellows and red browns, occurs less frequently. Invariably there is more color used than is at first apparent, particularly in details such as sails and, as in this instance, the red, white and blue Dutch flags which flank the composition – hanging tattered and still on the barge to the left and streaming behind the rowboat to the right – so subtly are they harmonized with the prevailing monochromatic tonality and fused with the hazy light and moist atmosphere. The composition gives the impression of having originally extended further to the right, but Ebbinge-Wubben (1969 Catalogue) reports that the priming of the canvas extends to all sides of the picture and therefore has not been cut. The use of somewhat arbitrarily truncated ships, especially to the left, is not an uncommon compositional device of van de Cappelle's but it does remain slightly disturbing here. The picture is otherwise of the greatest refinement and shows the artist at the height of his powers. M. Russell suggests a date of around 1660. The form of the signature with the "pp" and "ll" rather than Capel or Capelle was used after 1651 (W. Stechow, *Signaturen holländischer Künstler,* Festschrift Eduard Trautscholdt, 1965, pp.115–16).

Van de Cappelle is perhaps the greatest of the seventeenth-century Dutch marine painters. The comparison with Claude is certainly gratuitous but not farfetched in van de Cappelle's astounding masterpiece, *A Calm* (Wallraf-Richartz Museum, Cologne), a work which anticipates the luminous effects and compositional daring of Turner.

WILLEM CLAESZ HEDA

1599–1680/82
Active primarily in Haarlem

36. STILL LIFE

Oak, 43.5×68 cm.
Signed and dated on the blade of the knife: *HEDA 1634f*

Provenance: Sale, Cologne, 15 May 1956, no.37; acquired 1958.

Literature: 1969 Catalogue, no.126.

In the 1630s Heda and the painter Pieter Claesz (1597/8–1661), who also worked in Haarlem, created their distinctive "breakfast pieces," still lifes so called because they suggest a light meal. The pictures are usually of a modest size and horizontal in format, composed with just a few objects placed on a table aligned with the picture plane against a neutral background. The tableware generally implies a comfortable if not luxurious household with, as in the present still life, such solidly handsome objects as the early seventeenth-century green glass rummer with ovoid cup and pinchpoint pedestal, plain pewter plates and occasionally a more elaborate piece like the fluted silver tazza, perhaps overturned here to better show its design. There are two types of breakfast pieces: either a meal just prepared and waiting, or one recently consumed. In the former, the cloth or napkin laid over the end of the table would still be fresh, and a herring cut into bite-size pieces on a pewter plate and a hard morning roll might be placed next to a beaker of beer with a still frothy head. Rather than a decorative arrangement of objects these pictures have an immediacy which suggests an actual diner, or, as in the Thyssen picture, someone who has just left off eating. The cloth is rumpled and covered with nut shells, the pastry half consumed, and the drink in the glass has gone flat. There are, of course, touches of artifice, as in the case of the overturned tazza and the spiraling lemon peel, a favorite device in Dutch seventeenth-century still lifes, and the broken rummer. The latter may simply be employed for formal variety or as a virtuoso turn and no drama or narrative is implied. It is very unlikely that these breakfast pieces have any symbolic pretension, but if there is some residue of the moralizing tradition about them, a Vanitas theme, then the broken glass could possibly allude to the fragility of life and the half-consumed pastry to a meal suddenly interrupted. The objects are carefully composed, gently graded in height from right to left and from foreground to back, and buttressed respectively in both directions by the lower forms of the pewter plate with nuts and the broken glass. Heda is celebrated for the quality of light in his still lifes, and the Thyssen picture is filled with a silvery, softly diffused morning light from the windows reflected in the glass. There are no strong contrasts of light and shade, but the objects are given considerable relief and there is a great sensitivity to the variety of textures and surfaces. The warm, greyed background is gently washed with light, with a blush of slightly stronger illumination directly behind the rummer and silver tazza. The tonality of these still lifes is consistent with that in contemporary landscape paintings, in the so-called tonal landscapes of Salomon van Ruysdael and Jan van Goyen. Color, like light, is employed with remarkable effect within a very proscribed range; the objects themselves are rather subdued in color, and even the lemon which might provide a brilliant, sharp accent is here subtly integrated within the basically monochromatic scheme. Heda's later still lifes are larger, and the compositions become more grandiose and decorative, perhaps under the influence of Flemish still-life painting. The sober dignity and warmth of the works of his classic period, such as the Thyssen still life, must have been greatly admired by Chardin. Heda painted a simpler version of this composition in 1638, now in the Queen's Collection, Buckingham Palace, London.

JAN DAVIDSZ DE HEEM

Utrecht 1606 – Antwerp 1683/84

37. STILL LIFE WITH FLOWERS

Oak, 54.5×41 cm.
Signed upper right: *JD De Heem*

Provenance: Private Collection, England; acquired 1964.

Literature: 1969 Catalogue, no.128.

De Heem studied in Utrecht under Balthasar van der Ast who trained him in the painting

of elaborately composed and meticulously detailed flower pieces. From 1625–29 he was in Leiden where he specialized in Vanitas pictures, favoring those of piles of old worn books signifying the vanity of scholarly life, and forsaking the bright palette of his flower pieces for subtle tones of grey and ochre. He also painted "breakfast pieces" in the style of Pieter Claesz and Willem Claesz Heda (see no. 36). From the beginning he showed an extraordinary sensitivity to the nuances of color and tonal values. In 1636 he moved to Antwerp where, according to Sandrat, "one could have rare fruit of all kinds, large plums, peaches, cherries, oranges, lemons, grapes, and others in finer condition and state of ripeness to draw from life." Antwerp also offered him models of still-life painting in the grander, more opulent Flemish tradition, the work of Snyders, Adrian van Utrecht and Daniel Seghers, which the artist was quick to assimilate. In the large canvas by de Heem in the Louvre dated 1640, a table, within an architectural setting hung with great theatrical sweeps of drapery, is heaped with a profusion of food and vessels dominated by a large, tipped bowl filled with the luxurious, perfect fruits the artist sought in Antwerp. There is a great metal wine cooler and a lute placed at the sides of the table and all sorts of other paraphernalia and trappings. It is his most ambitous essay in the Flemish manner, brilliantly composed and glorious in color. The Thyssen flower piece, although a more conservative work, is also from his Antwerp period and shows the influence of Daniel Seghers. The prim symmetry of his earlier teacher, Balthasar van der Ast, has given way to a freer, more extravagant arrangement of the flowers and fruits; but the glass carafe is still centered and the carefully defined circular outline of the bouquet, completed below by the trailing cherries and the delicate branch of oak, is clearly apparent against the dark background. Within this formally balanced structure the flowers are so arranged as to create a lively if studied sense of movement. The concentration of larger flowers establishes a diagonal movement from the striped tulip at the top right, through the peonies to the spray of cherry blossoms at the lower left. The density of the heavier blooms is relieved by the juxtaposition of smaller, more delicate flowers; and the serpentine stalks of grain, the curling leaves and the heavily nodding or staunchly upright larger flowers all have an animated, gestural quality. On the other hand the butterflies, snails and the like seem as fixed in their movement as the reflection of the window in the carafe. The individual elements are recorded with the greatest fidelity and attention to texture and character, but they are brought into such detailed focus and so heightened in luminosity and color against the dark background that they have a somewhat unnaturally vivid presence. The fascination of the piece lies in exactly this interplay between naturalism and artifice. The short-lived beauty of flowers connoted the brevity of life for the seventeenth-century viewer, and while such flower pieces were generally understood as Vanitas pictures, such a meaning might no longer be central to de Heem's still life. Traditionally, almost all the plants and insects in the still life have symbolic meaning, and while a systematic inventory was surely never intended, some might still apply here. The peony was associated by Camerarius in his *Symbolorum* of 1590 with transitory voluptuousness, a gorgeous image; and the ears of grain, surprising in the context of the fruits and flowers but frequent in de Heem's arrangements, may indeed be eucharistic symbols. De Heem was to make his home in Antwerp until his death, although he did take leave of the city from time to time and was back in his native Leiden from 1669–72. While more decidedly Flemish than Dutch in his mature work, he provided an important link between the two schools and his influence on still-life painting was considerable.

PIETER DE HOOCH
Rotterdam 1629 – Amsterdam (?) after 1684

38. INTERIOR OF THE COUNCIL CHAMBER OF BURGOMASTERS IN THE TOWN HALL IN AMSTERDAM, WITH VISITORS

Canvas, 112×99 cm.
Signed lower left: *PD Hooch*

Provenance: Count of Stackelberg, Estonia (1907); W. J. R. Dreesmann Sale, Amsterdam, Frederik Muller, 22–25 March 1960, no. 4; acquired 1960.

Literature: 1969 Catalogue, no. 139; J. Rosenberg, S. Slive, E. H. ter Kuile, *Dutch Art and Architecture: 1600–1800*, Baltimore, 1972, p. 217, fig. 166.

De Hooch's paintings of the early 1660s, after his move to Amsterdam, still retain the intimacy and substance of his "classic" period in Delft. The finest of his pictures are those modest but comfortable interiors or street scenes constructed like Chinese puzzle-boxes in their linear and spatial permutations. The light is warm, finely observed, and richly varied in intensity and effect, with subtle gradations or dramatic constrasts of light and shade. The light is often as complicated in its play and structure as the space. His colors, too, are drawn from a broad spectrum and range considerably in brilliance and depth. The figures, well-to-do burghers at some homely occupation or pastime, have a quiet dignity and the pictures radiate a profound satisfaction and pleasure in the definition of a familiar and reassuring world. In the late 1660s de Hooch becomes susceptible to the opulent fashions and classicizing style cultivated in France under Louis XIV and which had then begun to take hold in Holland. The taste is for grand interiors with an emphasis on rich furnishings and decorations. De Hooch's domestic interiors become overburdened with such trappings, and the figures in these scenes, elegantly dressed and carrying on in "high style," are often rather self-consciously animated.

In such a spirit de Hooch turned to the marble halls of the recently completed town hall of Amsterdam. The Town Hall (which is today the Royal Palace) was built between 1648 and 1664 after the design of Jacob van Campen. The Burgomaster's Council Room (today called Van Speyk Hall) is on the main floor, immediately to the south of the principal façade on the Dam. The Town Hall was the most splendid of its kind in Europe at the time. Although not completed until 1664 this part of the building was cermonially opened on 29 July 1655. The Thyssen painting is, in effect, a topographical picture and a rare document, as it is the only one which shows the hall in its original condition. The great baroque drapery, an example of the grand effects employed by the artist, is here pulled to the side to reveal the large, splendidly decorated vaulted chamber, one of the richest ornaments of the city.

The pavement is of black and white marble, the coffers of the ceiling are painted, and the walls are hung with red and blue striped material which is pulled to the side at the left to uncover the doorway. The lower parts of the windows are fitted with red shutters, open here to the view onto the Dam. The principal decorations of the hall are the great marble fireplaces surmounted by vast canvases. The young gallant in the foreground is looking at the painting over the fireplace on the south wall which corresponds to the viewer's position. The high mantlepieces, supported by columns and pilasters, have elaborately sculptured friezes which include the old coat of arms of Amsterdam on the north side and the new on the south. The iconographic programs of the friezes allude to good government, as do the subjects of the paintings. They represent scenes showing the virtues of the Roman Consuls Gaius Fabricius and Curius Dentatus, *exempla virtute* which depict the moderation and steadfastness of the good governor, uncorrupted by bribes and unshaken by threats. The composition shown in the de Hooch is the Gaius Fabricius by Ferdinand Bol, 1656, with an accompanying verse by the seventeenth-century Dutch poet Joost van den Vondel inscribed below on the mantelpiece. The table, covered with a rug, where the Burgomasters used to sit is placed beneath this painting. The composition on the opposite wall is *The Virtuousness of Marcus Curius Dentatus* by Govaert Flinck. Some of the visitors, such as the family milling round the table, are rather simply dressed, while the dandy in the foreground is dressed in the beribboned height of fashion. The painting is generally dated 1666 to 1668 when de Hooch was already well-disposed to such subjects. The picture is one of the most splendid in this genre, but by the time of its execution the artist's style had already weakened and become more decorative. His use of color and the effect of light is thinner and more generalized. The old man and woman to the left are rather wooden and poorly drawn, and the woman standing before the window to the right will bear rather sad comparison with a similar figure in a work of de Hooch's Delft period, the woman standing in the light-flooded passageway in *A Maid with a Child in a Court* (1658) in the National Gallery in London.

There is a pentimento of the dog to the left of its present position in the foreground of the composition.

WILLEM KALF
Rotterdam 1619–Amsterdam 1693

39. STILL LIFE WITH NAUTILUS CUP

Canvas, 79×67 cm.
Signed upper left: *W. Kalf;* dated upper right: *A° 1662*

Provenance: Count Alexis Orloff-Davidoff, St. Petersburg; M. van Gelder, Uccle near Brussels; H. E. ten Cate, De Lutte near Oldenzaal, Holland; acquired 1962.

Literature: 1969 Catalogue, no. 150; J. Rosenberg, S. Slive, E. H. ter Kuile, *Dutch Art and Architecture: 1600–1800,* Baltimore, 1972, p. 341, fig. 268; L. Grisebach, *Willem Kalf: 1619–1693,* Berlin, 1974, pp. 117, 151, 173f., no. 117, pp. 266–267, fig. 128; A. de Gaigneron, "Nouveau regard sur la collection Thyssen," *Connaissance des Arts,* 306, 1977, p. 57, fig. 12; M. Wohlgemuth, "Willem Kalfs Stilleben der Amsterdamer Periode: Zwei Bilder der Sammlungen Bührle und Thyssen," *Der Landbote,* Winterthur, July 8, 1978, pp. 23–25, fig. p. 23.

Exhibitions: Brussels, 1971, Palais des Beaux Arts, *Rembrandt et son temps,* no. 58 with fig., p. 77.

Still Life with Nautilus Cup is perhaps the finest of Kalf's *pronkstilleven,* or luxurious still lifes (*pronk* meaning "show" or "ostentation"). Many of the precious objects in Kalf's still lifes appear in several compositions and may have been borrowed or drawn from his stock in trade as a dealer in works of art. The nautilus cup, possibly a late sixteenth-century work by the Utrecht silversmith Jan Jacobsz. van Royenstein, is an especially extravagant invention. The shell, supported by a triton, is ingeniously mounted as a monstrous fish surmounted by Neptune brandishing the trident. The small figure running before the gaping jaws lined with needle sharp teeth is no doubt Jonah. Light falling from the upper left glows softly through the translucent shell and reflects from the goldwork in precise highlights. The three principal objects are placed in graduated relation to the light. The tall lidded goblet, *à la façon de Venise,* looming mysteriously in the background is the furthest removed and is defined by the light filtered through the clear rose-colored wine and scattered over the crown like dying fireworks against a night sky.

The Ming bowl with high relief figures of the Eight Taoist Immortals, probably dating from the reign of the Emperor Wan Li (1573–1619), is placed forward in the light which reflects brilliantly off the white ground of the porcelain. An ornately worked silver spoon, propped in the sugar, provides a gestural and compositionally important accent against the unrelieved background. The Ming bowl sits on a silver platter richly decorated in the lobe style characteristic of Dutch silver of the first half of the seventeenth century. The agate-handled knife placed next to the half-peeled lemon is the only suggestion of human presence or activity in the still life. The pitted, spongey skin, the ragged edge of the peel and the juice-beaded flesh of the lemon, itself a luxury in the north, are foils to the elaborately fashioned *objets de luxe.*

The acid color, the saturated light and eccentric silhouette of the lemon suddenly quicken the composition; the spiraling peel, a favorite virtuoso turn of Kalf's, articulates the foreground space. The persian carpet lends a sonorous bass line to this extraordinary orchestration of light, color, shapes and textures. A simpler, minor theme is introduced at the right in the solid forms of the beaker and orange, and the nut and shells perched on the corner of the marble table are like a *diminuendo* or little coda. Such opulent displays were of course understood as Vanitas, reminders by attraction of the transiency of the life of the senses and the worthlessness of earthly treasures. The figure of Jonah fleeing before the fish on the nautilus cup, which appears in no other representations of such cups by Kalf, might have been added by the artist as a reminder of Redemption amidst the dazzling and tempting objects (Grisebach, *op. cit.,* p. 173f.).

To whatever extent the dramatic chiaroscuro reflects the influence of Rembrandt, the aesthetic or formal effect is very different. Kalf's affinity with Rembrandt lies more in the philosophical gravity and ambition of his late still lifes, especially in the very great example in the Thyssen collection. The composition invites contemplation rather than sensuous experience, the arrangement of objects appears immutable and at a remove from immediate reality.

The clear, intense colors and the quiet perfection of the composition invite comparison with the art of Vermeer. The technique of highlighting in small concentrated points of color recalls the similar effect in Vermeer's

paintings – and Kalf, too, may have availed himself of a mechanical device such as the camera obscura. This would also explain the sudden projection of elements in the foreground.

There are two copies of the Thyssen picture but neither is by Kalf: one in the Göteborgs Konstmuseum, Göteborg (inv. no. 708), attributed to Kalf's follower, Jurriaen van Streek; another in the Bank voor Handel en Scheepvart in Rotterdam.

JOOS DE MOMPER
Antwerp 1564–1634

40. VIEW OF A PORT, WITH MOTIFS FROM ROME

Oak, 50×93 cm.
Signed lower left with initials: *IDM*

Provenance: Baroness Isbary, Vienna; acquired 1967.

Literature: 1969 Catalogue, no. 218.

Joos de Momper's most characteristic landscapes are spacious, panoramic views of ranges of mountains, invariably with small figures of travelers in the foreground – staffage figures which are often the work of other artists. He must have known the landscapes of Pieter Breughel the Elder although it is most probable that, like Breughel, de Momper was himself similarly inspired by the Alps on a trip to Italy. The mannerist device of creating an atmospheric recession into depth by a sequence of predominantly brown, green and blue zones of color, as in the landscapes of Paul Brill, persists in his early landscapes and lingers in *View of a Port with Motifs of Rome*. The painting is unusual in de Momper's œuvre because of the subject and also because it bears a monogram, IDM, a distinction which it shares with four other landscapes originally in a private collection in Vienna and a fifth in the Gemäldegalerie in Dresden. All are of the same dimensions, have southern motifs and must have formed a series of ideal views. De Momper could have derived the Castel Sant' Angelo from prints, but if he did indeed make a trip to Rome, which seems very likely, and possibly a second journey as well, then he would have had first-hand knowledge of the monument

and would have known what the shores of the Tiber were like at the time. As in his mountain landscapes, the vantage point is high and the foreground expansive and with little immediate relief. The bit of embankment and house with drying laundry to the right is peripheral, and the viewer is drawn further on in space to the picturesque group of houses on the quay to the left. The scene is lively with the activity of men unloading barrels from boats, and the group of well-dressed men standing about must be merchants. The houses are charmingly lopsided with rickety stairs and trellises going off at different angles – the sort of buildings one might expect along the waterfront. The facing side of the central house is awash with warm, low sunlight which also strikes the clouds behind. The right side of the house and the large, masted boats are in the deepest shadow and give a more dramatic perspective on the Castel Sant'Angelo across the river. The hills in the background immediately behind the Castello might fairly suggest the view across the Tiber towards Monte Mario, and even the rise to the right in the area of the Pincio might have some basis in reality.

Several versions of this landscape exist, of varying degrees of fidelity in composition and dimension, but none of the others bear the monogram. The Thyssen picture, like the other related ideal landscapes, is dated late in de Momper's career and because of the southern motifs may relate to a possible second journey to Italy.

FRANS JANSZ POST
Haarlem 1612 (baptized) –1680

41. VILLAGE WITH "CASA-GRANDE" IN BRAZIL

Oak, 37×54 cm.
Signed and dated lower right: *F. Post 1656*

Provenance: Private Collection, Vienna; acquired 1958.

Literature: 1969 Catalogue, no. 254; J. de Sousa-Leão, *Frans Post: 1612–1680*, Amsterdam, 1973, no. 23, p. 73, with illus.

The signal event in Post's life was his journey in the retinue of Count Johan Maurits of Nassau-Siegen on his expedition to the north-

eastern part of Brazil to consolidate the position of the Dutch West India Company there. Post was in Brazil from 1637–44, during which time he not only painted landscapes but made drawings and sketches which were to provide him with motifs after his return to Haarlem. Those painted in Brazil are in fact the first landscapes painted by a European in the New World.

Village with "Casa-Grande" is one of the works executed by Post after his return from Brazil. The painting shows a typical *aldeia* – a small village, or perhaps more correctly a plantation compound, in the interior. The Casa-Grande of the owner or overseer of the plantation, where mostly sugar cane was grown, is to the left; a priest and monk stand before the chapel, which is surrounded by the workers' huts. All the buildings are rather flimsy, distinguished one from the other mostly by variations in size and state of decay. On the slope in the foreground a group of workers have laid down their baskets for a bit of impromptu merrymaking and dancing; the "simple, happy natives." There is a large pond in the center and the low rolling hills in the background are planted with sugar cane. Post repeated this compositional formula numerous times with only slight variation, such as palm trees or heavier foliage in the foreground. His specialization in these Brazilian views, dependent as they were on drawings and original impressions, kept Post apart from contemporary developments in Dutch landscape painting. His style of landscape painting is, in fact, archaic, with it's bird's-eye view and dark *coulisse* of trees in the foreground; the progression of defined strong areas of color from brown, green and blue, foreground to background, to suggest distance and atmosphere recalls such organization in late mannerist landscapes. But such outmoded methods sit rather happily with Post's curious genre, and his pictures continue to exert the charm they must have held for his contemporaries.

REMBRANDT HARMENSZ VAN RIJN
Leiden 1606 – Amsterdam 1669

42. PORTRAIT OF A MAN BEFORE AN ARCHWAY

Canvas, 106×78.7 cm.
Signed and dated lower right: *Rem...f 164*

Provenance: Jurriaans, Amsterdam (1817); Thomas Emerson Gallery, London (1836); Collection Alfred Morrison, Carlton House Terrace, London; Collection Hugh Morrison, Fonthill; Lord Margadale of Island, Fonthill House, Tisbury, Wilshire; acquired 1976.

Literature: J. Smith, *A Catalogue Raisonné of the Works of the Most Prominent Dutch, Flemish, and French Painters,* 1886, vol. VII, no. 339; E. Michel, *Rembrandt,* 1893, p. 558, no. 433; W. Bode and C. Hofstede de Groot, *The Complete Work of Rembrandt,* 1897, no. 287; W. R. Valentine, *Rembrandt, Des Meisters Gemälde. Klassiker der Kunst,* Berlin, 1909, no. 267; C. Hofstede de Groot, *A Catalogue Raisonné of the Works of the Most Eminent Dutch Painters of the Seventeenth Century,* 1916, vol. VI, no. 747; A. Bredins, *The Paintings of Rembrandt (Rembrandt Gemälde),* Vienna, 1935, no. 222; K. Bauch, *Rembrandt Gemälde,* Berlin, 1966, no. 390; H. Gerson, *Rembrandt Paintings,* Amsterdam, 1968, p. 342, no. 246; A. Bredius (rev. H. Gerson), *Rembrandt, The Complete Edition of Paintings,* London, 1969, no. 180; D. Lecaldano, *The Complete Paintings of Rembrandt,* London, 1973, p. 111, no. 252; J. Bolten and H. Bolton-Rempt, *The Hidden Rembrandt,* Oxford, 1978, p. 190, no. 317.

Exhibitions: London, Royal Academy, *Old Masters on Canvas,* 1892, no. 129; London, Royal Academy, *Works by Rembrandt,* 1899, no. 62; London, Grosvenor Gallery, *National Loan Exhibition,* 1914, no. 6; London, Royal Academy, *Dutch Art,* 1929, no. 147.

A man in his middle years, shown in half-length, stands before an archway. The face is handsome with large expressive eyes, aquiline nose, a mustache and goatee. Thick, curly blond hair shows beneath the broad brim of the hat. The heavy black cloth of his costume is richly worked, ribbed and appliquéd, and he wears a wide, starched ruff and cuffs trimmed with lace. The light is dramatically concentrated on the left side of the face and ruff, the shoulder, cuff and hand. The rest of the figure is enveloped in deep shadow. The dark background and dimly defined archway, as well as the man's stance, with his cape drawn round under his arm, lend a slightly melodramatic air to the portrait, as if he had suddenly stopped and turned in his path. There are inconsistent reports in the lit-

erature as to the completeness of the signature and the date; the latter is repeatedly given as 1643 with the exception of Gerson, who records only the first three numerals: 164.

Whether the "3" exists or ever existed, the picture would not seem to date later than 1643, and without the evidence of the third numeral one might be inclined to date it earlier than the fourth decade. The precise and conspicuous details of the costume recall portraits of the thirties, and the little fillip of the curl of the cuff, the edge frosted with light, is a surprising attention given Rembrandt's increased breadth of handling in the forties. Though less overtly expressive, there is a somewhat restrained alacrity and commanding elegance about the sitter which would also bear interesting comparison with the earlier portraits, even those of the first half of the thirties. Such observations are not intended to question the evidence of a date in the forties; and a certain stylistic ambivalence in the early part of the decade, a complicated juncture in Rembrandt's development, is understandable. On the other hand, the face is painted with great breadth, richly impasted and glazed, and powerfully modeled, all the more startling because of its juxtaposition with the tightly rendered ruff. The man's expression suggests that he is distracted from his "attitude" by some sobering reflections. It is in the forties that Rembrandt becomes increasingly fascinated with such expressions of unguarded intimacy, of vulnerability and isolation.

If the Thyssen portrait is still somewhat stylistically unresolved and tentative in characterization, it is nevertheless a brilliant piece of painting which already gives a good measure of Rembrandt's later powers and more profound preoccupations.

JACOB ISAACKSZ VAN RUISDAEL
Haarlem 1628/29–1682

43. WINTER LANDSCAPE

Canvas, 64.5×93.5 cm.
Signed below: *JvRuisdael* (JvR joined)

Provenance: Jan Gildemeester Jansz. Sale, Amsterdam, 11 June 1800, no.191 (fl.825 to Labouchère); Sir

S.Clarke, Bt., Sale, London, 14–15 May 1802 (£73.10s); Sir Simon H.Clarke, Bt. (Oakhill, Herts.) Sale, London, 8–9 May 1840 (£210); Sir E.H.Scott, Bt., Sale, London, 21 November 1934, no.117, with illus.; acquired 1934.

Literature: 1969 Catalogue, no.273.

Ruisdael is the great poet of the seventeenth-century Dutch landscape painters. If he drew inspiration during his *Wanderjahre* (from about 1650–55) from the more dramatic landscapes of Germany, he was always able from his earliest years to find an heroic dimension in his often unpromising native countryside. Unlike the Italianate Dutch landscape painters, he was neither tempted by the classical landscape style of Claude Lorrain, nor did he have recourse to the paraphernalia of antiquity, of ancient temples or ruins. But he was attentive and faithful to the variety and grandeur of Nature – to the forms of great, venerable trees, the mysteries of undisturbed forests, the sweep of dunes or the coastline, and most of all to the movement of clouds over the low-lying Dutch landscape. His earlier pictures depended to a great extent on large, heavy foreground elements for their effect, but after he settled in Amsterdam, about 1656, his compositions, possibly under the influence of the panoramic views of Philips Koninck, opened with a longer, more contemplative view. Often there is little to lead us to the distant horizon but a road and a few small trees, roof tops, or patches of sun breaking through the overcast sky, but the movement through space is both exhilarating and moving. Winter landscapes form a special category within Ruisdael's œuvre and occupy a special place within that genre in Dutch seventeenth-century landscape painting: "It is as though greatness in the interpretation of winter as a drama had been reserved for one single artist: Jacob van Ruisdael." (W.Stechow, *Dutch Landscape Painting of the Seventeenth Century,* London, 1966, p.96.)

In Ruisdael's deeply moving *Winter Landscape* in the Rijksmuseum, Amsterdam, the small figures move slowly in the bleak stillness towards a group of houses silhouetted against a sky dense with ominous, leaden clouds. The trail of smoke from a chimney promises little consolation in the unyielding and oppressive gloom. The looming verticality of a house isolated against the sky conveys

a feeling of loneliness and fragility as do the bare branches of the trees and the mast of a ship. The compositional structure of the Thyssen picture, the diagonal frozen waterway leading into depth from right to left, the clouds rolling up and out in the distance in a countermovement, is essentially the same as in the Amsterdam painting, but the season here presents a less intimidating prospect. This is in part due to the horizontal format where the effect of the low-lying groups of houses, less dwarfed by the sky, is more intimate and less forbidding. The boats are heaped picturesquely and the feathery, iced tree to the left cuts a very pretty ornamental figure. Even the dark clouds look thinner, less threatening and on the move, and the figures here stroll about, fall on their bottoms, ice skate and have snowball fights. The rich ochres of the warehouses in the middleground glow warmly against the cold blue-grey clouds in the reflected winter light.

Stechow places the Thyssen picture among the very last of Ruisdael's winter landscapes, in his very late period when the artist's powers begin to slacken (*op. cit.,* p.97). Surely Stechow does not begrudge Ruisdael this lighter mood, although the artist is most impressive in his more solemn interpretations of nature, but the winter landscape in Lugano does seem more matter-of-factly painted than the finest of Ruisdael's work in this genre, to make only that comparison. The values are wonderfully true, the lights and darks are broadly and masterfully massed, and the clouds, as always in Ruisdael, are painted as if by second nature. But there are also signs of simplification rather than breadth of handling, a mechanical facility in the schematically rendered trees and even a certain indifference in the rendering of the figures.

SALOMON VAN RUYSDAEL
Naarden in Gooiland 1600/3(?) – Haarlem 1670

44. RETURN OF THE FISHERMEN

Oak, 46×63 cm.
Signed with monogram and dated: *1660* or *1666*

Provenance: Perhaps sold in Leiden, Aug. 26, 1788, 127 "Blick auf den Kanal bei Voorschooten," fl. 100, to van Zante; C. Sedelmeyer, Paris, 1906; E. Kann Collection, Paris, 1911; T. Agnew, London; D. Heinemann, Munich; Thyssen-Bornemisza Collection, Lugano; P. de Boer, Amsterdam; Matthiesen Gallery, London; H. Becker Collection, Dortmund; acquired 1976.

Literature: A. L. Mayer, *Pantheon,* 1, 1928, p. 112, fig. p. 110; R. Heinemann, *Catalogue Sammlung Schloss Rohoncz,* Lugano-Castagnola, 1937, no. 376, p. 137, pl. 154 (with bibliography); W. Stechow, *Salomon von Ruysdael, eine Einführung in seine Kunst,* Berlin, 1938, no. 293, p. 101; *Catalogue of the H. Becker Collection,* Dortmund, 1967, no. 82; W. Stechow, *Salomon van Ruysdael, eine Einführung in seine Kunst,* Berlin, 1975, no. 293, p. 112.

Exhibitions: Paris, 1911, 138 (Ausstellungswerk van Dayot no. 147); Munich, Neue Pinakothek, *Sammlung Schloss Rohoncz,* 1930, no. 292, pl. 60 (with false date 1645); Delft, 1952, 65; Amsterdam, P. de Boer, 1952, no. 48; Essen, Villa Hügel, Kunstwerke aus Kirchen, Museen und Privatbesitz, p. 15, no. 13b; Dortmund, Schloss Cappenburg, 1954, 49.

In the 1630s Salomon van Ruysdael developed his celebrated tonal landscapes, very close in style, if more subdued in mood, to those of Jan van Goyen. His gently lyric river scenes are the most memorable of this period. They are usually quite simply composed, mostly sky and water, and often in the middleground a strand banked with feathery trees recedes softly into the distance, reflected in the still surface of the river. A small boat or barrel may dot the water, but there is little pictorial or anecdotal incident to intrude on the stillness. These scenes are most affecting in the way the artist is able to capture the moist, silvery atmosphere of Holland. His palette is almost monochromatic, delicate harmonies of subtly modulated shades of grey, cool greens and yellows.

In the mid-1640s, under the influence of the younger generation (his more famous nephew among them), his compositions become more adventurous, his colors more full-bodied; the air has cleared to reveal skies shot with the colors of a sunset. *Return of the Fishermen,* a late work of the 1660s (the date is either 1660 or 1666), is a very ripe example of this development. At this stage his color becomes darker and more emphatic; the sky here is brilliant with great banks of clouds, streaked with orange by the setting sun and deep blue against the light. The picturesque silhouettes of the shoreline, houses and fishing boats are dramatically clustered to the left

against the stretch of open water, where the sense of space is heightened by the few small boats heading home. The distance is emphasized by the diagonal opposition of the darkest stretch of shoreline in the foreground and the small pocket of light sky on the horizon at the extreme right. An especially nice detail is the fisherman with his wife in the rowboat in the right foreground. The figures in the larger boats are barely indicated but sufficiently so to communicate their activity and the marvelous sense of the end of the day.

JAN STEEN
Leiden 1625/26–1679

45. SELF PORTRAIT

Oak, 55.5×44 cm.
Signed below, right: *JSteen* (joined)

Provenance: Sir George Yonge, Bart., Sale, London, 24–25 March 1806, no. 68; J. A. Brentano, Sale, Amsterdam, 13 May 1822, no. 324 ("Fiks en geestig gepenseeld"); A. M. Meynts Sale, Amsterdam, 15 July 1823, no. 120; J. G. Baron Verstolk van Soelen, The Hague; obtained from Verstolk van Soelen Collection 1846 by Thomas Barin, London, bequeathed by him to his cousin Lord Northbrook; Earl of Northbrook, London; acquired before 1930.

Literature: 1969 Catalogue, no. 287; J. S. Held, "Jan Steen," *Encyclopedia of World Art*, vol. 13, New York, 1967, col. 374; H. W. Groon, "Jan Steen," *Kindlers Malerei Lexikon*, vol. 5, fig. p. 422; J. Rosenberg, S. Slive, E. H. ter Kuile, *Dutch Art and Architecture: 1600–1800*, Baltimore, 1972, p. 230, fig. 182; O. T. Banks, *Watteau and the North: Studies in the Dutch and Flemish Baroque Influences on French Rococo Painting*, Diss., Princeton, 1975, Garland Series, New York-London, 1977, p. 187, fig. 127; A. de Gaigneron, "Nouveau regard sur la collection Thyssen," *Connaissance des Arts*, 306, 1977, p. 56, fig. 10; B. D. Kirschenbaum, *The Religious and Historical Paintings of Jan Steen*, New York, 1977, p. 78, fig. 108.

Jan Steen's good-natured face is familiar from the many genre scenes in which he portrayed himself – carousing with his family and laughingly offering a pipe to his young son, poking fun at himself as a flattered and deceived old rake, or feasting on oysters. He painted very few formal portraits, and then perhaps only under duress to meet some bills. There is only one instance (in the Rijksmuseum, Amsterdam) in which Steen, in Sunday best, striking a dignified attitude, painted a traditional self-portrait. In other cases where the artist takes himself as a subject alone he is invariably cast in some character role. The Thyssen portrait is an especially playful characterization; he is dressed in the romantic-gallant costume worn by lovers in the Dutch seventeenth-century theater. The mandolin, guitar and lute are the traditional instruments with which they wooed their ladies. There is a marvelous toss to his head, an expectant glint in his eyes, a bit of self-mockery and a great deal of amusement in his broadly smiling face. Steen loved the theater; he frequently drew on theatrical subjects in his paintings and included figures dressed in the costumes of the Italian commedia dell'arte as well as the contemporary Dutch theater. Judging from Steen's age in the portrait, it must date from the 1660s when he was in Haarlem, and the influence of Hals might account for the swagger of the pose and the somewhat greater breadth of handling. The style of the painting, however, still depends on the formative influence of the Leiden school, with a preference for finely drawn and painted small-scale figures. The hands, poised with the lute, are especially fine and beautifully drawn. The paint is thinly applied, and the ground shows in the hastily painted green drapery behind. But even in the more highly finished figure the paint is still thinly applied, the touch fine and fluid. The still life, the silver tankard, the books, sketch pad and brush are painted with both delicacy and brio. The color is low in key, essentially earth colors – greens and browns and pale orange; but even when Steen's palette is richer it is always, as here, unified by a silvery tonality.

The portrait is a wonderful souvenir of this great Bohemian and master of revels; one feels both his wit and his warmth.

FRENCH

FRANÇOIS BOUCHER
Paris 1703–1770

46. LA TOILETTE

Canvas, 52.5×66.5 cm.
Signed and dated lower left: *f. Boucher, 1742*

Provenance: Count Karl Gustav Tessin, Paris; Count Karl Gustav Tessin, Akerö, Sweden; L. Masreliez, Stockholm; Baron E. Cederström, Löfsta, Sweden; Baron Nathaniel Rothschild, Vienna; Baron Alphonse Rothschild, Vienna; Rosenberg and Stiebel, New York; acquired 1967.

Literature: 1969 Catalogue, no. 39; C. Sterling (R. Heinemann, ed.) *Sammlung Thyssen-Bornemisza,* Lugano-Castagnola, 1971, no. 39, pp. 49–51, pl. 307; A. Ananoff, *François Boucher,* Lausanne-Paris, 1976, vol. 1, no. 208, p. 324, fig. 643; A. de Gaigneron, "Nouveau regard sur la Collection Thyssen," *Connaissance des Arts,* 306, August 1977, p. 58, fig. 15.

A fashionable young woman sits close to the fire, doing up her stocking. Still in the plain white duster worn while her maquillage was applied and her hair powdered, she turns to look at the bonnet her maid offers for her approval. The young mistress is Boucher's creature *par excellence,* with her complacent, pretty little face, creamy complexion, small, full breasts and elegantly turned leg. She appears in many guises in Boucher's work, never greatly distinguished except by costume, or lack of costume; and one wonders at Madame Pompadour's use of Boucher to depict the young girls retained at the Parc aux Cerfs at Versailles when she wished to interest the King in a "new face." Her deshabille and her pose are charmingly provocative and, lest we miss the point, a cat playing with a ball of thread is placed within the shelter of her raised petticoats. The maid is exquisitely posed, and her costume – subtly striped in the palest mauve and green – is perhaps the finest bit of painting in the picture. The eye is constantly distracted and delighted by the profusion of detail, the picturesque disarray of bibelots and all the accoutrements of a pampered life. What seems to be a pastel portrait by Rosalba Carriera peers above the screen, decorated with yellow ground Chinese bird paintings. (This same screen appears in the portrait of Madame Boucher in the Frick Collection, New York.) There is an abundance of crumpled silks and taffetas: the hanging seen through the glazed door, the draped mirror, and the fur-trimmed wrap thrown carelessly on the chair. A bellows, sweep, and painted fan lie on the floor; a sewing bag hangs waiting on the firescreen; and the mantel is laden with objects: a lighted candle in a silver bougie, a letter, a lidded porcelain bowl with ormolou mounts, a ceramic bird and ribbons. A steaming pot of tea with cups and saucers stands on a table beside our little *élégante.*

Boucher's appeal as a colorist, as in all aspects of his art, is immediate and uncomplicated. The brilliant, colorful effect of *La Toilette* depends basically on primary colors: red, blue and yellow, highly saturated, only slighted modified throughout the composition, and distributed with the sure eye of a great decorator. Color has the intensity of pure paint rather than the simulation of color under the conditions of light and shade. Ananoff *(loc. cit.)* published two drawings in relation to *La Toilette:* one for the figure of the young woman tying her garter (Musée des Beaux-Arts d'Orléans, dossier Fourché, no. 322 M, att. to Fragonard; a copy according to Sterling), and another in which the connection may be superficial, but which might have been adapted for the figure of the maid (Collection F. Lugt, Institute Neerlandais, Paris). The picture, dated 1742, was acquired directly from Boucher by Count Karl Gustav Tessin, Swedish Ambassador to France from 1736–42, and a friend and patron of Boucher. In 1745 Tessin ordered a series of four pictures from Boucher representing "The Hours of the Day of a Fashionable Lady." Only one picture from this series is known, possibly the only one painted, the *Matin* (dated 1746) in the National Museum at Stockholm. There was yet another series in this genre, "Hours of the Day," showing half-length figures of young women, which was engraved by Petit. Count Tessin, who must have had a special weakness for such subjects, owned a grisaille by Boucher, *Matin,* which corresponds to the first engraving, and probably only grisailles were executed. Sterling cites a letter by Tessin's secretary, Berch, written in Paris on 27 October 1745, which discusses a projected series of paintings of "Points du Jour" in which the times of the day would also correspond to the sea-

sons; and because of similarities between the description of "L'Après-diner" (also "L'Automne") and the Thyssen picture he suggests that the latter might have been part of such an earlier series. He also suggests that the series might have depicted the "Hours of the Day of a Courtesan" somewhat after Hogarth's "The Harlot's Progress" but without moralizing.

Despite this, he also suggests that Madame Boucher posed for the young woman fastening her garter. According to Diderot and other contemporary sources, it seems that Boucher used his wife as a model in mythologies and other risqué subjects, as well as in domestic genre scenes. According to J. Cailleux (Burlington Magazine, February 1966), she appears in the Déjeuner (1739) in the Louvre, and the Matin in Stockholm. However, the resemblance between Madame Boucher in the picture in the Frick Collection and the young thing in the Thyssen Toilette is not compelling, and one wonders if Boucher even needed a model in the latter case.

In the context of Boucher's La Toilette, it is perhaps worth mentioning a work such as Jan Steen's Morning Toilette in the Queen's Collection, Buckingham Palace, where drawing on a stocking becomes the erotic focus of attention. Certainly Steen was an important influence in developing such themes in French eighteenth-century painting, although by 1742 such subjects had taken on their own momentum and without the benefit of moralizing. The Thyssen picture finds Boucher in one of his happiest and most seductive manifestations.

There is a copy of the composition, with variations in the furnishings, in the Jesse I. Strauss Collection, New York.

JEAN-HONORÉ FRAGONARD
Grasse 1732 – Paris 1806

47. THE SEESAW

Canvas, 120×94.5 cm.

Provenance: Baron de Saint-Julien, Paris; Morel Collection, Paris; Comte de Sinety, Paris; Baron Nathaniel de Rothschild, Vienna (inv. no. 253); Baron Maurice de Rothschild, Château de Prégny; acquired 1956.

Literature: 1969 Catalogue, no. 98; F. J. B. Watson, "Treasures from Toledo, Ohio: Eighteenth-Century Painting and Decorative Arts," Apollo, 86, 1967, pp. 461, 464; D. Wildenstein and G. Mandel, L'opera completa di Fragonard, Milan, 1972, p. 88, no. 54; P. Rosenberg, The Age of Louis XV: French Painting 1710–1774, Toledo Museum of Art, 1975, p. 39, no. 36; Toledo Museum of Art, Catalogue of European Paintings, University Park-London, 1976, p. 59; P. W. Wakefield, Fragonard, London, 1976, p. 23, pl. 4; D. Posner, "Review of A. Ananoff's François Boucher," Art Bulletin, 60, 1978, p. 561.

The Seesaw ("La Bascule") and its pendant, Blind Man's Bluff, in the Toledo Museum of Art, are heavily indebted to Boucher and were probably painted while Fragonard was still in the studio of Boucher. The Goncourt brothers considered them pastiche after Boucher, claiming that without the legend in the engraving they would in fact be attributed to the older master. The compositions were engraved in 1760 by Jacques-Firmin Beauvarlet and the first states actually named Boucher as the artist. This was later corrected to Fragonard (M. Roux, Bibliothèque Nationale, Graveurs du XVIIIe siècle, Paris, 1933, II, p. 218, nos. 31, 32). A drawing published by A. Ananoff (François Boucher, Lausanne-Paris, 1976, II, p. 9, fig. 900, 313/1) and said to be by Gabriel de St. Aubin includes four marginal drawings, two of which repeat the compositions of the Thyssen and Toledo pictures, the latter reversed, with the annotation: Vu chez remy [a collector and picture dealer] 4 peintures par mr. boucher psseur et mr. fragonard élève qui ne les aime point. Remy dit que l'invention est de deshays 46p 70p. Ananoff's confusing and obtuse presentation of the drawing and the collateral material has already been commented upon in reviews of Ananoff's publication (D. Posner, loc. cit.; R. S. Slatkin, Burlington Magazine, CXXI, Feb. 1979, p. 123), and while the drawing would seem to shed remarkable light on the problem of Boucher and early Fragonard, and the Thyssen and Toledo pictures, it raises questions which cannot be properly answered at this time. The Seesaw and Blind Man's Bluff, with mention of the Beauvarlet engravings, appeared in the catalogue of the Saint-Julien sale of 1784 but with different dimensions. For all purposes and intent the width given is the same as in the Thyssen and Toledo pictures, but there is a considerable difference in the height, over ninety centimeters. The dimensions given under the same

titles, again with mention of the Beauvarlet engravings, in the catalogue of the Morel sale of 1786, two years later, are similar to the two known compositions. Sterling *(1969 Catalogue)* believes the two pairs to be identical and feels that there was either a misprint in the dimensions given in the Saint-Julien catalogue or that the compositions, originally tall mural decorations, were cut down to easel picture size in the intervening two years. Rosenberg *(loc. cit.)* also believes that the pictures in the Saint-Julien and Morel sales are identical and that they were cut down, probably in the nineteenth century. George Wildenstein (*The Paintings of Fragonard*, New York, 1960, nos. 47, 48) believes they are different sets of pictures. A misprint in the Saint-Julien catalogue, if the easiest, would also seem to be the most sensible solution. The dimensions given in the Saint-Julien catalogue would make the pictures more than twice as high as they are wide, and one wonders how successfully the compositions might be extended to such a height. In later works Fragonard creates such soaring effects, but in those compositions the emphasis is more on the landscape and the figures are diminutive. The scale of the figures in relation to the landscape background and the height of the compositions in *The Seesaw* and *Blind Man's Bluff* is consistent with other early, Boucher-influenced works by Fragonard including those clearly intended as mural decorations.

The Lugano and Toledo pictures do seem somewhat truncated and might be extended vertically with generally happier results. They in fact do not agree with the engravings, in which the trees continue in height to more felicitous resolutions of the compositions, but if the pictures have been reduced, then it has been by no more than about thirty centimeters if the engravings were faithful to the originals. Be that as it may, the present compositions are fascinating documents of Fragonard's early style, very much under the sway of Boucher, but in which he begins to show his own mettle.

The Seesaw is charged with a vitality and exuberance all but inaccessible to Boucher. The naive ardor with which these delicious creatures pursue their game heightens the anticipation of the inevitable tumble amidst peals of laughter and the excitement of first discovery. The interlacing of the young boy and the babe nestled against his chest, the child's hand pushing against that of the older boy, who in turn presses down on the little fellow's bottom, are delightful inventions already imbued with that tender, familial warmth so characteristic of the later Fragonard. The expression on the face of the child who gazes out, momentarily distracted from his task, has an appeal which is very different from Boucher's more blandly attendant amors. The longing gaze of the young boy and the intensity with which the babes throw themselves into the game anticipates the mock but touching heroics of Fragonard's later series *The Conquest of Love* (Frick Collection, New York) rather than the more contrived titilation of *The Swing* (Wallace Collection, London), to which *The Seesaw* is most frequently compared. The color already seems more luminous and the light somewhat blonder, more diffuse and atmospheric than in Boucher.

Such a decided show of his own temperament would be consistent with Sterling's and Rosenberg's dating of *The Seesaw* towards the end of Fragonard's tenure in Boucher's studio, around 1750–52.

NICOLAS LANCRET
Paris 1690–1743

48. LA TERRE

Canvas, 38×31 cm.

Provenance: Marquis de Beringhen, Paris (his sale, 2 July 1770, no. 30); Marquis de Lassay, Paris (his sale, 22 May 1775, no. 71); Alfred de Rothschild, Halton Manor, England; Almina, Countess of Carnarvon; acquired 1976.

Literature: E. Bocher, *Les Graveurs Françaises du XVIII^e Siècle; ou, catalogue raisonné des estampes... de 100 à 1800*, vol. 4, N. Lancret, Paris, 1877, pp. 57–58, no. 75; C. Davis, *A Description of the works of art forming the collection of Baron Alfred de Rothschild*, London, 1884, p. 1, no. 56 (repr.); G. Wildenstein, *Lancret*, Paris, 1924, p. 53, 69–70, no. 3 (Cochin engraving illus. fig. 3).

The setting is dominated by the soft silhouette of the large tree and the richly decorated architectural fountain. A similar structure, with variations in the sculptural ornament,

appears in *Le Jeu de Colin-Maillard (au Jardin)*, (Wildenstein, *op. cit.*, no. 226, fig. 52), which was exhibited at the Salon of 1737. The young men apply themselves diligently to the flower bed, and the young women in the foreground fuss over the very pretty still life of fruits and vegetables. A basket and wheel barrow are carelessly laid about. The women are dressed in pastel colors and the men in more sober tones, with the exception of the one seated on the edge of the fountain, who presents a bouquet to his companion. Wildenstein mentions a red chalk drawing for this figure in the Musée Carnavalet in Paris.

The treatment of the subject clearly depends from the *fêtes galantes* of Watteau but with a difference. The genre, here employed as allegory, is presented as a scene of simple and straightforward pleasures, with the obligatory allusions to amorous pursuits but with none of the ambiguous poignancy which pervades Watteau's little gatherings. Lancret's figures seem positively robust next to Watteau's, and less delicate in bearing and action. They are also sometimes less than happily drawn, as in the left arm of the girl waiting to catch an apple in her skirts. If Lancret's compositions are less accomplished and less affecting, he remains an artist of considerable gifts and his well-arranged and decorative pictures, in silvery pastel colors, perhaps give a more characteristic measure of the eighteenth century in France than do the more personally hermetic inventions of Watteau.

La Terre is one of an original set of four pictures representing the Elements – *La Terre, Le Feu, L'Eau, L'Air* – which belonged to the Marquis de Beringhen, *Premier Ecuyer* to Louis XV. An inventory made at his death describes them on view in a room looking onto the garden of his hotel in the Rue Saint-Niçaise. (*Le Feu* from the Beringhen series is in the Galleria Nazionale, Palazzo Barberini, Rome [*I Quadri Italiani e Francesi della Collezione del Duca di Cervinara*, Rome, 1962, no. 11, as the writer was kindly informed by M. Roland Michel].) Engravings of the pictures were sold by the Veuve Chereau and the reference to *La Terre* in the notice of the sale in the *Mercure de France* of August 1732 reads: "La Terre est heureusement exprimée par des Jardiniers, des jeunes Jardinières et

par quantité de fleurs et de fruits, etc. Cette Estampe est gravée par le sr. Cochin." (Wildenstein, p. 53) The other engravings were by Desplaces *(L'Eau)*, B. Audran *(Le Feu)*, and N. Tardier *(L'Air)*.

There is a version of *L'Eau* which differs from the Desplaces engraving after the painting in the Beringhen series *(ibid.,* p. 70, pl. 5) and which therefore possibly indicates another series. Wildenstein cites a series of the Elements, painted on panel and given to Lancret, in the catalogue of the Beaujon sale (1787), where it is stated that they were engraved "par son (Lancret's) ami Larmessin, pour lequel ils furent peints." According to Wildenstein the dimensions are almost exactly the same as those of the Beringhen "Elements" and possibly they were replicas of that series. There are, however, no known engravings by Larmessin of the "Elements," after Lancret.

JACQUES LINARD
c. 1600 – Paris 1645

49. CHINESE BOWL WITH FLOWERS

Canvas, 53.2×66 cm.
Inscribed in the middle of the ledge: *I^S. LINARD 1640*

Provenance: Unknown; acquired 1969.

Literature: C. Sterling (R. Heinemann, ed.), *Katalog Sammlung Thyssen-Bornemisza*, Lugano-Castagnola, 1971, no. 166a, p. 223.

A burial document of 1645, Paris, reports that Jacques Linard died at about the age of forty-five; his exact birthdate and place of origin are unknown. His life was cut short during the maturity of his artistic development, ending what would seem to have been a splendid career. In 1631 he was named "Valet du chambre ordinaire du Roi" and would therefore have moved in the society of high court officials and functionaries. The godfather of his firstborn was of the nobility, and a still life of 1627 is dedicated to the powerful Cardinal Richelieu. The names of Linard and the wife of the painter Claude Vignon are mentioned together as godfather and godmother in a baptismal record, and there are other indications that Linard, a master painter himself, had close associations with and

was highly esteemed by the leading artists of his time (M. Faré, *Le Grand Siècle de la Nature Morte en France*, Fribourg-Paris, 1974, pp. 17–40). He would seem to have been a man of considerable parts and enjoys a distinctive place as one of the founders of French still-life painting.

Linard was certainly aware of international currents in still-life painting but was most strongly influenced by the Flemish school. He must have been familiar with the colony of northern artists who lived, as did Linard before he and his wife moved to the more fashionable parish of St-Nicolas-des-Champs, in the quarter of St-Germain-des-Prés. There was also a brisk traffic in Dutch and Flemish pictures in Paris, to the consternation of the Painters' Corporation of the city. Linard's *Basket of Flowers* in the Louvre, painted in the late twenties, is within the tradition of "Velvet" Breughel and Ambrosius Boschaert. Linard lacks the technical brilliance of these northern masters; his still lifes are more restrained, the paint is applied rather dryly with something of the care and even earnestness of a naïf. His perspective is unsure, the point of view often high and the tabletop tipped in a somewhat "archaic" manner, and his pictures lack the finish and optical refinement of Dutch and Flemish counterparts. He favors severe, almost artless arrangements as in the Thyssen flower piece, with a single bowl of fruit or vase of flowers centered on a table against a dark, neutral background. These are very similar to those of his contemporary, Louise Moillion. Even in his more ambitious compositions, notably those representing the five senses, there is usually a dominant object placed in the center with a deliberate but unaccented distribution of the other elements, often rather curiously juxtaposed, and invested with an awkward but affecting intensity. His still lifes are informed by a sober dignity which has been compared to contemporary portraiture and the peasant subjects of the Le Nain brothers. Linard is never tempted to the anecdotal and, to quote Jacques Thuiller, "all he needs is two moths to evoke from a dish of fruit that delicate and somewhat melancholy poetry we find in his 'Vanitas' pictures." (*French Painting from Le Nain to Fragonard*, Geneva, 1964, p. 41.) A "Vanitas" (Paris, private collection) dated 1644, a year before his death,

shows a skull sitting on a book from between the pages of which protrudes a paper with the inscription: *Voilà comment touts nos beaux jours deviennent;* there is a glass carafe with a few rather wan flowers and an expiring candle in the background. The Thyssen flower piece, signed and dated 1640, has no such morbid connotations. Boldly decorative, it is also, however, strangely animated. Individual flowers, with their curling leaves and thick snaky stems, have an eccentric, aggressively physical presence. The colors are strong and slightly raw, modulated mostly by the simple addition of white with touches of black in the shadow, but as Sterling *(loc. cit.)* has observed, the more Flemish-derived palette, the mosaic of color, in the earlier Louvre *Basket of Flowers* has here evolved into "a silvery harmony of colors," dominated by the saturated tones of red. Symmetry still prevails – the bowl is centered on the ledge, and there is an insistent central axis established by the ball of sweet william placed directly above the sprig of orange blossom – but the arrangement of flowers is less predictable than in the earlier work. The bouquet is also more cohesive: it convincingly occupies the bowl, and the flowers address themselves in the round. The perspective is still somewhat unsure; the foot of the Chinese bowl doesn't sit quite properly, although the ledge, carefully chipped, recedes at a smart angle.

But despite this lack of facility, and perhaps in part because of the painstaking eagerness of the execution and the sense of seriousness of purpose, the flower piece has great force and an oddly impressive and sympathetic appeal. According to Sterling, the Chinese bowl appears again in Linard's *Five Senses* in Strasbourg. The configuration of flowers and buds at the extreme left here, as well as the centered orange blossom with similarly arranged flowers below, is repeated in another of the artist's *Five Senses* (private collection, Paris; Faré, *op. cit.*, p. 34 repr.).

ANTOINE WATTEAU

Valenciennes 1684 – Nogent-sur-Marne 1721

50. LA HALTE

Canvas, 32×42.5 cm.

Provenance: Jean de Jullienne, Paris, by 1729; Prince de Conti, Paris, 8 April 1777, no. 665 (with pendant); Mena-

geot, Paris, 17 March 1778, no. 107 (with pendant); Anonymous sale, Paris, 27 March 1787, no. 185; Earl of Egremont, Petworth House, by 1834; Lord Leconfield, Petworth House; Agnew, London; Duveen, New York; Sotheby Parke Bernet, New York; Dunlop Collection, New York; acquired 1975.

Literature: E. and J. de Goncourt, *Catalogue raisonné de l'œuvre d'Antoine Watteau*, Paris, 1975, p. 58, no. 57; V. Josz, *Antoine Watteau, Mœurs du XVIIIᵉ siècle*, Paris, 1903, p. 54; C. H. Collins Baker, *Catalogue of the Petworth Collection... in the possession of Lord Leconfield*, 1920, no. 632; E. Dacier and A. Vuaflart, *Jean de Jullienne et les graveurs de Watteau au XVIIIᵉ siècle*, Paris, 1922, vol. III, no. 222 (repr. of Moyreau's engraving); L. Dimier, *Les Peintres français du XVIIIᵉ siècle*, Paris, 1928, vol. I, p. 33, no. 45; L. Reau, *Les Peintres français du XVIIIᵉ siècle*, Paris, 1928, no. 45, pl. 26; W. R. Valentiner, *Unknown Masterpieces*, London, 1930, no. 1; H. Adhémar, *Watteau, sa vie, son œuvre*, Paris, 1950, no. 35, pl. 16; K. T. Parker and J. Mathey, *Antoine Watteau, Catalogue Complet de Son Œuvre Dessiné*, Paris, 1957, I, nos. 5, 159, 247; II, 950; E. Camesasca, *The Complete Paintings of Watteau*, New York, 1968/1971, p. 95, no. 40 (engraving repr.); J. Ferré, *Watteau*, Madrid, 1972, vol. I, pp. 84, 208, 212; vol. II, pp. 465–66; vol. III, p. 924 (B. 2); vol. IV, pp. 1097, 1104, 1128 (321).

Exhibitions: London, Suffolk Street, 1834, no. 102.

The small group of early works by Watteau with themes of military life appears to have begun with *Recrue Allant Joindre le Régiment* of 1709. The picture was sold to the dealer-collector Sirois, to whom Watteau was introduced by his friend and fellow painter, Spoud. The sale was extremely important to the young artist, as it seems to have given him the courage to emancipate himself from the last of his apprenticeships (to Audran) and establish his independence. The introduction to Sirois also brought Watteau within a circle of people influential in the artistic milieu of Paris who, immediately recognizing his talent as well as his impractical and fragile nature, not only concerned themselves with his professional advancement but also his personal well-being. The sixty livres Watteau received for the picture paid for a trip home to Valenciennes. Because of Louis XIV's military campaigns in the north Watteau must have seen troops throughout the countryside. His stay in Valenciennes was short, and although some of the scenes were painted there, the majority were probably executed in 1709–10 after his return to Paris, based on the many sketches made during his journey. The subjects are little entr'actes of military life – marches and anecdotal scenes of camp life in which smoke is more likely to rise from a cooking pot than from a cannon (the artist must have been aware of the camp scenes of Wouverman). Watteau's attitude to war was as delicate as his approach to love.

La Halte (or "Alte") is one of the most charming of these little bivouacs. The woman in yellow with her back turned, holding her skirts up from the mud, seems to be a new arrival. She may be the special companion of the officer in the metal cuirass to her left who directs the unloading of her baggage. She stands before another young woman, seated, who appears to take some notice of her comrade-in-arms; but the difference in dress might indicate a difference in clientele and their attitudes something of a social confrontation. In the distance between the two women, a couple heads towards a makeshift shelter, decorated with a wreath, for their rendezvous. The peasant woman carrying a child on her back provides a more sobering note as she sits staring out. One of the soldiers sleeps at the base of the tree while others smoke, raise a glass or look with some interest at the young woman in yellow, especially the wounded fellow to the right. There is a cooking detail in the background next to the supply wagons.

The two large feathery trees divide the composition into interlaced vignettes – perhaps a persistence of the habits acquired painting decorative "arabesques" in the employ of Audran. The composition is in fact not painted to the edges of the canvas and is irregular in shape, with shallow curves at the bottom corners and steeper ones at the top – a shape which would fit more happily in a *boiserie* panel or some other decorative ensemble than it would in a picture frame.

The composition was known from Moyreau's engraving which was announced in the *Mercure de France* of July 1729, but the whereabouts of the present picture were unknown after it left the Duveen collection. On the basis of photographs, both Adhémar and Camesasca considered the painting heavily restored and were cautious in their discussion of its attribution to the master. Removal of the overpainting when the picture was acquired by Baron Thyssen at public auction in 1977 revealed an autograph work of the highest quality and restored another example of

this early genre to Watteau's œuvre. *La Halte* sometimes appeared in sales as a pendant to *Defillé,* now lost, which was also engraved by Moyreau; Adhémar *(loc. cit.)* reports a drawing by Delacroix after the engraving of *La Halte.*

The most immediate index of the change in status these military scenes brought Watteau was the 200 livres he was paid for the second scene he painted for Sirois, as opposed to the 60 he received for the first. These two pictures were submitted to the Academy by the artist in the competition for the Prix de Rome in 1709. Watteau received second place.

Several drawings for *La Halte,* all red chalk, are published by K.T. Parker and J. Mathey (*op. cit.,* I, nos. 5, 159, 247; II, 950). The central figure in no. 5 (Musée Carnavalet, Paris), was used for the woman dressed in yellow to the left and was engraved by B. Audran for *Figures de différents Caractères de Paysages et d'Etudes,* no. 125, and the central figure in no. 159, a counterproof (National Museum, Stockholm, inv. 4050, ex. coll. Count Tessin), corresponds to the seated woman at the left; Parker-Mathey state that only two of the four figures – the one at the left and the other at the right – were used for *La Halte,* the first for the man unpacking the trunk at the extreme left of the painting and the second for the soldier standing at the extreme right; the two middle figures of soldiers were, according to Parker-Mathey, used in *Détachement faisant Halte.* They were in fact used in both compositions and the figure lying down in the drawing, second from the left, is for the soldier second from the right in *La Halte.* The remaining figure in the drawing is for the fourth soldier from the right, sitting up with his gun under his arm and looking to the left. This is characteristic of Watteau; the drawings made on his journey served like a repertory company from which he drew his figures for different compositions, often recombining them. II, no. 950 (Paris, coll. Mme. L. du C.), includes two figure studies, one for the soldier asleep under the tree, the other for the one with his arm in a sling.

ANTOINE WATTEAU
Valenciennes 1684 – Nogent-sur-Marne 1721

51. PIERROT CONTENT

Canvas, 35×31 cm.

Provenance: Duc de Choiseul, Paris, 1786; Henry Cary, New York; Thomas G. Cary, New York; Mrs. Charles P. Curtis (née Carline Cary), Boston; acquired 1977.

Literature: E. and J. de Goncourt, *Catalogue raisonné de l'œuvre d'Antoine Watteau,* Paris, 1975, no. 153; E. Dacier and A. Vuaflart, *Jean de Jullienne et les graveurs de Watteau au XVIIIᵉ siècle,* Paris, 1923, vol. II, pp. 28, 60, 99, 161; vol. III, pp. 87–88, no. 180; vol. IV, p. vi, no. 80 (engraving); H. Adhémar, *Watteau, sa vie, son œuvre,* Paris, 1950, p. 208, no. 62; K.T. Parker and J. Mathey, *Antoine Watteau, Catalogue Complet de Son Œuvre Dessiné,* Paris, 1957, I, nos. 41, 52, 61, 81; E. Camesasca, *The Complete Paintings of Watteau,* New York, 1968/1971, p. 101, no. 81; J. Ferré, *Watteau,* Madrid, 1972, vol. I, pp. 100, 113, 373, nos. 1728, 1832, 1846; vol. III, pp. 944–45 (1316); vol. IV, pp. 1100, 1104, 1122, 1129 (794); Y. Boerlin-Brodbeck, *Antoine Watteau und das Theater,* Basel, 1973, p. 143.

Exhibitions: Boston, Museum of Fine Arts, *Art in New England…,* 1939, no. 138; Cambridge, Massachusetts, Fogg Museum of Art, 1941; Boston, Museum of Fine Arts, 1942; Boston, Museum of Fine Arts, 1943.

A gathering in a park: four figures are grouped around Pierrot, who is seated on a bench, posed *en face,* with his legs slightly apart and his hands placed symmetrically on his thighs. To the left a woman dressed in rose and yellow inclines towards him, playing a guitar, and a man dressed as Mezzetin in mulberry and blue stripes turns to listen. To the right another woman dressed in olive green and blue touches her chin with her fan and appears to look across at Mezzetin; her companion, in yellow-orange and grey, is seated on the ground with his arm placed familiarly on her knee. The dark thicket behind opens to the left in a view of sky with clouds, and a tall herm of a faun may be seen between the trees behind Pierrot. There are two figures in the shrubbery to the right; they are faint and difficult to read, but they can be identified from the engraving after the composition by Jeurat, 1728, as another Mezzetin (or perhaps Scaramouche) and Harlequin, excited by the scene which greets them. The background has no doubt darkened with time because of Watteau's hasty and poor working methods and heavy use of oil. The painting originally would have been lighter and more

warmly unified in color and tone and the figures, in their shimmering satins and silks, less brilliantly contrasted against the dark trees. His celebrated "rosy" palette derived from Rubens, whom he studied in the series of the *Life of Marie de Medici* in the Luxembourg Palace. But if he was able to penetrate the secrets of the great Fleming's use of color, he was unequal to him in spirit, and he turned to the smaller Flemish and Dutch masters such as Teniers and Steen. In the case of the latter he was perhaps influenced by the later, more lyric works of the master, such as *The Garden Party* (1677), formerly Amsterdam, L. Rozelaar Collection, and *Two Men and a Young Woman making Music on a Terrace* (1670), London, National Gallery. The great Venetians – Giorgione and the young Titian, the former at least in spirit – spoke sympathetically to the young artist in the rarified and elusive poetry of the *Concert Champêtre* now in the Louvre but then in the Royal Collection, and to which he must have had access, as he did to the Venetian drawings in the house of his friend Crozat. From such diverse sources and assiduous studies from nature, from the decorative vocabulary of the arabesques he painted for Audran and the fantasies and conventions of the theater, he drew to his own needs and invented a world physically and emotionally tempered to his most private fears and dreams.

He invented the *fêtes galantes,* those gatherings of exquisitely fashioned creatures under the spell of a secret place in some gently enchanted park or wood. In *Pierrot Content* reality is confounded and held at bay by the intermingling of figures in costumes of the commedia dell'arte. The air is redolent of love and Pierrot sits mutely, isolated at the center of a cat's cradle of longing and unspoken desire. The enigmatic presence of the clown, the odd man out, always beset, lonely and misunderstood, haunted Watteau's imagination, and the artist perhaps identified with him. Jeurat's engraving after *Pierrot Content* shows a wider composition, with landscape extended to either side and a stone pedestal with ball near a pond in the right foreground. The Thyssen picture agrees in height with the dimensions given on the engraving but the canvas has been cut and it is of course impossible to determine to what extent.

Pierrot Content is one of the earliest of the *fêtes galantes* and a very close variant of *Les Jaloux* of 1712. Although the latter is lost, its composition is known from copies and from the engraving by Scotin. The format of Scotin's engraving is horizontal, as is Jeurat's after *Pierrot Content*. The landscape shows a pedestal with a sphinx instead of a ball, and the costumes vary somewhat from those in Jeurat's engraving: there is banding on the skirt of the guitarist, and Mezzetin's beret is longer and Pierrot's hat smaller and raked. But the figural composition is almost exactly the same, including the two figures in the bushes, with the exception of the woman to the right of Pierrot, who differs from the one in the Thyssen picture and is without a companion. Rather she draws close to Pierrot, turning in pure profile to look at him and placing her right hand on his left shoulder. This explains the faint smile on Pierrot's face in *Les Jaloux;* his central position and the symmetry of his pose, the same as in *Pierrot Content,* have a completely different meaning there, where he is the center of attraction.

There are two pentimenti in the Thyssen picture: one in the dark area between the heads of Pierrot and the woman with the fan to her chin, and another below the skirt of the same woman. The first agrees with the head and shoulders of the woman to the right of Pierrot in *Les Jaloux,* and the second with the drapery of the clown's trophy at her feet. At a fairly advanced point the artist evidently changed the composition in the Thyssen picture and *Les Jaloux* became *Pierrot Content.* There are sufficient differences between the engraving of *Les Jaloux* and the painting here to indicate that the model for the former was not identical with the first composition of the Thyssen picture. Watteau must have made a replica of *Les Jaloux* which he then decided to change.

The persistence of the pentimenti would suggest that the changes were made before the paint had completely dried, which would have been characteristic of the master and would also explain the less than satisfactory surface in the area of the two new figures. The special place *Les Jaloux* enjoys in Watteau's œuvre and career might account for the initial repetition of the composition. The picture was one of several submitted to the

Academy for his candidacy. It is the only one of the group we know of by name, as Mariette mentions it in the *Abecedario* as the picture for which Watteau was made an *Agréé* of the Academy. Apart from its pictorial or painterly merits, the jurors must have been impressed by the originality of the conception. Nothing like it existed and indeed, when Watteau finally submitted his *morceau de réception* in 1717, the *Cythera* (Louvre, Paris), the Academy paid tribute to this originality by creating a new category for the artist and received him as a painter of *fêtes galantes*. The significance of *Les Jaloux* must have been immediately apparent, and the fact that Mariette singled it out would indicate that the painting enjoyed some celebrity. Under such circumstances one can easily imagine Watteau receiving a commission for a replica and his impatience at having to repeat himself so exactly. Because of the closeness of the compositions it is sometimes assumed that *Pierrot Content* was one of the other pictures submitted to the Academy along with *Les Jaloux*. This is unlikely, however, as the degree to which the former so closely replicates the latter might have been considered a want of imagination.

According to the entry in the 1939 Boston exhibition catalogue, the Thyssen picture, then in the Curtis Collection in Boston, bore an old label which stated that the painting was acquired by Henry Cary (great-uncle of Mrs. Charles P. Curtis, née Cary) from the Duc de Choiseul Sale, Paris, 1786. The cataloguer of the Boston exhibition was unable to find a listing for such a sale but there was one, *"Notice des Objets curieux dépendans de la succession de feu M. le Duc de Choiseul,"* in Paris, Monday 18 December 1786 (Ferré, *et. al., op. cit.,* vol. IV, p. 1135), and F. Lugt (*Répertoire des Catalogues de Ventes Publiques, vers 1600–1825,* The Hague, 1938) indicated that there were fifty pictures in the sale along with drawings, prints, etc. This writer has been unable to consult the appropriate eighteenth-century sales catalogues referred to in the literature; however, if the label is to be trusted, then references to *Pierrot Content* either by title or description in catalogues of later sales such as the Lapeyriere sale in 1832 (where the dimensions agree by a centimeter or so with those of the Thyssen picture) would indicate other versions. The change in composition in the Thyssen painting would argue in favor of an autograph work and a first version – in fact, the invention of *Pierrot Content.*

Parker and Mathey give four drawings related to *Pierrot Content,* but if the sequence of events suggested here is correct, then two of them properly belong only to the creation of *Les Jaloux.* The four are: I, 41 (Paris, private collection), a study of three men, the one to the left for the Mezzetin seated on the bench at the left, and the middle figure for the alarmed Mezzetin(?) in the shrubbery, both figures dressed in contemporary costume; I, 81, which includes a sketch of the figure of the seated Mezzetin – more highly finished in the head and shoulders and shown in theatrical costume – at the extreme right of the sheet; I, 52, with three studies of women, which shows the figure of the man seated on the ground in *Pierrot Content,* with the figure of his companion very slightly indicated; and I, 61, which includes a drawing of a woman at the upper left which, if not in exact agreement with the woman seated to the right of Pierrot in the Thyssen composition (her fan is in her left hand, at her side, and her right arm is extended and incomplete), was most probably adapted for *Pierrot Content.*

SPANISH

FRANCISCO JOSÉ DE GOYA Y LUCIENTES
Near Saragossa 1746 – Bordeaux 1828

52. EL TÍO PAQUETE

Canvas, 39×31 cm.

Provenance: Don Mariano Goya; Conde de Dona Marina; Marqués de Herdia; acquired 1935.

Literature: 1969 Catalogue, no.111; E. Harris, *Goya*, London, 1969, p.90, no.46; P. Gassier and J. Wilson, *Vie et Œuvre de Francisco Goya*, Fribourg, 1970, p.329, fig.1631; J. Gudiol, *Goya*, Barcelona, 1971, vol.1, pp.205, 346, no.723; vol.4, fig.1198.

Exhibitions: The Hague, Mauritshuis, *Goya*, 1970, no.53; Paris, Louvre, *Goya*, 1970–71, no.53.

The identification of the subject depends on the inscription *El celebre ciego fijo* on the back of the original canvas which was covered when the picture was relined (before 1887). "The well-known blind man" was "Uncle" Paquete, a beggar who sat on the steps of the Church of San Felipe el Reale in Madrid. He was popular as a singer and guitar player and was frequently invited to entertain in the fashionable houses of the capitol. The face and white collar are compellingly luminous. The head rolls to the left, and the broad, concentric swipes of the brush seem to take the face out of focus and give the effect of movement, as if to the rhythms of an inaudible belly laugh. The face is grotesque with its scarred eye sockets, bulbous broad-nostrilled nose and grinning, gap-toothed mouth. The ambiguous jolly/sardonic expression of the blind man is perhaps comparable to the often uncontrolled and disquieting sounds of the speech of the deaf. One can only imagine the fascination the indomitable old man must have held for Goya. The face could take its place in the horrific company of the Black Paintings, among the hordes of ghoulish beggars trailing in an endless file across a barren landscape. The portrait is certainly less exaggerated in effect and not without warmth, but reflects that state of mind which gave rise to those eschatological hallucinations and nightmarish visions with which Goya covered the walls of his country house, La Quinta del Sordo, "The House of the Deaf Man," as it was called. The sombre colors and tonality and the broad execution and thickly applied paint would also indicate that the portrait belongs to the period of the Black Paintings of around 1819 to 1820. E. Harris *(loc. cit.)* observes that the *Tío Paquete* is painted like the dwarfs in Velásquez and the partially obliterated image anticipates Francis Bacon.

FRANCISCO JOSÉ DE GOYA Y LUCIENTES
Near Saragossa 1746 – Bordeaux 1828

53. ASENSIO JULIÁ IN HIS STUDIO

Canvas, 54.5×41 cm.

Inscribed lower left: *Goya a su / amigo Asensi.*

Provenance: Purchased in Spain by Baron Taylor, c.1835–37; King Louis-Philippe, Paris; the Duc de Montpensier, Palace of San Telmo, Seville; the Infante Don Antonio de Orléans, San Lúcar de Barrameda; the Comtesse de Paris; Durand-Ruel, Paris; Arthur Sachs, Paris; acquired 1971.

Literature: Notice des Tableaux de la Galerie Espagnole exposés… au Louvre, 1838, no.104; C. Yriarte, *Goya*, Paris, 1867, no.77; Conde de la Viñanza, *Adiciones al Diccionario Histórico de Ceán*. Bermúdez, 1887, no.110; A. de Beruete y Moret, *Goya as Portrait Painter*, London, 1922, pp.124–25; Z. Aravjo Sánchez Cantón, *Goya*, 1930, p.70, pl.56; C. Terrasse, *Goya y Lucientes*, Paris, 1931, p.87; F. Boix, "Asensio Julia," *Arte Español*, 10, 1931, pp.138–41; A. L. Mayer, "Notes on Some Self-Portraits of Goya," *Burlington Magazine*, 64, 1934, p.175, fig.c; E. Lafuente Ferrari, *Goya*, Barcelona, 1946, p.152; X. Desparmet Fitzgerald, *L'œuvre peinte de Goya*, Paris, 1950, vol.2, no.382; F. J. Sánchez-Cantón, *Vida y Obras de Goya*, Madrid, 1951, pp.64, 169, pl. XXXII; E. Lafuente Ferrari, *Les fresques de San Antonio de la Florida*, New York, 1955, p.108; E. G. Trapier, *Goya: A Study of his Portraits*, New York, 1955, pp.18–19, fig.21; J. A. Gaya Nuño, *Pintura Española fuera de España*, Madrid, 1958, no.960; E. G. Trapier, *Goya and His Sitters*, New York, 1964, p.39; R. Schickel, *The World of Goya*, New York, 1968, illus. p.107; J. Baticle, "Orangerie des Tuileries. Goya," *La Revue du Louvre*, 20, 1970, illus. p.260; P. Gassier and J. Wilson, *Vie et œuvre de Francisco Goya*, Fribourg, 1970, pp.146, 189, fig.682; J. Gudiol, *Catálogo analitico de las pinturas de Goya*, New York, 1970, no.378; F. Davis, "Painters of Contrasting Styles," *Country Life*, 149, 1971, illus. p.1302; J. Gudiol, *Goya*, Barcelona, 1971, vol.1, pp.98, 102, 283, no.378; vol.3, figs.546, 547; L. Seghers, "Goya en Londres," *Goya*, 101, 1971, illus. p.374; J. Gantner, *Goya: Der Künstler und Seine Welt*, Berlin, 1974, pp.79, 258, no.60; A. de Gaigneron, "Nouveau regard sur la Collection Thyssen," *Connaissance des Arts*, 306, Aug. 1977, p.59, fig.17.

Exhibitions: Paris, Louvre, 1838–48; Paris, Musée de l'Orangerie, *Peintures de Goya des Collections de France,* 1938, no. 9 (repr.); Paris, Musée Jacquemart-André, *Goya,* 1961–62, no. 54 (repr.); The Hague, Mauritshuis, *Goya,* 1970, no. 20 (repr.); Paris, Musée de l'Orangerie, *Goya,* 1970, no. 20.

The painter Asensio Juliá, the son of a fisherman, was born in 1748, just two years after Goya. He taught at the Academy of San Fernando, where he was nick-named *El Pescadoret,* "The Little Fisherman." He was a follower of Goya, did engravings after him, and also painted subjects from the War of Independence; but he never developed independently as an artist of any consequence. He died in 1830. Sanchéz Cantón suggested that Juliá assisted Goya in the execution of the frescoes in the Church of San Antonio de la Florida in Madrid, 1798, and that he is here portrayed standing by the supports of the scaffolding in the cupola. Juliá stands with his feet apart, firmly planted; his right arm hangs at his side, his left is tucked into his robe. His head is turned somewhat rhetorically to the right. The deep blue robe trimmed in gold is so fluidly brushed that it appears to be still freshly painted. His feet are shod in the prettiest notations of black bowed slippers, and the whole costume is brilliantly set off by the white shirt and hose. Goya's touch, though still dazzlingly fast and economical, takes on a certain delicacy in the face, as if careful not to overpower the fragile features, framed by the fine black hair swept over the high brow. Because of the relatively small scale of the figure, the deep foreground and vaguely defined space, Juliá appears isolated and vulnerable; he seems to try to stand taller than he is amidst the planks, timbers, paintpots and brushes. The concentration of color in the figure against the tonal background intensifies this effect. The wayward grid of the scaffolding and loose boards create an eccentric geometric pattern of planes and pockets of soft warm light and deep velvety shadows. The setting is painted with the breadth of execution which characterizes the frescoes in San Antonio de la Florida, and for which Goya supposedly used sponges along with his brushes to apply his great swaths of color.

The Thyssen painting was engraved by N. E. Sotain. Another portrait of Juliá, dated 1814, is in the Sterling and Francine Clark Institute in Williamstown.

EL GRECO (DOMENICO THEOTOCOPULI)
Candia, Crete 1541 – Toledo 1614

54. THE ANNUNCIATION

Canvas, 117×98 cm.

Provenance: Collection Princess Corsini, Florence; Professor Luigi Grassi, Florence; Sulley, London (1927); Trotti and Cie, Paris; Knoedler, New York (1929); Contini-Bonacossi, Florence; acquired 1975.

Literature: A. L. Mayer, *El Greco,* Munich, 1926, no. 30aa; L. Venturi, "Una nuova Annunziazione del Greco," *L'Arte,* 30, 1927, pp. 252–55; E. K. Waterhouse, "El Greco's Italian Period," *Art Studies,* 1930, pp. 61–88, no. 1; G. Fiocco, in *Enciclopedia Italiana,* Rome, 1933, vol. 17, p. 919; J. Camon-Aznar, *Domenico Greco,* Madrid, 1950, no. 22, pl. 41; H. E. Wethey, *El Greco and His School,* Princeton, 1962, vol. 2, p. 32, no. 37, pl. 17; T. Frati, *L'opera completa del Greco,* Milan, 1969, no. 15c; J. Gudiol, *Domenikos Theotokopulos, El Greco 1541–1614,* New York, 1973, pp. 34, 35, 340, no. 19, figs. 26, 27.

Exhibitions: Rome, National Gallery of Modern Art, *The Old Spanish Masters from the Contini-Bonacossi Collection,* 1930, no. 34, pl. 25.

Mary, dressed in a voluminous blue robe and mantle lined in yellow, is seated at a lectern. She turns from her devotions to receive the angelic salutation, her left hand resting on the open book, her right raised in a gesture of humility. Gabriel, dressed in yellow and white touched with pink, greets her from the right. He half stands, half kneels on a trail of cloud with his right arm extended to Mary and a gold staff in his left. His languidly serpentine pose is exquisitely balanced by the rise and dip of his wings. The Annunciation is set on a terrace closed by a low wall at the back: the pavement is set in a grid of white, grey and salmon-colored stone. A rose-colored curtain hanging at the left, drawn up by a putto, dissolves in the bank of clouds and golden light from which the dove of the Holy Ghost issues. Two other putti look on. The *Annunciation* is a work of El Greco's Italian period, and has been variously dated between 1565 and 1576. Waterhouse proposes a date of 1572 to 1574, during El Greco's stay in Rome; and Wethey 1575 to 1576, when presumably the artist returned to Venice for some months before leaving for Spain.

Whether the painting was executed during or after his sojourn in Rome, one need look no

further than Venice for its sources, although the monumentality and confident execution of the picture might be explained by El Greco's removal from the city of his apprenticeship and the experience of Rome. The *mise en scène* and general composition recall Titian's *Annunciation* in the Scuola Grande in Venice as well as several compositions by Veronese, but no single work by either master takes precedence as a model. In Venetian Annunciations of the sixteenth century Gabriel consistently approaches from the left, but El Greco chooses the less orthodox approach from the right. The figures have their greatest affinity with those in Tintoretto's *Annunciation* in the Scuola di San Rocco in Venice. The ample form and heavy draperies of El Greco's Virgin surely have their source in Tintoretto's heroic *Annunciate* and most telling are the hands, so large and conspicuous in both figures. The mannered but robust elegance of the angel, and the weight and suspension of the figure also betray El Greco's debt to Tintoretto – most graphically in a detail such as the leg.

The color and diffusion of light are glorious and certainly derive from the work of Titian of the middle of the century, although the general effect is lighter and higher in color, as if one were seeing a painting by the older master without the final glazes. The rather ropy modeling of the drapery indicates the example of Tintoretto, although the handling of the highlights is already more agitated and arbitrary. The influences of Titian, Tintoretto and Veronese are certainly all present; but the picture is such a mature synthesis of all that El Greco could have learned from the great Venetians, assimilated with such authority and ambition, that such an analysis is like shadow boxing. The composition is carefully structured, stable and harmoniously balanced. The perspective is exactly centered and the grid of the pavement, the low wall, and the lectern are all laid parallel to the picture plane. The generously scaled figures are placed at measured intervals within this rationally structured space, and there is a gracefully ascendant movement into depth from Mary to Gabriel to the putti – a movement which subtly counters the effect of symmetry and frontality. Mary and Gabriel are exquisitely balanced and harmoniously correspondent in the torsion and interaction of

their poses. The Archangel's staff is like a plumb line that stabilizes the slight inclination of the figures to the left. In no other subject picture of the Italian period, and certainly none after, does El Greco so deliberately strive for an effect of such grand equilibrium and which suggests a self-conscious and virtuoso essay in the classical style of the High Renaissance. Indeed, the painting is so accomplished a demonstration in the Venetian High Renaissance style that without the benefit of historical perspective one would here be hard put to anticipate El Greco's later development.

EL GRECO (DOMENICO THEOTOCOPULI)
Candia, Crete 1541 – Toledo 1614

55. THE ANNUNCIATION

Canvas, 114×67 cm.
Probably inscribed on the embroidered strip in the basket, in Greek letters: *O Kheretismos* (The Annunciation)

Provenance: Pascual Collection, Barcelona; acquired 1954.

Literature: 1969 Catalogue, no. 118; T. Frati, *L'opera completa del Greco*, Milan, 1969, no. 107b; M. B. Cossío, *El Greco*, Barcelona, 1972, p. 356, no. 11; J. Gudiol, *Domenikos Theotokopulos, El Greco 1541–1614*, New York, 1973, pp. 181, 349, no. 136, figs. 163, 165; A. de Gaigneron, "Nouveau regard sur la collection Thyssen," *Connaissance des Arts*, 306, August 1977, p. 59, fig. 16.

The Thyssen Collection is especially fortunate to have such extraordinary examples of both El Greco's Italian and Spanish periods. There could be no more dramatic contrast to the large early *Annunciation* than this smaller composition of the same subject painted at the very end of the century. The figures are extravagantly elongated, drawn out of all natural or even consistent proportion: Mary, though kneeling, is almost equal in height to the standing figure of Gabriel. The poses and attitudes are preciously mannered and Gabriel and the angelic musicians have a courtly, fragile elegance. Draperies have no organic relation to the bodies they cover and are distended and crushed like the wired and padded costumes of Neapolitan crèche figures. The colors are intense and jewel-like,

though slightly discordant, and charged with cold white highlights which break erratically across the surface. The narrow, densely filled composition is vertiginously organized in two registers, unified by the heavy eddying clouds. While there is no pronounced distinction between the two realms, the effect is somewhat more glorious below, and we are, to quote Waterhouse, "in some corridor of heaven," overwhelmed by this sumptuous epiphany and persuaded to El Greco's ecstatic vision. The intensity of pitch, sometimes strained in El Greco, is brilliantly sustained in this little masterpiece. If the tenor of religious life in Spain was conducive to such expression, El Greco's remoteness from the great centers of art perhaps contributed to the development of so personal a style. If he learned to paint in Venice, it was in Toledo that the schematic and abstract images of Byzantine art – the images of his earliest memories – were actively revived and fused with the sensuous art of Italy.

The sewing basket in the foreground is a fairly common attribute of the Virgin Annunciate, a sign of her pious handiwork on the Veil of the Temple. The burning bush just behind is less usual: just as the bush burned and was not consumed when the Lord appeared to Moses, so the Virgin received the Divine Light at the moment of the Incarnation. The canvas is slightly cut at the bottom through the lower step, the basket and the cloud.

The Thyssen *Annunciation* is almost identical with a canvas more than twice its size now in the Museo Balaguer in Villanueva y Geltrú. The larger version was originally the central panel of the altarpiece of the Colegio de Doña María de Aragón in Madrid. El Greco received the commission in 1596, and the altarpiece was delivered from Toledo to Madrid in 1600. The artist was responsible for the architectural framework, the sculpture and the paintings. The altarpiece is now dispersed. The other two panels of the altarpiece are the *Baptism* in the Prado, Madrid, and possibly the *Adoration of the Shepherds* in the Roumanian National Gallery, Bucharest. There are small workshop replicas of all three compositions: the *Annunciation* in the Museo de Bellas Artes, Bilbao; the *Baptism* and *Adoration* in the National Gallery, Rome. The

Thyssen *Annunciation* is possibly a finished study, or *modello,* for the central panel; such preparatory studies are very rare in El Greco's œuvre.

BARTOLOMÉ ESTEBAN MURILLO
Seville 1618–1682

56. THE MADONNA AND SAINTS APPEARING TO SAINT ROSE

Canvas, 190×147 cm.

Provenance: Capuchin Convent (?), Seville, Mr. Stanhope, later Lord Harrington, since 1729; Dukes of Rutland, Belvoir Castle, Leicestershire; Count Contini-Bonacossi, Florence; acquired 1968.

Literature: 1969 Catalogue, no. 228; D. A. Iñiguez, "Algunos Dibujos de Murillo," *Archivio Español de Arte,* 47, 1974, p. 108, fig. 22.

Saint Rose of Viterbo (c. 1235–1252) was a Franciscan Tertiary who in 1457 was canonized by Pope Calixtus III. According to the account of the Saint's life, she was restored from a grave illness by the Virgin, who appeared in a vision and ordered her to join the Third Order of St. Francis. The vision in Murillo's painting is not specifically related to this episode, but is treated in a more general and idealized fashion. The Madonna and Child appear attended by four Virgin Martyrs dressed in white robes and carrying palm fronds. Saint Rose, wearing the Franciscan habit, kneels before the Child and offers him a rose. The Virgin in red and blue draws her forward and looks down on the child-like figure of the Saint with great tenderness. Four putti in a bank of clouds are lively witnesses to the touching scene. The figure in the background with the raised arm addressing the crowd has been identified as St. Francis preaching; but he is clearly wearing a white shawl over a brown habit as does Saint Rose, and the shawl would be inappropriate to St. Francis. Surely the scene represents St. Rose herself preaching penance to the people of Viterbo in 1247, when the town was held by Frederick II of Germany and prey to political strife and heresy.

The painting is a very fine example of Murillo's mature style. It is softly brushed, and the

modeling and passage from one form to another is fluid and effortless. The colors are warm and glowing; and though the red and blue of the Virgin's robes may be traditional, they are delicately saturated and tempered to hues especially associated with Murillo. The glory of golden light behind the Virgin Martyrs is balanced by the pools of deep shadow in the lower part of the composition which embrace the principal figures and link them with the narrative vignette in the background. The women are generalized, all sisters, and more pleasing than striking in their looks, with the exception of the ascetic Saint Rose, who is somewhat homelier and sallow in complexion, especially next to the Madonna. Heaven and earth are joined in sweet agreement and the vision of the celestial company is given reassuring and familiar reality. The picture is close in style to the extensive series of paintings Murillo executed between 1666 and 1668 for the Capuchin Convent in Seville and may be dated around that time.

There is a pencil drawing in the Biblioteca Reale in Turin of the Virgin and Child with St. Rosalie and three Martyr Saints; it varies only in small details from the Thyssen composition, but is reversed and in an oval format. It does, however, according to Iñiguez, coincide exactly with a painted copy in the Wallace Collection, which shows only the Virgin and Child and St. Rosalie in half figure, and the drawing must preserve the full composition of a lost original. Iñiguez makes no mention of the possibility of an intermediate engraving.

FRANCISCO DE ZURBARÁN

Fuente de Cantos 1598 – Madrid 1664

57. SAINT AGNES

Canvas, 140×107 cm.

Provenance: Duque de Béjar, Madrid; acquired 1957.

Literature: 1969 Catalogue, no. 336; J. Gállego, J. Gudiol, *Zurbarán 1598–1664*, London, 1977, pp. 113, 114, no. 457; M. Gregori, T. Frati, *L'opera completa, Zurbarán*, Milan, 1973, no. 161.

Among the most attractive of Zurbarán's productions are his paintings of single female saints in sumptuous and picturesque contemporary costumes. They may be shown either in full or three-quarter length, often turned to the side, but looking out, and dramatically lighted against a dark neutral background. Some were installed in altarpieces, others may have been independent devotional pictures, but the majority were painted in series to be hung in churches along the nave wall, and the effect of such a stately and resplendent file of Christian heroines must have been magnificent. Zurbarán first treated the subject in the early 1630s, but the taste for these female saints reached its height in the 1640s, when Zurbarán and his workshop produced them in large numbers, sometimes in groups numbering a dozen or so, unfortunately now all dispersed.

The Virgin Martyr Saint Agnes is shown in three-quarter view and turned slightly to the right; she holds the martyr's frond in her right hand and in her left the lamb which symbolizes her love of Christ and which is also a play in Latin on her name *(agnus)*. The neckline of her brilliant yellow gown is heavily bordered with jewels; the cuffs are deep mauve velvet. She is wrapped in a great swath of brilliant blue stuff which, draped over her left arm, encircles her body and covers her from the waist down. Her hair is piled high and elaborately dressed with strings of pearls and a jeweled clasp. The richness of her dress is a metaphor for the splendor of the Saint's faith and is befitting a member of the heavenly court. The coiffure, more extravagant and conspicuous than in comparable pictures by Zurbarán, and even a bit overwhelming for the face of the young girl, might allude to a notable episode in the life of St. Agnes. She refused to marry the son of the prefect of Rome, as she had declared herself a Bride of Christ. The boy's father, unable to persuade her, determined to shake her resolve by shaming her and brought her to a house of ill repute where she was stripped of her garments. As she prayed that her body be kept pure, her hair miraculously grew to a great length and covered her. The great ropes of hair bound in pearls might be a discreet reference to this miracle.

There is the possibility that such paintings of saints were allegorical portraits of noblewomen. The faces of the women, as in the *St. Agnes*, are always individualized, but this

could simply reflect the likeness of an anonymous model.

The picture is of great quality, brilliant in color and grand in effect, but the attribution to Zurbarán is rejected by Soria ("Francisco de Zurbarán" *Gazette des Beaux-Arts*, XXV 1944, pp. 167–68) who considers the *Saint Agnes* "too elegant and painterly conceived." His subsequent attribution to Alonso Cano seems wide of the mark and is rejected by Wethey (*Alonso Cano*, Princeton, 1955, p. 165). Wethey, however, does not attribute the picture to Zurbarán, as stated in the 1969 Thyssen Catalogue (p. 366, in the *Literature*), but simply remarks that "The style reflects Zurbarán..."

INDEX

(by catalogue number)

Altdorfer, Albrecht 27

Amberger, Christoph 28

Anonymous, Burgundian Master 18

Anonymous, Nürnberg Master 32

Anonymous, South German Master 33

Antonello da Messina 1

Baldung, Hans, called Grien 30

Bartolommeo, Fra (Baccio della Porta) 2

Bellini, Giovanni 3

Boucher, François 46

Canaletto (Giovanni Antonio Canale) 4, 5

Cappelle, Jan van de 35

Carpaccio, Vittore 6

Ceruti, Giacomo 7

Christus, Petrus 19

Cossa, Francesco del 8

Duccio di Buoninsegna 9

Eyck, Jan van 20

Fragonard, Jean-Honoré 47

Giovanni di Paolo 10

Gossaert, Jan, called Mabuse 21

Goya y Lucientes, Francisco José de 52, 53

Greco, El (Domenico Theotocopuli) 54, 55

Grien – see *Baldung*

Guardi, Giovanni Antonio 11, 12

Heda, Willem Claesz 36

Heem, Jan Davidsz de 37

Heemskerck, Maerten van 22

Hooch, Pieter de 38

Juán de Flandes 23

Koerbecke, Johann 31

Lancret, Nicolas 48

Linard, Jacques 49

Longhi, Pietro 13

Lucas van Leyden 24

Mabuse – see *Gossaert*

Memling, Hans 25

Momper, Joos de 40

Murillo, Bartolomé Esteban 56

Palma Vecchio (Jacopo Negretti) 14

Piazzetta, Giovanni Battista 15

Post, Frans Jansz 41

Rembrandt van Rijn 42

Rubens, Petrus Paulus 26

Ruisdael, Jacob Isaacksz van 43

Ruysdael, Salomon van 44

Steen, Jan 45

Strigel, Bernhard 34

Tintoretto (Jacopo Robusti) 16

Titian (Tiziano Vecellio) 17

Watteau, Antoine 50, 51

Zurbarán, Francisco de 57